# TYPOGRAPHY 28

## THE ANNUAL OF THE TYPE DIRECTORS CLUB

COLLINS DESIGN

*An Imprint of* HarperCollins*Publishers*

# ACKNOWLEDGMENTS
### AND
## SOME OTHER STUFF

Typography 28
Copyright © 2007 by the
Type Directors Club

For information, address
Collins Design
10 East 53rd Street
New York, NY 10022

HarperCollins books may be purchased for educational, business, or sales promotional use For information, please write: Special Markets Department HarperCollinsPublishers
10 East 53rd Street
New York, NY 10022

Collins Design is an Imprint of HarperCollinsPublishers.

First Edition

First published in 2007 by:
Collins Design An Imprint of
HarperCollinsPublishers
10 East 53rd Street
New York, NY 10022
Tel: (212) 207-7000
Fax: (212) 207-7654
collinsdesign@harpercollins.com
www.harpercollins.com

Distributed throughout the world by
HarperCollinsPublishers
10 East 53rd Street
New York, NY 10022
Fax: (212) 207-7654

The Library of Congress Control Number or LCCN is a serially based system of numbering books in the Library of Congress in the United States. This numbering system has been in use since 1898.

Library of Congress
Control Number:
2007928776

ISBN: 978-0-06-117342-4
ISBN-10: 0-06-117342-8

Printed in China
First Printing, 2007
Produced by Crescent Hill Books

The Type Directors Club gratefully acknowledges the following for their support and contributions to the success of TDC53 and TDC² 2007:

See page 351.

Design: Number Seventeen
Editing: Susan E. Davis

Judging Facilities:
Fashion Institute of Technology
Exhibition Facilities: The One Club
Chairpersons' and Judges' Photos:
Christian DiLalla

TDC53 Competition
(call for entries):
Design: Number Seventeen
Printer: Jaguar Advanced Graphics
Paper: Scheufelen
Prepress Services: A to A Graphic Services, Inc.
TDC² 2007 Competition
(call for entries):
Design: Gary Munch

The principal typefaces used in the composition of TYPOGRAPHY 28 are Gotham and Egyptienne

Gotham is a family of geometric sans serif typefaces created by by American type designers Hoefler & Frere-Jones in 2000. Gotham's letterforms are inspired by a form of architectural signage that achieved popularity in the mid-twentieth century and are especially popular throughout New York City.

Egyptienne is an adaptation of the Hellenic Wide typeface by American Type Founders. Hellenic Wide is a typical late-century adaptation of the slab serif or Egyptian style developed in the early nineteenth-century and popular ever since.

The International Standard Book Number, or ISBN (sometimes pronounced [iz'-bin]), is a unique identifier for books, intended to be used commercially. The ISBN system was created in the United Kingdom in 1966 by the booksellers and stationers WH Smith and was originally a nine-digit code called Standard Book Numbering or SBN.

# CONTENTS

TYPOGR

APHY 28

# PAULA SCHER: TDC MEDALIST 2006

The Type Directors Club Medal was awarded to Paula Scher, a principal in the New York office of Pentagram. Scher, the twenty-third recipient of the Medal, has produced an outstanding body of work in the first 30 years of her career. She has been named to the Art Directors Hall of Fame, received the Chrysler Award for Innovation in Design, served on the national board of the American Institute of Graphic Arts and president of the New York Chapter, and received the AIGA Medal. Her work is in the permanent collections of the Cooper Hewitt National Design Museum, The Library of Congress, the Museum of Modern Art, and many international museums and collections.

Scher's work has been included in twenty-two *TDC Annuals*, beginning with *Typography 6*, in addition to the book you are holding. This is a remarkable achievement. Hung as a group of 38 pieces, her competition winners created the most popular show ever held in the TDC Gallery.

The Medal of the Type Directors Club is awarded in recognition of outstanding contributions to typographic excellence. The first Medal was awarded to Hermann Zapf in 1967. The recipients of the twenty-two other Medals, awarded over 40 years, are listed in the back of this Annual.

*The Board of Directors*

1974 CHANGES

1975 COMMON SENSE

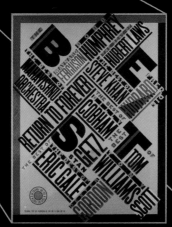

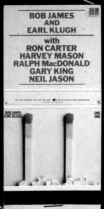

1978 BARTÓK

1979 BEST OF JAZZ

1979 ONE ON ONE

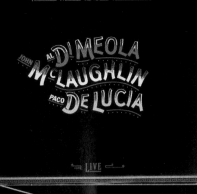

1981 FRIDAY NIGHT IN SAN FRANCISCO

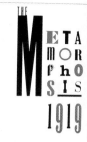

1984 GREAT BEGINNINGS

1986-88 ÖOLA

1985 PRINT

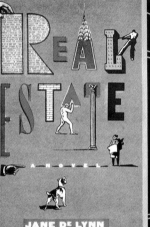

1988 REAL ESTATE

1990 AIGA ANNUAL

1994-95 ALPHABET

1991 THE BIG A

1992 SVA

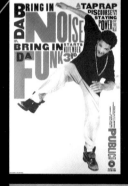
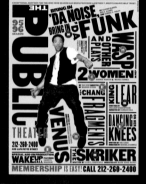
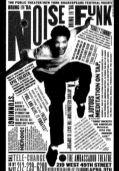

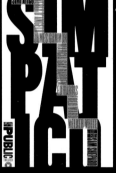
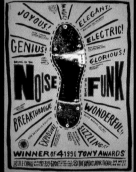
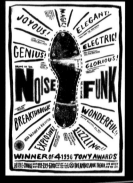
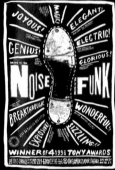

1994 PUBLIC THEATER

1995-98 BRING IN DA NOISE

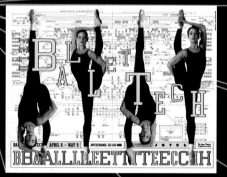
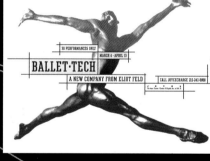

1997-2000 BALLET TECH

1998 CITI

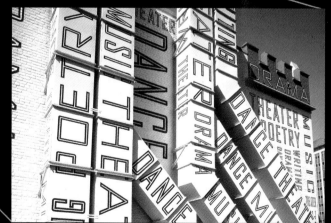

2000 NEW 42ND

2001 NJPAC

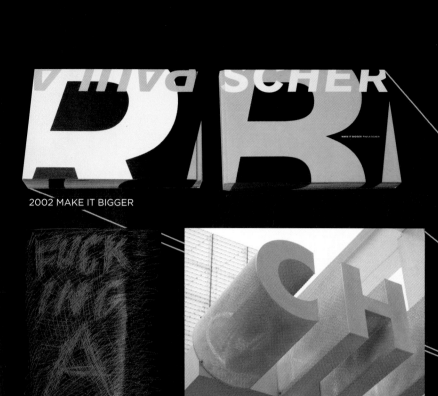

2002 MAKE IT BIGGER

2002 SYMPHONY SPACE

2003 FUCKING A

2004 CHILDREN'S MUSEUM OF PITTBURGH

2004 JAZZ AT LINCOLN CENTER

The Met
ropolitan
Opera

The Metropolitan Opera

2005 BLOOMBERG

2005 CHAUMONT

2006  METROPOLITAN OPERA

2007

# GRAHAM CLIFFORD

2006 marked the 60th anniversary of the Type Directors Club, and it was a great honor to be asked to chair this year's competition.

So much has changed in the club's 60-year history, but fortunately so much has stayed the same as we witness fresh, outstanding, breakthrough work in this book.

This is what I find so fascinating and inspirational about the art of typographic design.

Congratulations to the 215 winners selected from 2,043 entries from 34 countries.

The *TDC Annual* is useful for documenting a historical record of excellence as well as inspiring designers and students all over the world.

A special thanks to members of my magnificent jury who all hail from different geographic and typographic backgrounds: Marian Bantjes, British Columbia; Len Cheeseman, New Zealand; Deanne Cheuk, New York; Bruce Licher, Sedona, Arizona; John Pobojewski, Chicago; Paul Sahre, New York; and Armin Vit, New York.

The jury was surprised and amazed at the high overall standard of work. They were tough. Over the course of one weekend, they ploughed through and picked, in their opinion, the best work of 2006.

I very much hope you enjoy the annual.

Graham Clifford

Graham Clifford is a second-generation type director. He was trained by his father before working for some of London's best advertising agencies, including Collett Dickenson Pearce and Gold Greenlees Trott. Graham moved to New York in 1989 and plied his craft at Chiat/Day and Ogilvy. In 1994 the germ of independence took root, and Graham opened his own design consultancy collaborating with agencies and directly with clients on projects that include advertising, logo design, and brand identity.

Awards over the years have included the Art Directors Club, Communication Arts, One Show Pencils, the Type Directors Club, and a silver at D&AD. Graham judged the typography category at D&AD this year and is chair of the TDC Program Committee.

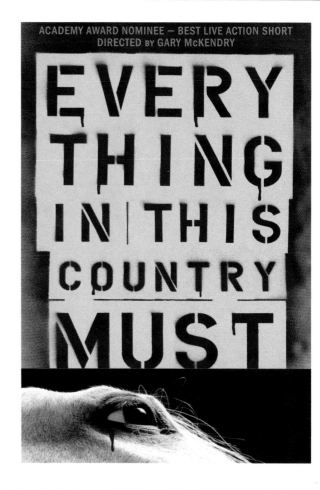

ACADEMY AWARD NOMINEE – BEST LIVE ACTION SHORT
DIRECTED BY GARY McKENDRY

EVERY THING IN | THIS COUNTRY MUST

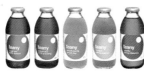

teany
white tea with
pomegranate
100% natural

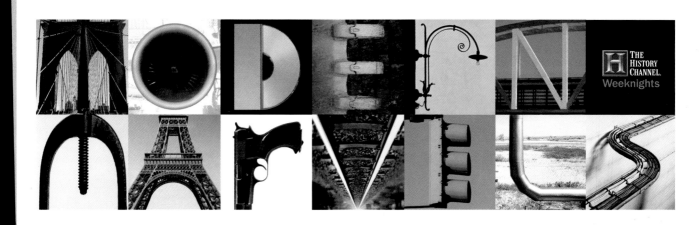

THE HISTORY CHANNEL.
Weeknights

# TDC53 JUDGES

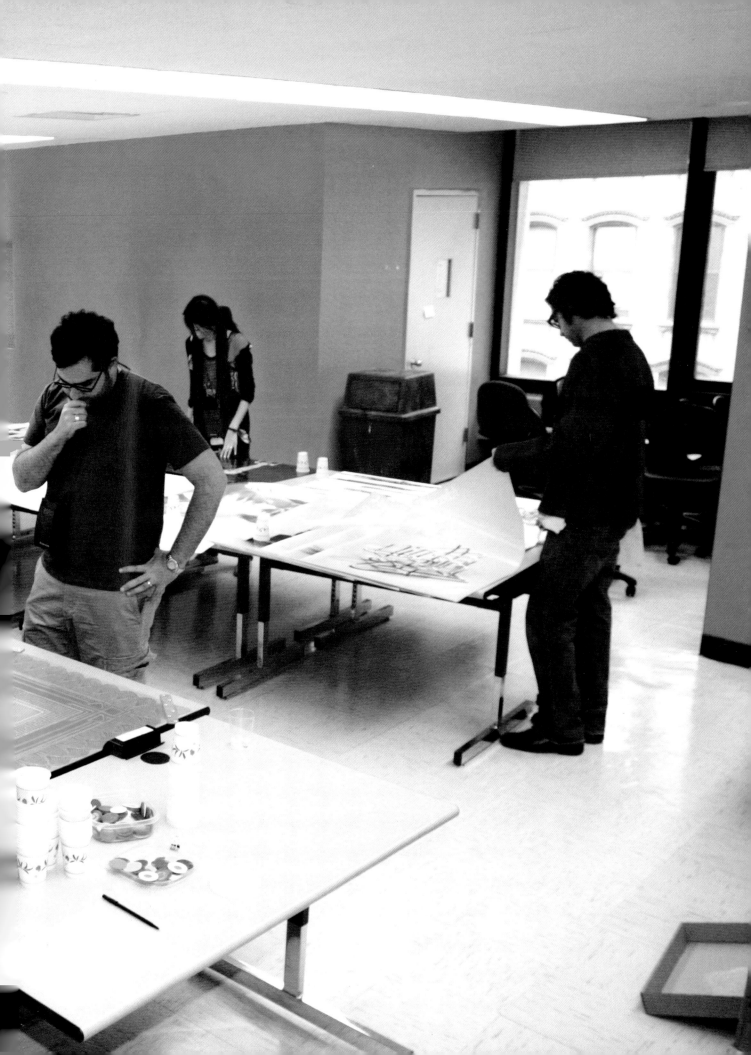

# BRUCE LICHER

Bruce Licher is the founder and principal of Independent Project Records & Press and Licher Art & Design. A musician, artist, graphic designer, photographer, and letterpress printer, Bruce studied in the Fine Arts Department at The University of California, Los Angeles. He created his first "art record" in an independent project in early 1980. In 1982 Bruce happened upon a class in letterpress printing at the LA Women's Graphic Center where he learned how to create album covers for his band, Savage Republic.

Establishing his own letterpress shop in an old warehouse in downtown LA in 1984, Bruce began designing and printing album covers and announcements for Independent Project Records and soon was in demand from an ever-increasing number of clients. He released four Savage Republic albums in the 1980s, whose music was featured in motion pictures including "Silence of the Lambs." With his current group Scenic, Bruce creates all-instrumental landscapes released in all-cardboard Discfolio packaging featuring his panoramic desert photography. Bruce is also working on a solo album.

Nominated for a Grammy for his record album packaging in 1986 and 1987, Bruce is generally credited with starting the trend in hand-letterpress printed CD and record packaging using industrial-style chipboard. His graphic design and letterpress printing work was featured in two shows at the Cooper Hewitt National Design Museum (1996 and 2000) in New York City. His letterpress design work was recently exhibited in two shows in France.

Bruce lives in Sedona, Arizona, where he continues to design and print CD and record packaging, along with an array of other creative letterpress projects.

# JOHN POBOJEWSKI

John Pobojewski is a designer/artist/musician who seeks to express humanity in design through creating connections. He is a graduate of Northern Illinois University with a BFA in visual communication and a BA in music in performance. At Thirst, in collaboration with Rick Valicenti, he has served clients including Herman Miller, Illinois Institute of Technology, Lyric Opera of Chicago, Wright Auctions, and many others.

As a designer John has received recognition from *Graphis*, *STEP 100*, and the Type Directors Club, and his work has appeared in *I.D. Magazine* and *Print*. In 2006 he was selected as one of *Print Magazine's* New Visual Artists: 20 under 30. He has lectured at Northern Illinois University and the University of Illinois at Urbana-Champaign.

As a musician John is a founding member of the Base4 Percussion Quartet, a chamber group that performs modern percussion works in cutting-edge performances featuring interactive visuals. The group's debut CD "[one]" was released in 2003.

make
new
*friends*
for *life*

I know
I'm really
talented

# MARIAN BANTJES

Marian Bantjes is a self-described [typo]graphic artist, writer, educator, and lapsed designer who sometimes rises from the dead to design again. After ten years as a book typesetter and nine with her own design firm, she now works independently supplying combinations of art, custom type, and design to clients such as Pentagram, Stefan Sagmeister, Winterhouse, Young & Rubicam Chicago, *The Guardian*, *The New York Times Book Review*, *Wallpaper Magazine*, and *Wired*, among others. Marian is an author of the design weblog "Speak Up," and has had her work and her writing featured in magazines and publications in North America and Europe, including *Communication Arts*, *étapes, Eye, Print*, and *STEP*. Marian works from her home on Bowen Island, British Columbia, Canada.

# LEN CHEESEMAN

Len Cheeseman trained originally as an old-school compositor and then studied design at Camberwell Art College in London. Following that he spent many years as a type director at several noted London ad agencies until relocating with his family to New Zealand in 1992 to work for Saatchi&Saatchi, where he remained for twelve years. During that period the office was considered one of the top ten agencies in the world, and creative opportunities were plentiful, both in traditional type direction as well as graphic design, motion graphics, and art direction,

Many examples of Len's work can be seen over the years in the pages of the *TDC Annuals* as well as D&AD and Award in Australia. Len has won Pencils for typography in both hemispheres as well as three silver Pencils for art direction in Australia. Len is now an independent consultant working on a range of projects in both print and motion.

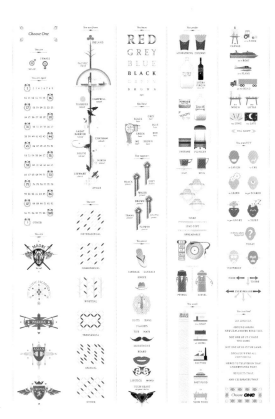

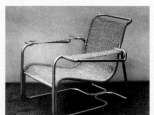

IN 1941, THIS WAS REGARDED AS A

# THREAT TO

# NATIONAL SECURITY

POOR ERNST PLISCHKE. HE JUST ESCAPES TO NEW ZEALAND FROM NAZI GERMANY, WHEN HIS NEW NEIGHBOURS REPORT HIM FOR ESPIONAGE. AFTER SEEING STEEL TUBES DELIVERED TO HIS HOUSE THEY ASSUMED THIS AUSTRIAN REFUGEE HAD EVIL PLANS AFOOT. FURNITURE PLANS AFOOT WAS MORE ACCURATE, AND THE ONLY THINGS HE THREATENED WERE THE ARCHITECTURAL CONVENTIONS OF THE TIME. COME AND SEE THE RESULTS.

ERNST PLISCHKE ARCHITECT

# ARMIN VIT

Born and raised in Mexico City, Armin Vit is a graphic designer and writer now living in Brooklyn, New York. He has written for *AIGA's VOICE, Creative Review, Emigre, Eye, HOW,* and *STEP* magazines, among others. He is a former faculty member of the Portfolio Center and currently teaches at the School of Visual Arts. Armin has lectured on topics ranging from typography to branding in locations ranging from San Diego to Berlin. He is co-founder of UnderConsideration which runs the (in)famous Speak Up (included in Cooper Hewitt's 2006 National Design Triennial), The Design Encyclopedia, Brand New, and Quipsologies. Currently, Armin spends his days working at Pentagram. Feisty behind the keyboard, Armin remains timid at heart.

# BRAND NEW

UIPSOLOGIES

STOP BEING SHEEP

# DEANNE CHEUK

Deanne Cheuk is an art director, illustrator, and artist from Perth, Western Australia, the most isolated city in the world. She got her first job as a magazine art director at the age of 19, the same year she graduated from university with a degree in graphic design. Since then Deanne has art directed or designed many magazines, including most recently *Tokion Magazine.*

Deanne's art direction has been heavily influenced by her illustrative work, and she is renowned for her illustrative typography. She has been commissioned by such companies as Converse, ESPN, MTV2, Nike, and Sprint, and she is a contributor to *Blackbook, Dazed and Confused, The Fader, Flaunt, The Guardian, The New York Times Magazine,* and *Nippon Vogue.* She has worked with Doug Aitken, David Carson, and Conan O'Brien.

2005 saw the release of Deanne's first book, *Mushroom Girls Virus,* which sold out worldwide in three months. In 2006 Target launched a line of products designed by her. Deanne self-publishes a nonprofit, contributor-based graphic zine called "Neomu." She lives in New York City.

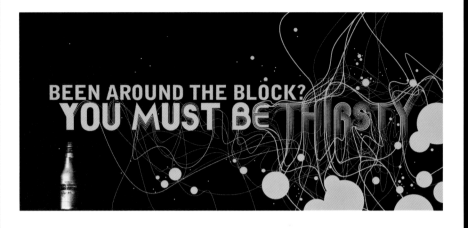

# PAUL SAHRE

Graphic designer, illustrator, educator, lecturer, foosballer, and author, Paul Sahre established his own design company in New York in 1997. Consciously maintaining a small office, he has nevertheless established a large presence in American graphic design. The balance he strikes, whether between commercial and personal projects or in his own design process, is evident in such things as the physical layout of his office: part design studio, part silkscreen lab where he prints designs and prints posters for various Off-Off Broadway theaters, some of which are in the permanent collection of the Cooper Hewitt National Design Museum. On the other side of the office he is busy designing book covers for such authors as Chuck Klosterman, Ben Marcus, Rick Moody, and Victor Pelevin. Paul is also a frequent contributor *The New York Times* op-ed page.

Paul is co-author of *Hello World: A Life in Ham Radio*, a book based on a collection of QSL cards, which amateur radio enthusiasts exchange after communication with other operators around the world.

Paul received his BFA and MFA in graphic design from Kent State and teaches graphic design at the School of Visual Arts. He is a member of Alliance Graphique Internationale.

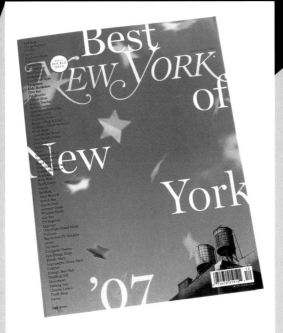

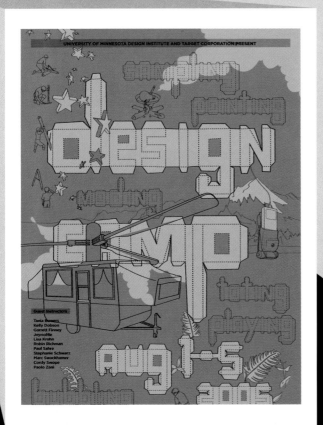

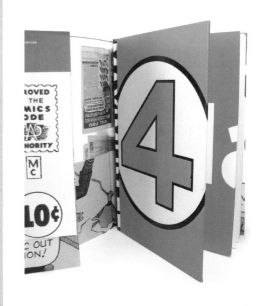

TDC

# 53
## JUDGES' CHOICES & DESIGNERS' STATEMENTS

**BRUCE LICHER**
Judge

While there were a number of entries in the competition that appeared to explore similar territory to the aesthetic I've worked with over the years (and most of them were excellent pieces), my first impulse was to choose something completely different for my Judge's Choice. After all, we don't want to be too obvious, do we?

But during the final run-through of a long day of looking at thousands of pieces of work, I saw a poster that was mining a familiar style yet stood out from all the other letterpress-on-chipboard entries. There was something quite special about the hand-carved art-deco-style illustration and how it was combined with hard-edged and more traditional handset type and ornamentation.

I like work that doesn't jump out at first but holds you with intrigue and makes you look closer to see what's really going on. Upon further inspection the multiple layers of white revealed themselves as a beautiful reduction carving, and the subtlety in the work and the skillfulness of its execution won me over. Excellent work, Brady and Matt. How can I get a copy?

Our main goal with this poster was to communicate a different and more experimental sound on the newest Wilco recording "A Ghost Is Born." We didn't want to make a poster that looked at all "alt-country" (stupid term) or like a typical broadside type piece sometimes seen in letterpress posters. The large field of white that makes up the "wilco" type and the very, very small cityscape vignette at the bottom of the piece were printed in four separate layers of white as a reduction linoleum cut. Each layer creates a more opaque and glossier white on top of the previous layers of white. We don't usually illustrate our posters. However, Matt McNary did a beautiful job on this illustration, and it made the piece. Three things influenced this piece: Atari graphics, Chris Ware, and wintertime.

**MATT MCNARY &
BRADY VEST**
Designers

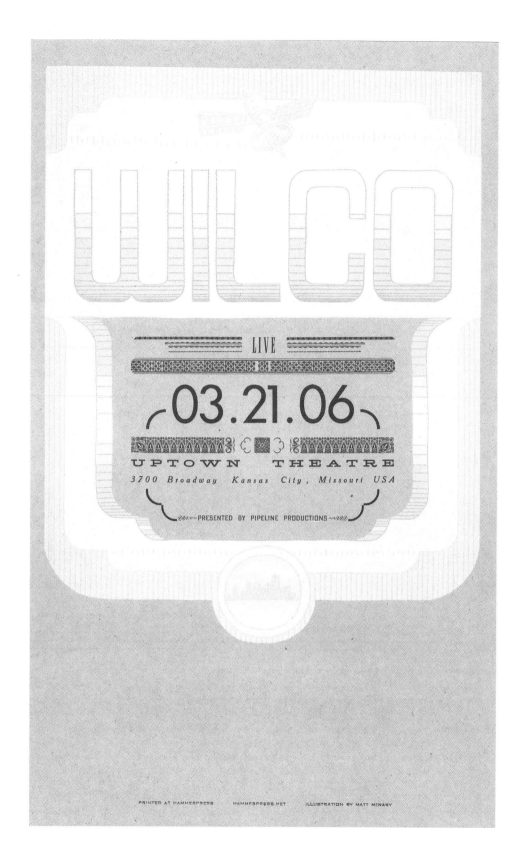

**DESIGN** Matt McNary *Kansas City, MO*

**ART DIRECTION** Brady Vest

**DESIGN OFFICE** Hammerpress

**CLIENT** pipeline productions

**PRINCIPAL TYPE** Various wood and lead type

**DIMENSIONS** 15 x 26 in. (38.1 x 66 cm)

BIG TYPE SAYS MORE truly says it all.

This museum installation by Dutch duo Strange Attractors stopped me in my tracks. A commentary on messaging, materials, craft, personality—this piece has much to say.

I was struck at first by the beauty of the hand-drawn letterforms and how they were interwoven to create one seamless form ending with a great crescendo to the LED CUT. The pacing and the flow of the piece couldn't feel any better.

If the letterforms are the voice, the materials are the soul. The designers use everything about this raw medium to their advantage, right down to the exposed edges of the honeycomb structure. I'm in awe of the dynamic space created out of such simple moves, using just a few levels of cut cardboard. Even details like the structural plywood spacers somehow seem to work.

To me the success of this piece lies in how the voice and soul become a reflection of the designers themselves. When every part of a piece comes from the designer's hand, from typography to form to installation, one cannot help but feel the real human presence of the individuals who created it. It is that essence, that personality, which makes this piece resonate so strongly with me even months later.

We all strive to have our work resonate with others. These designers have shown us how to do it using our own voices.

**JOHN POBOJEWSKI**
Judge

Over the course of five weeks, using industrial hand-held jigsaws and paint, we manually produced a five-layer-thick, 2.83-meter-high, and over 17-meter-wide typographic installation as part of the ongoing exhibition "Cut for Purpose" at Museum Boijmans van Beuningen in Rotterdam. The typographic structure was positioned as the front part of a spatial honeycomb cardboard structure by Stealth Ltd., enticing the viewer from the windows and glass entrance and rewarding them as they approach with increasingly complex yet graceful forms. Our objective was to merge contemporary technology with traditional craftsmanship while representing the diverse, multicultural, architectural city of Rotterdam. In the end custom-programmed microcontrollers with sequenced LEDs were mounted to add "a touch of Vegas" to the type that we created specifically for this project. "BIG TYPE SAYS MORE" has been acquired as part of the permanent collection of Museum Boijmans van Beuningen.

**STRANGE ATTRACTORS DESIGN**
Designers

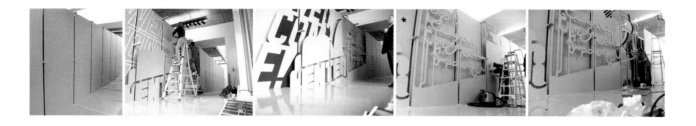

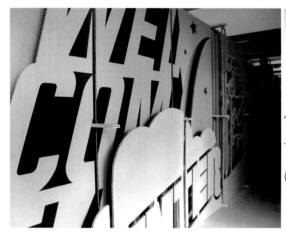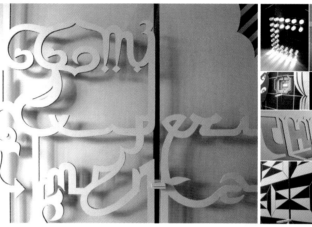

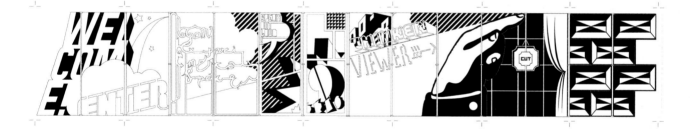

**DESIGN** Catelijne van Middelkoop and
Ryan Pescatore Frisk *The Hague,*
*The Netherlands*

**ART DIRECTION** Catelijne van Middelkoop and
Ryan Pescatore Frisk

**CREATIVE DIRECTION** Catelijne van Middelkoop
and Ryan Pescatore Frisk

**LETTERING** Catelijne van Middelkoop and
Ryan Pescatore Frisk

**PRODUCTION** Catelijne van Middelkoop and
Ryan Pescatore Frisk

**STUDIO** Strange Attractors Design

**CLIENT** Museum Boijmans van Beuningen
*Rotterdam, The Netherlands*

**PRINCIPAL TYPE** Turfhaus and custom

**MARIAN BANTJES**
Judge

While I am not a religious person, I am fascinated by religious expression in graphics. This piece has an energetic joy that is captured both in a common everyperson way, through the use of handlettered (felt pen?!) type, and with permanence through the medium of laser-cut steel. It has a sense of rabid graffiti, a kind of mania, which brings this sense of energy and aliveness to the type. The letterforms, while individually "penned," also allude to older, more traditional text forms with nestled letters. The type bucks and dances with varied size and baseline yet is controlled within lines, which again create this interesting juxtaposition of restrained exuberance. Pentecostal meets Catholic? I don't really care what it's singing; it just sings.

The idea of a public nativity was initiated by Christian churches and proposed by the City of Melbourne as an installation on a prominent wall in the City Square. The design response was to redirect the brief away from the traditional figurative nativity scene toward a less predictable interpretation that functioned on more than one level at the same time. The work needed to encapsulate the churches' request to publicly display the Christmas story. The design intention aimed to elevate the status of the design idea toward that of a work of art and to activate the public space by creating an attraction that was open and accessible to a broad cross-section of the community. The specific nativity scripture from the Bible was visually expressed in a naïve calligraphic manner, laser-cut from stainless steel sheet, installed away from the wall surface forming a perforated screen. Existing up-lighting between the wall and the screen was used to generate a compelling nighttime presence.

**GARRY EMERY**
Designer

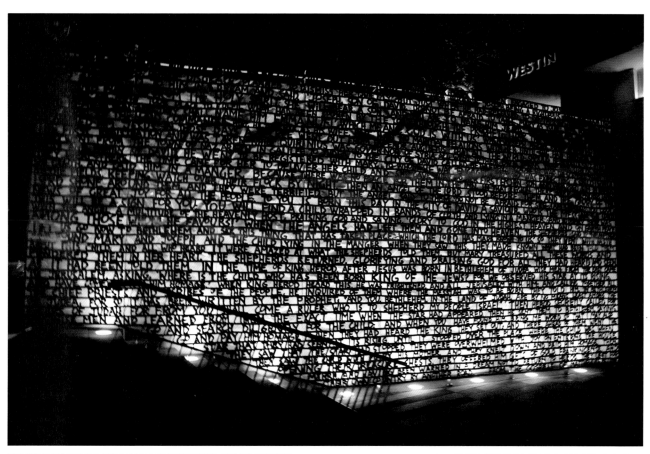

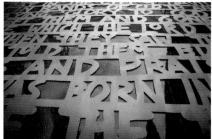
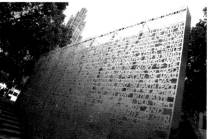
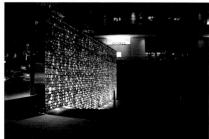

**DESIGN** Mark Janetzki *Melbourne, Australia*

**CREATIVE DIRECTION** Garry Emery

**LETTERING** Mark Janetzki

**STUDIO** emerystudio

**CLIENT** City of Melbourne

**PRINCIPAL TYPE** Handlettering

**SIGNAGE** 35

**LEN CHEESEMAN**
Judge

Sometimes a piece of work takes me completely by surprise and rewards me with that exhilarating moment when I say to myself, "I wish I'd done that." I love that moment, hot jealousy tempered with admiration and an immediate desire to want to lift my own game. As a judge I had that moment hit me on several occasions—something way more exciting than anything I have encountered at the neutered excuse of a category that typography has become at D&AD.

I should have known the world of design would give me pleasures that seem to largely elude me these days in the advertising world that I have spent most of my career playing about in, but I wasn't prepared to be stopped in my tracks by an annual report. Sure, there were super motion pieces and fabulous posters at this show, but an annual report and from Eastern Europe? Crikey. It's not my thing. Rick Valicenti once gave me a couple he had designed which were brilliant but that was years ago, and I've never thought about them since.

Perhaps it's because this work is grounded in a good idea for the food producing company, Podravka, "cooking with heart" that brings the adman out in me. It's definitely the craft, the design, the little stickers with recipes on them, the great idea of the financials being produced as an accountant's computer printout from the 1980s that's been elegantly inserted, the business percentages appearing on kitchen appliances such as toaster dials, the lovely old lady in the kitchen cooking with heart.

Well, the whole piece is just delightful, restrained, perfectly balanced, and for only the second time in my life an annual report has made me briefly ponder doing one myself. But, no, these guys are too good, to the point where this terrific piece is not only about cooking with heart, it's been designed by people with their aesthetic hearts in the right place.

Podravka, "the company with heart," is one of the biggest food companies in the Zagreb region. The belief that everything needs to be done by heart can be seen everywhere—from the logo of the company to the production process that includes handmade techniques when necessary.

"Excerpt of the eternal debate about the heart" is structured in two parts: in the first part the interviewed people doubt the importance of the heart, while the second part proves that it is the only thing that matters.

Except for the usual data about the company, the annual report is full of why it is important to cook with heart. The central illustration of this is the autobiographical handwriting of the Croatian writer Ante Tomic which describes his childhood full of Podravka's products that became more than food but a group of scent and taste sensations that remind millions of people of home and growing up. The annual report is also full of recipes. The revisor's report is written on an endless tape used worldwide by accountants in the seventies and eighties.

This is the sixth annual report for Podravka made by the creatives of Bruketa & Zinic OM. Using the possibilities of print technology to the maximum, the annual reports stop being books filled with data and become ambassadors of Podravka's brand—books that are read and kept in the private libraries of those they are made for.

**DAVOR BRUKETA & NIKOLA ZINIC**
Designers

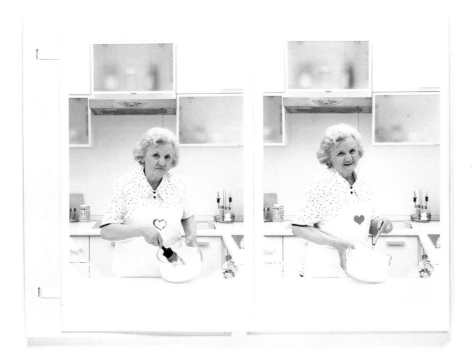

**DESIGN** Davor Bruketa, Mirel Hadzijusufovic, Imelda Ranovic, and Nikola Zinic *Zagreb, Croatia*

**ART DIRECTION** Davor Bruketa and Nikola Zinic

**CREATIVE DIRECTION** Davor Bruketa and Nikola Zinic

**PHOTOGRAPHY** Domagoj Kunic and Marin Topic

**AGENCY** Bruketa & Zinic OM

**CLIENT** Podravka

**PRINCIPAL TYPE** DIN Medium Rounded, Minion Pro, and DC SysDot

**DIMENSIONS** 8.5 x 13.8 in. (21.5 x 35 cm)

**ARMIN VIT**
Judge

I don't have enough fingers and toes in my immediate limbs to count the number of typographic details that I consider offensive about the typography in this catalog. Seriously. There are things I hate, like all the colorful strokes around the irritatingly colorful typography; things I loathe, like the sometimes too-narrow, river-infested justified boxes of text; and things that make me laugh, like the generously open tracking of lowercase found throughout.

Despite these repelling reactions, I cannot stop looking at the catalog. I find myself mesmerized and lost in its unique, typographically oblique world. I become impatient to turn the pages to see what in the world could possibly come next, giddy by all the candy-colored typography attacking my visual sense, and oddly delighted by the intricate texture that this catalog has achieved through a perverse determination and commitment to creating a unique tone of voice that could not come from anywhere else than CalArts.

I have never been so seduced and so appalled at the same time by a single piece of typographic design. Yet here I am, scratching my temples wondering if there is something wrong me. I flip one more time through the catalog and finally find a simile of how this piece makes me feel. It's like morbidly watching someone bungee jump, swim with sharks, or some other dumb, life-threatening activity as my palms sweat and I think, "Man, I would never...," all the while taking wicked pleasure in seeing others take the risk. Thanks for the thrill, CalArts.

The CalArts Admission Catalog is used to promote the lively, bold, creative environments of the school to prospective students. California Institute of the Arts is comprised of six schools: Art, Dance, Music, Theater, Film/Video, and Critical Studies. Each school has programs, faculty, and facilities that are specific to the school, while each shares resources with the other schools within the Institute. The challenge for recruitment and promotional materials is to represent each school on its own terms as well as the greater CalArts community.

We designed individual catalogs for each of the schools that fit inside a CalArts overview booklet. Perspective students are given an overview booklet with the catalog for their particular school inserted in the back-cover pocket. The booklets can also be used separately without the CalArts overview. We also had 2,000 complete sets of all seven books sewn and glued together for counselors, libraries, and other people who want to see everything.

Although the content and design strategies are unique to each school, continuity is established by using a traditional two-column layout with center axis typography throughout all seven books. Also only one type family (designed by Keedy) is used, and all the patterns, ornaments, and graphic devices are from that font.

**JEFFERY KEEDY
& PENNY PEHL**
Designers

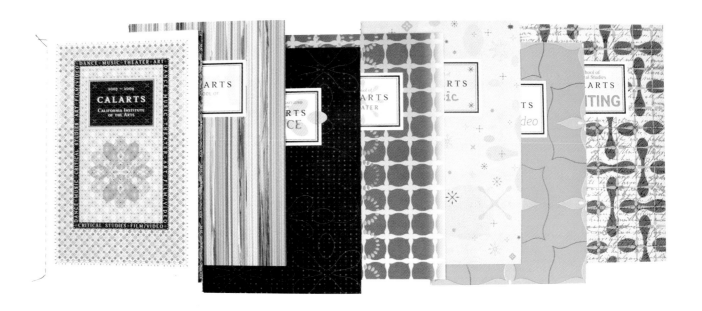

**DESIGN** Jeffery Keedy and Penny Pehl
*Los Angeles, CA*

**CREATIVE DIRECTION** Jeffery Keedy and
Penny Pehl

**SCHOOL** California Institute of the Arts

**PRINCIPAL TYPE** Keedy Casual, Keedy Gothic, and
Keedy Roman

**DIMENSIONS** 6 x 9 in. (15.2 x 22.9 cm)

**DEANNE CHEUK**
Judge

I always like to see what *The New York Times Magazine* and *T Magazine* are up to with their art direction, I have worked with them before, and they do an amazing job of being really creative with their collaborations. It's one thing to devote a whole page to illustrated type, but it's another thing to actually do it well, and here it is done beautifully.

These pieces from *T Magazine* immediately appealed to all of my creative sensibilities—typography, art direction, illustration, and art. I love that "The Damned" title page is so delicate and dark at the same time. There are so many lovely details like the snakes at the top coiling directionally to add perspective to the curves and the designer's initials hidden in the illustration. The black on white is so strong, and there is the tiniest hint of dimensionality in this one because the T was photographed rather than just scanned in. That attention to detail adds to the overall impact of all three of these pages.

I love the idea of a design having layers of meaning and depth, and I'm all about using typography in an illustrative way. I am thrilled that something as different as these was published in such a highly distributed publication.

The goal was to establish a unique graphic identity for *T: The New York Times Style Magazine*. To that end we commissioned type designer Matthew Carter to develop a T, asking him to base it on Times Fraktur but to transform it into a kind of letter on steroids—a rounded, enriched version of our font. To further create buzz for each issue of the magazine, we commissioned a different artist or designer to work with the letter, transforming its appearance and creating a work of art or design, each one reflecting the mood or style of the season. This series is the work of Lacemakers at Oscar de la Renta, the artwork of Michael Dal Veechio (vampires were a big influence in men's wear that season), and a crafty design of Fernando and Humberto Campana.

**JANET FROELICH**
Designer

40

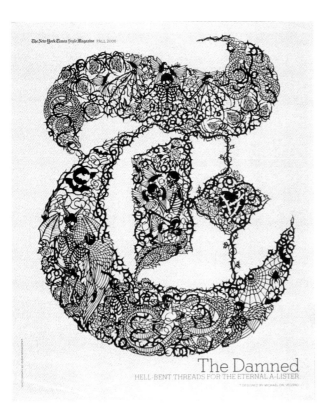

The Damned
HELL-BENT THREADS FOR THE ETERNAL A-LISTER.

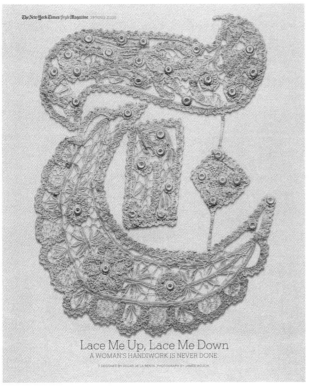

Lace Me Up, Lace Me Down
A WOMAN'S HANDIWORK IS NEVER DONE.

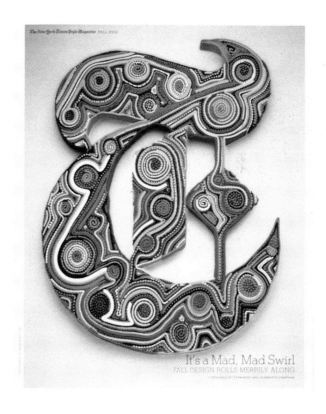

It's a Mad, Mad Swirl
FALL DESIGN ROLLS MERRILY ALONG

**ART DIRECTION** Christopher Martinez
*New York, NY*

**SENIOR ART DIRECTION** David Sebbah

**CREATIVE DIRECTION** Janet Froelich

**MAGAZINE** T: The New York Times Style Magazine

**PRINCIPAL TYPE** Fraktur and Stymie

**DIMENSIONS** 9.5 x 11.5 in. (24.1 x 29.2 cm)

**PAUL SAHRE**
Judge

This book documents Michael Bierut's (with various collaborators) response to a set of very limiting production and design perimeters for a specific client over a period of time. The book reproduces forty posters, each designed for the Yale School of Architecture and each limited to one color (mostly), a set format, and typographic elements only (again mostly).

I imagine that an institution like Yale could spring for color, so I have to believe that these restrictions were at least partially self-induced, and therefore I see each poster as a sort of self-assigned design challenge:

"OK. Black and white. Typography only. 22 x 32 inches. Let's see what I can do."

The result is a series of posters that surprise and inspire, providing evidence that, in the hands of an exceptional designer, limitations are really opportunities in disguise.

Eight years ago I was asked by the newly appointed dean of the Yale University School of Architecture, Robert A. M. Stern, to help promote the school's ambitious schedule of lectures, exhibitions, and symposia. The result was the series of posters collected in this book.

**MICHAEL BIERUT**
Designer

We decided at the outset to reflect the eclecticism of the school's programming by using different typefaces and graphic approaches for each poster. The only common elements are the trim size, the use of black and white, and the Y in a circle that serves as the school's unofficial logo. In keeping with the theme of "consistent diversity," the Y changes each time to suit the poster's theme.

Michael Bierut

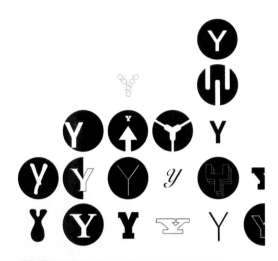

Open House
2006

Designers
Michael Bierut
Michelle Leong

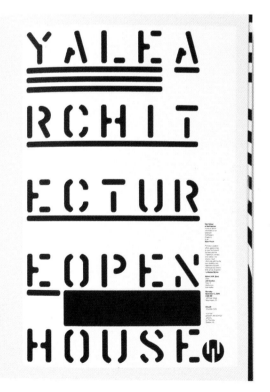

**DESIGN** Michael Bierut and Michelle Leong
*New York, NY*

**ART DIRECTION** Michael Bierut

**AGENCY** Pentagram Design Inc.

**CLIENT** Yale School of Architecture

**PRINCIPAL TYPE** Various

**DIMENSIONS** 7.25 x 10 in. (18.4 x 25.4 cm)

**BOOK** 43

TDC

# 53

ENTRIES SELECTED FOR
TYPOGRAPHIC EXCELLENCE

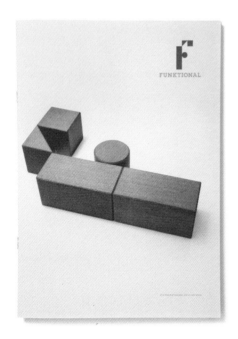

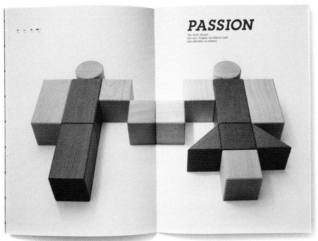

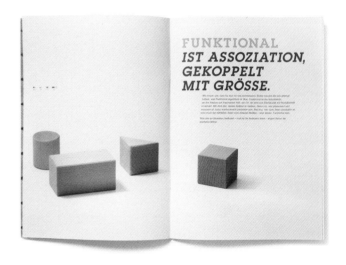

**46** **BROCHURE**

**DESIGN** Markus Koll *Hamburg, Germany*

**ART DIRECTION** Michel Fong and Markus Koll

**CREATIVE DIRECTION** Olaf Stein

**PHOTOGRAPHY** Karsten Wegener

**DESIGN OFFICE** Factor Design *Hamburg, San Francisco*

**CLIENT** Römerturm Feinstpapier GmbH & Co. KG, *Frechen, Germany*

**PRINCIPAL TYPE** ITC Lubalin Graph

**DIMENSIONS** 8.3 x 11.7 in. (21 x 29.7 cm)

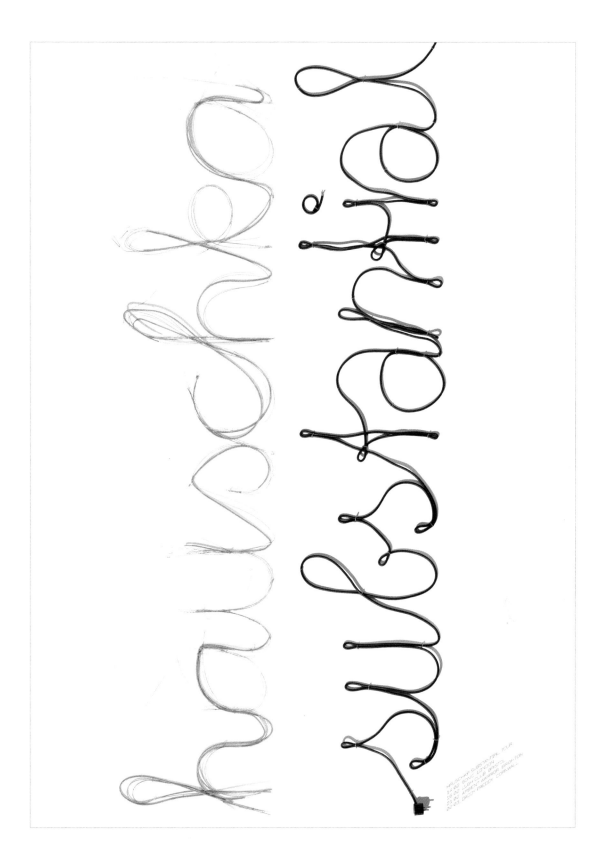

**DESIGN** Fons Hickmann and Barbara Baettig
*Berlin, Germany*

**ART DIRECTION** Fons Hickmann and
Barbara Baettig

**CREATIVE DIRECTION** Fons Hickmann

**LETTERING** Fons Hickmann and Barbara Baettig

**PHOTOGRAPHY** Simon Gallus *Biberach, Germany*

**STUDIO** Fons Hickmann m23

**CLIENT** Hauschka

**PRINCIPAL TYPE** m23_piano

**DIMENSIONS** 33.1 x 47.2 in. (84 x 120 cm)

**SIGNAGE**

**DESIGN** Fabian Herrmann *London, England*

**ART DIRECTION** Angus Hyland

**AGENCY** Pentagram Design Ltd.

**CLEINT** Cass Art

**PRINCIPAL TYPE** Trade Gothic

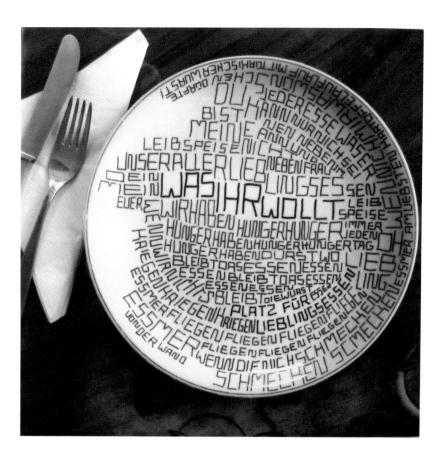

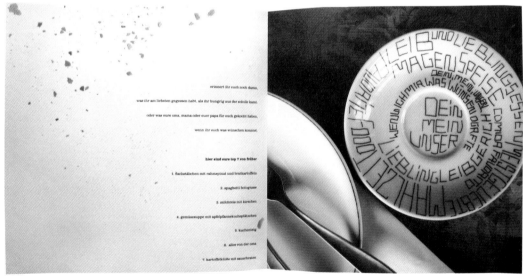

**DESIGN** Lisa Rienermann *Cologne, Germany*

**PROFESSOR** Gerolf Reichenthaler

**SCHOOL** University of Essen

**PRINCIPAL TYPE** Clarendon Light, Clarendon Medium, and handlettering

**DIMENSIONS** 7.9 x 7.9 in. (20 x 20 cm)

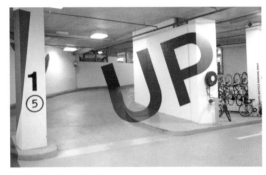

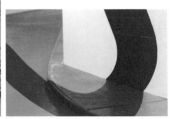
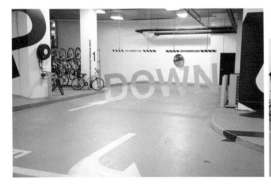
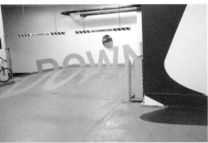
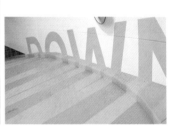

**50**    **SIGNAGE**

**DESIGN** David Crampton, Axel Peemoeller,
and Job van Dort *Melbourne, Australia*

**CREATIVE DIRECTION** Garry Emery

**STUDIO** emerystudio

**CLIENT** Eureka Tower

**PRINCIPAL TYPE** Akkurat Bold

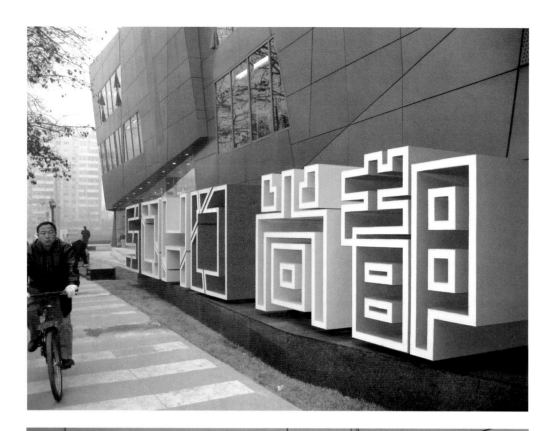

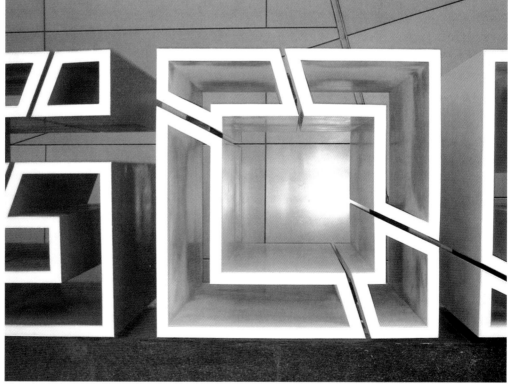

DESIGN David Crampton *Melbourne, Australia*

CREATIVE DIRECTION Garry Emery

LETTERING Mark Janetzki

STUDIO emerystudio

CLIENT SOHO China

PRINCIPAL TYPE Custom

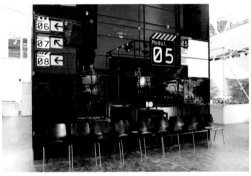

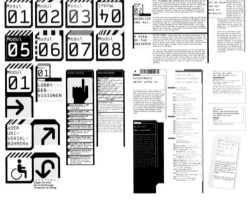

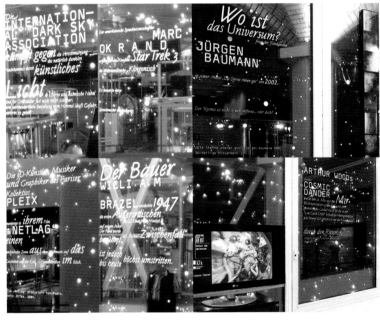

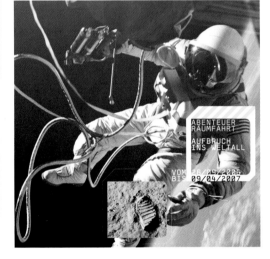

**DESIGN** Dmitri Lavrow *Berlin, Germany*

**ART DIRECTION** Rundi Beier

**CREATIVE DIRECTION** Dmitri Lavrow and
Peter Wellach

**DESIGN OFFICE** HardCase Design

**AGENCY** id3d-berlin

**CLIENT** Landesmuseum für Technik und
Arbeit, Mannheim

**PRINCIPAL TYPE** Claude Sans, Fig Serif, Rundfunk
Antiqua, FF Typestar, and others

**DIMENSIONS** Various

  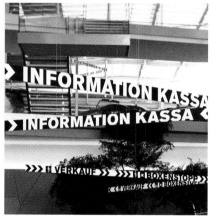

**DESIGN** Büro Uebele Visuelle Kommünikation *Stuttgart, Germany*

**CREATIVE DIRECTION** Andreas Uebele

**PROJECT MANAGER** Beate Gerner

**DESIGN OFFICE** Büro Uebele Visuelle Kommünikation

**CLIENT** Car Dealer Pappas, Salzburg

**PRINCIPAL TYPE** Akzidenz Grotesk Super Bold

**SIGNAGE** 53

**54**    **TYPOFONIE**

**DESIGN** Tanja Fassold, Sascha Hanke,
Dirk Hensiek, Mario Lautscham, Peter Leckelt, and
Michael Okun *Hamburg, Germany*

**DESIGN OFFICE** tisch eins/design studio

**CLIENT** Konzerthaus Dortmund, Philharmonie
für Westfalen

**PRINCIPAL TYPE** Helvetica

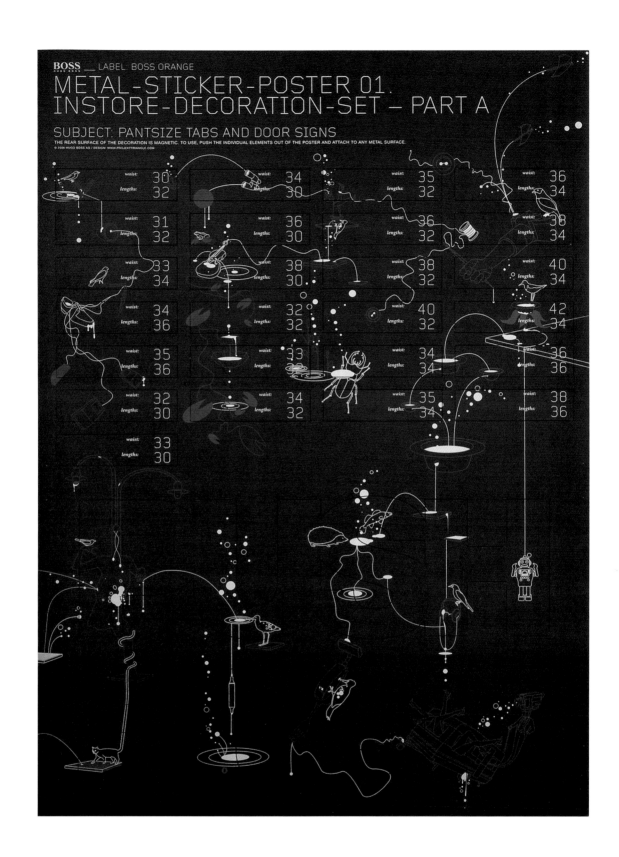

**DESIGN** Franz Stämmele and Roman Heinrich
*Stuttgart, Germany*

**CREATIVE DIRECTION** Martin Grothmaak

**DESIGN OFFICE** Projekttriangle
Information Design

**CLIENT** Hugo Boss AG

**PRINCIPAL TYPE** Architype Gridnik Light,
Helvetica Neue, and Minion

**DIMENSIONS** 16 x 21.5 in. (40.6 x 54.6 cm)

THE
MAN WHO
WANTED
EVERYTHING

MICHAEL OVITZ

AND THE
DARK DREAMS OF HOLLYWOOD

NIKKI FINKE

**BOOK JACKET**

**DESIGN** Henry Sene Yee *New York, NY*

**ART DIRECTION** Anne Twomey

**CREATIVE DIRECTION** Anne Twomey

**PHOTOGRAPHY** Henry Sene Yee

**PUBLISHER** 12 BOOKS

**PRINCIPAL TYPE** Helvetica Neue Medium Condensed

**DIMENSIONS** 6.25 x 9.5 in. (15.9 x 24.1 cm)

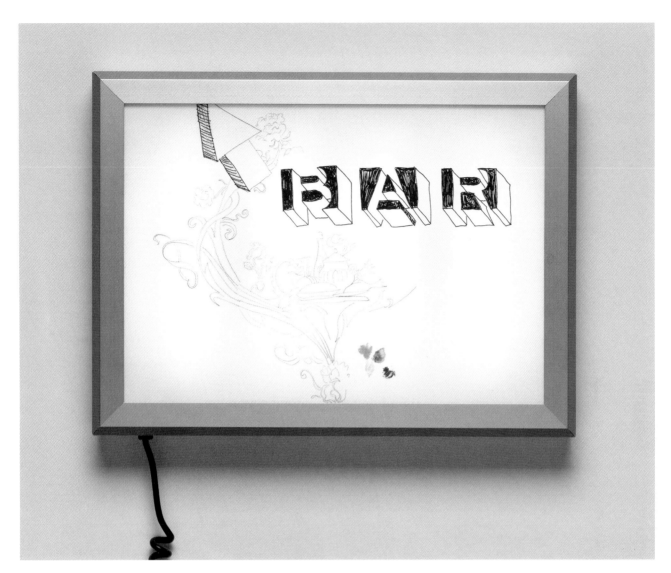

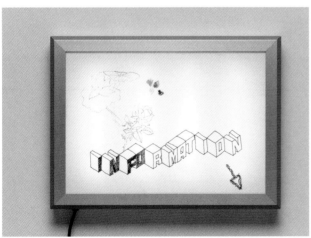

**DESIGN** Antonia Henschel *Frankfurt, Germany*

**ART DIRECTION** Antonia Henschel

**CREATIVE DIRECTION** Antonia Henschel

**LETTERING** Antonia Henschel

**AGENCY** Sign Kommunikation GmbH

**CLIENT** Stylepark AG

**PRINCIPAL TYPE** Helvetica Neue Medium and handlettering

**DIMENSIONS** 16.5 x 11.7 in. (42 x 29.7 cm)

58   **INVITATION**

**DESIGN** Annette Apel *Frankfurt, Germany*

**CREATIVE DIRECTION** Annette Apel

**STUDIO** annetteapel.com

**CLIENT** Schirn Kunsthalle, Frankfurt

**PRINCIPAL TYPE** Schirn Black and Schirn Bold

**DIMENSIONS** Various

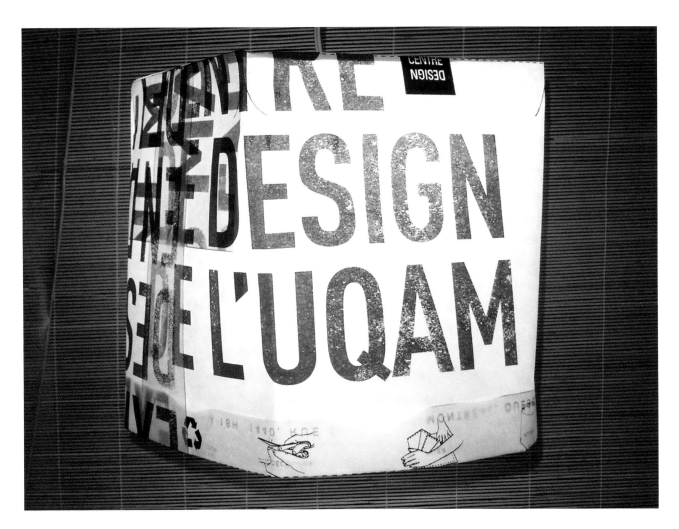

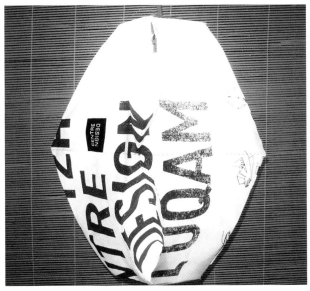

**DESIGN** Elisabeth Sylvia Charbonneau
*Montréal, Canada*

**INSTRUCTOR** Yan Mooney

**SCHOOL** Université du Québec á Montréal
(UQAM)

**PRINCIPAL TYPE** DIN and Akzidenz Grotesk

**DIMENSIONS** 24 x 36 in. (61 x 91.4 cm)

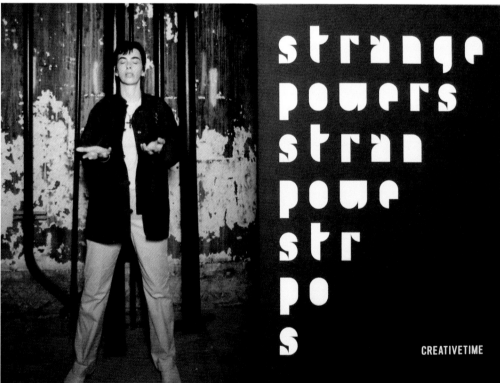

**CATALOG AND INVITATION**

**DESIGN** Willy Wong *New York, NY*

**CLIENT** Creative Time

**PRINCIPAL TYPE** Albernaut, Futura, and Pressure

**DIMENSIONS** Catalog: 5 x 7 in. (12.7 x 17.8 cm)
Invitation: 5.75 x 9.25 in. (14.6 x 23.5 cm)

**DESIGN** Erik Montovano, Tim Regan, and
Gregory St. Amand *New York, NY*

**ART DIRECTION** Erik Montovano and
Gregory St. Amand

**CREATIVE DIRECTION** Gregory St. Amand

**ANIMATION** Erik Montovano, Tim Regan, and
Gregory St. Amand

**AGENCY** Saintkid Inc.

**CLIENT** Jive Records

**PRINCIPAL TYPE** Various

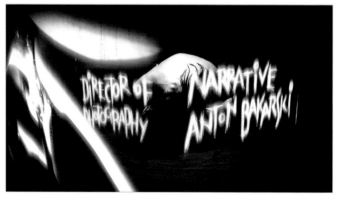

**MAIN
TITLES**

**DESIGN** Maxim Ivanov Sofia, Bulgaria

**ART DIRECTION** Maxim Ivanov

**CREATIVE DIRECTION** Maxim Ivanov

**CALLIGRAPHY** Maxim Ivanov

**DESIGN OFFICE** Topformstudio

**CLIENT** The Journey Film Group

**PRINCIPAL TYPE** Handlettering

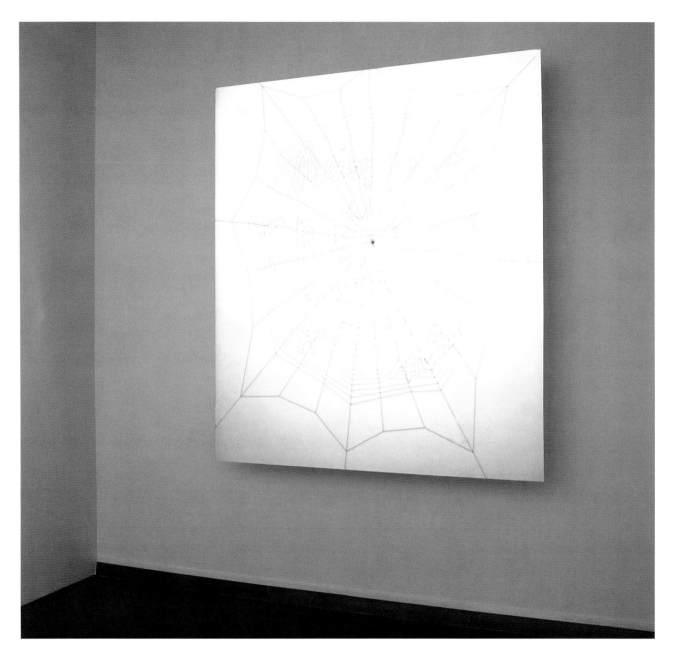

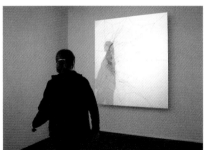
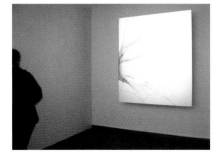
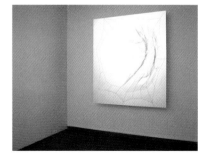

**DESIGN** Stefan Sagmeister and Ralph Ammer
*New York, NY, and Munich, Germany*

**ART DIRECTION** Stefan Sagmeister and
Ralph Ammer

**CREATIVE DIRECTION** Stefan Sagmeister and
Ralph Ammer

**LETTERING** Stefan Sagmeister and Matthias
Ernstberger

**PROGRAMMER** Ralph Ammer

**DESIGN OFFICE** Sagmeister Inc.

**CLIENT** The Austrian Cultural Forum (ACF),
New York

**PRINCIPAL TYPE** Handlettering

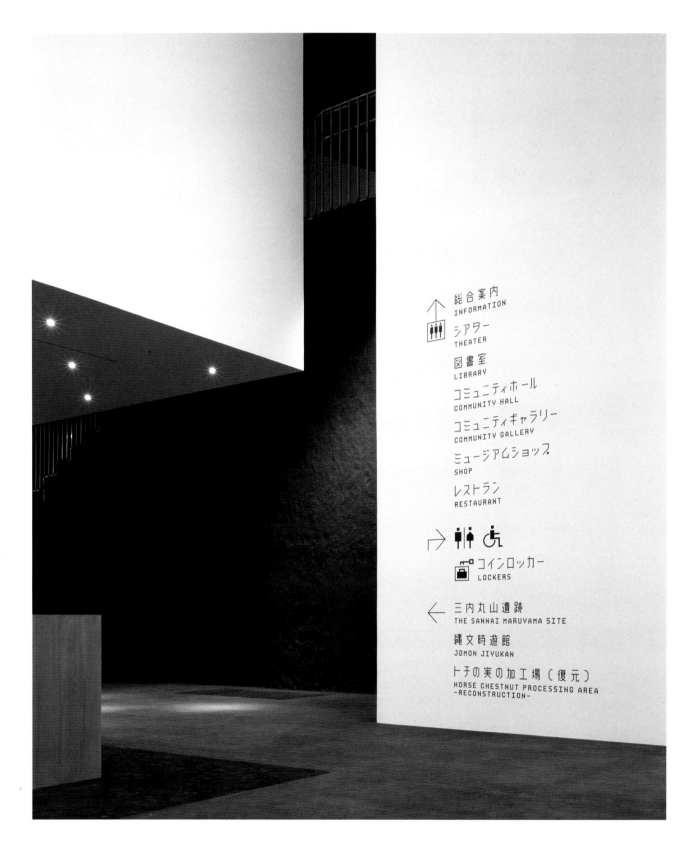

総合案内
INFORMATION

シアター
THEATER

図書室
LIBRARY

コミュニティホール
COMMUNITY HALL

コミュニティギャラリー
COMMUNITY GALLERY

ミュージアムショップ
SHOP

レストラン
RESTAURANT

コインロッカー
LOCKERS

三内丸山遺跡
THE SANNAI MARUYAMA SITE

縄文時遊館
JOMON JIYUKAN

トチの実の加工場〔復元〕
HORSE CHESTNUT PROCESSING AREA
-RECONSTRUCTION-

**64**   **SIGNAGE**

**DESIGN** Atsuki Kikuchi, Shoichiro Moriya, Shinji Nemoto, and Tilmann S. Wendelstein *Tokyo, Japan*

**ART DIRECTION** Atsuki Kikuchi

**DESIGN OFFICE** Bluemark Inc.

**CLIENT** Aomori Municipal Government

**PRINCIPAL TYPE** Aomori

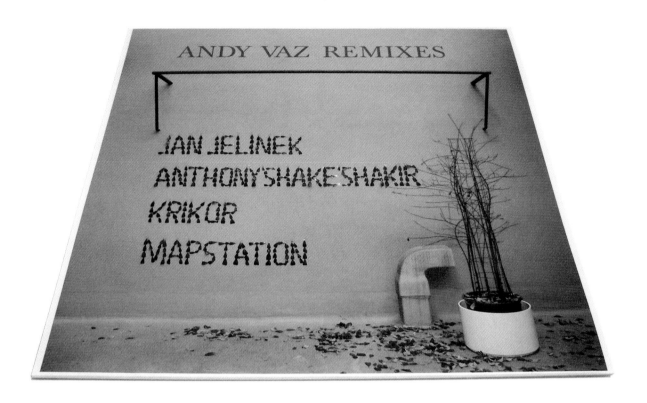

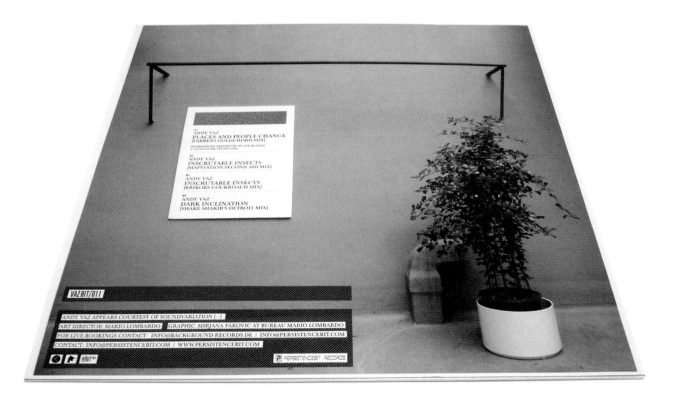

**DESIGN** Mario Lombardo and Mirjana Parovic
*Cologne, Germany*

**ART DIRECTION** Mario Lombardo

**DESIGN OFFICE** Bureau Mario Lombardo

**CLIENT** Persistence Bit Records, Italy

**PRINCIPAL TYPE** Monotype Grotesque,
Mila, and Times

**DIMENSIONS** 12.1 x 12.1 in. (30.8 x 30.8 cm)

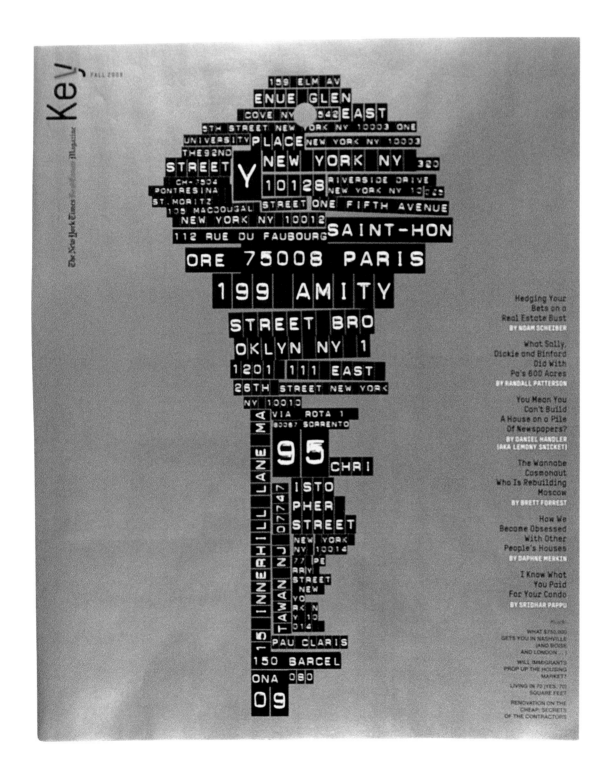

**66** **MAGAZINE COVER**

**DESIGN** Dirk Barnett *New York, NY*

**ART DIRECTION** Arem Duplessis and Dirk Barnett

**CREATIVE DIRECTION** Janet Froelich

**LETTERING** Carin Goldberg

**MAGAZINE** Key Magazine and The New York Times Magazine

**PRINCIPAL TYPE** Helvetica Neue Bold

**DIMENSIONS** 9.5 x 11.5 in. (24.1 x 29.2 cm)

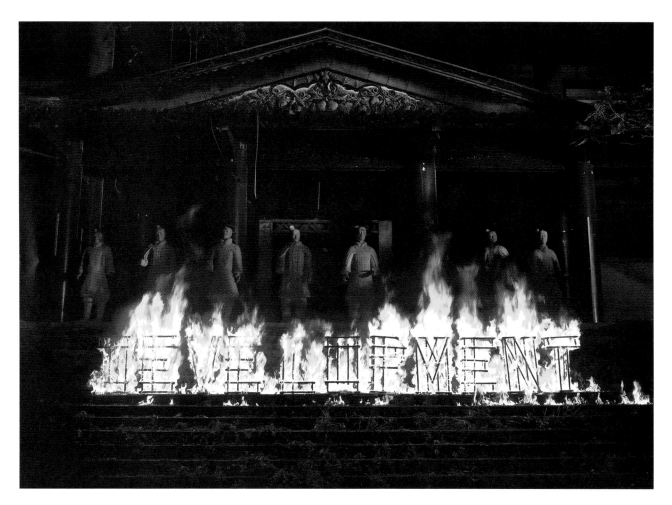

**DESIGN** Matthias Ernstberger and
Stefan Sagmeister *New York, NY*

**DIRECTION** Stefan Sagmeister

**CREATIVE DIRECTION** Richard Johnson *Singapore*

**LETTERING** Stefan Sagmeister and Stephan Walter

**DESIGN OFFICE** Sagmeister Inc.

**AGENCY** M&C Saatchi, Singapore

**CLIENT** MDA Singapore

**PRINCIPAL TYPE** Custom

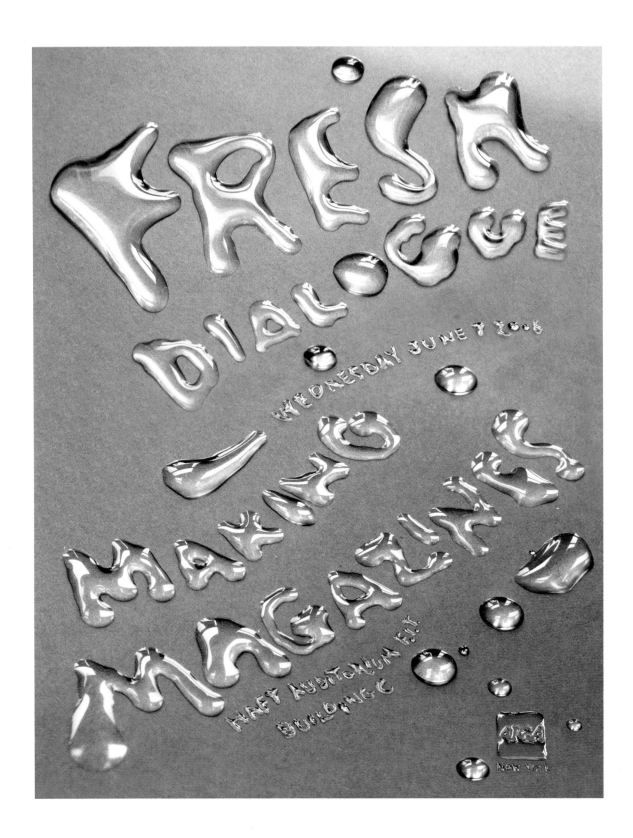

**POSTER**

**DESIGN** Stephen Doyle *New York, NY*

**CREATIVE DIRECTION** Stephen Doyle

**DESIGN OFFICE** Doyle Partners

**CLEINT** American Institute of Graphic Arts

**PRINCIPAL TYPE** Custom-made with water

**DIMENSIONS** 17 x 22 in. (43.2 x 55.9 cm)

DESIGN Lisa Rienermann *Cologne, Germany*

PROFESSOR Sven Hornscheid

SCHOOL University of Essen

PRINCIPAL TYPE Handlettering

DIMENSIONS Various

STUDENT
PROJECT 69

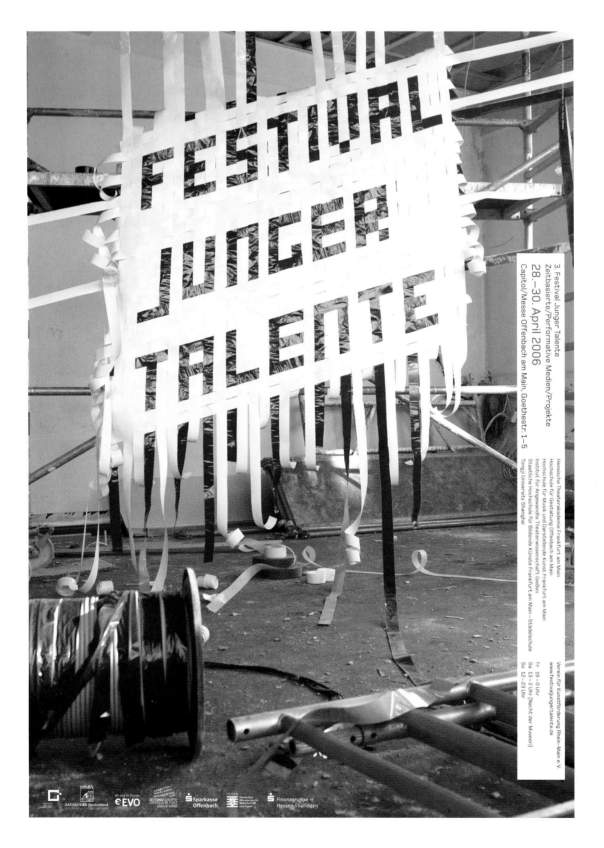

**STUDENT PROJECT**

**DESIGN** Christina Föllmer and Catrin Sonnabend
*Offenbach, Germany*

**ART DIRECTION** Christina Föllmer and
Catrin Sonnabend

**CREATIVE DIRECTION** Christina Föllmer and
Catrin Sonnabend

**PHOTOGRAPHY** Klaus Wäldele

**PROFESSOR** Klaus Hesse

**SCHOOL** Hochschule für Gestaltung
Offenbach am Main

**PRINCIPAL TYPE** Foundry Monoline

**DIMENSIONS** 33.1 x 46.8 in. (84.1 x 118.9 cm)

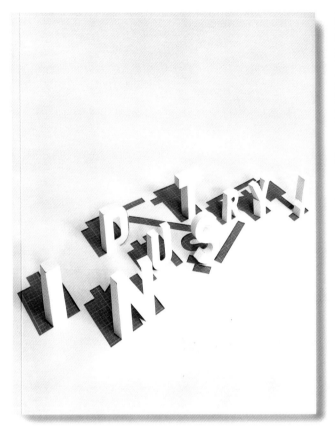
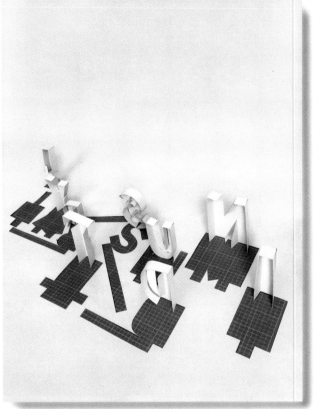

**DESIGN** Ariane Spanier *Berlin, Germany*

**ART DIRECTION** Ariane Spanier

**STUDIO** Ariane Spanier Graphic Design

**CLIENT** Norsk Form and PROJEKT 0047
Oslo, Norway

**PRINCIPAL TYPE** Custom

**DIMENSIONS** 9.1 x 11.8 in. (23 x 30 cm)

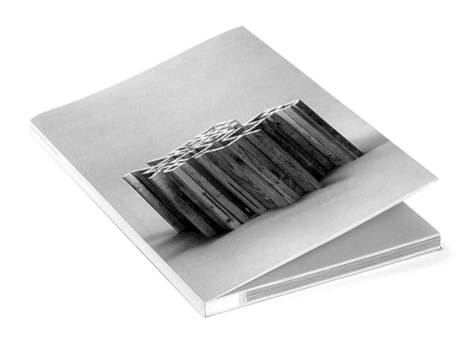

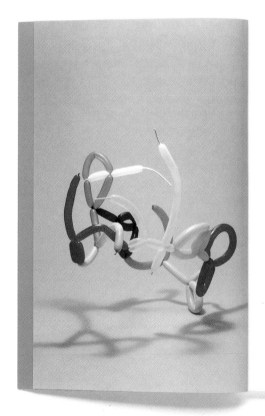

Hopscotch
Compendium
2005/06

**CATALOG**

**DESIGN** Mark Gowing and Tim Rogers
*Sydney, Australia*

**ART DIRECTION** Mark Gowing

**CREATIVE DIRECTION** Mark Gowing

**LETTERING** Mark Gowing

**SCULPTURES** Mark Gowing and Tim Rogers

**DESIGN OFFICE** Mark Gowing Design

**CLIENT** Hopscotch Films

**PRINCIPAL TYPE** Hopscotch and Frutiger

**DIMENSIONS** 6.3 x 9.4 in. (16.1 x 23.8 cm)

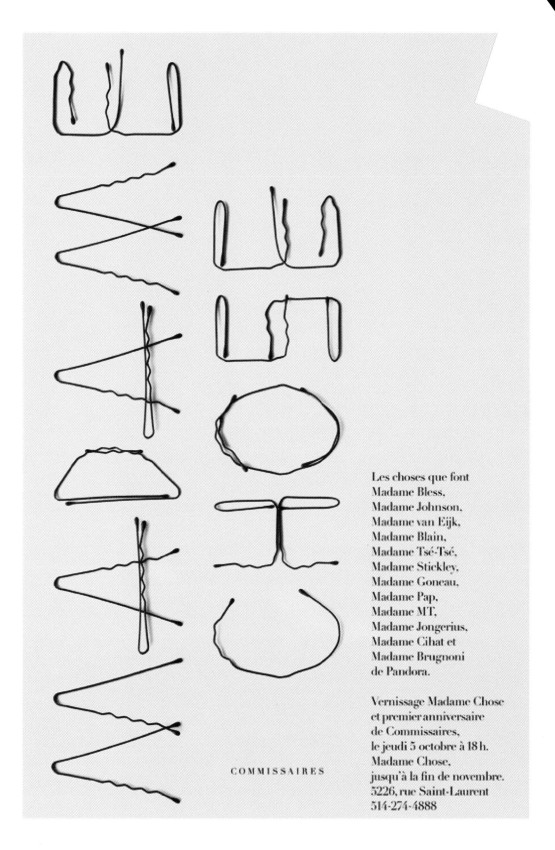

Les choses que font
Madame Bless,
Madame Johnson,
Madame van Eijk,
Madame Blain,
Madame Tsé-Tsé,
Madame Stickley,
Madame Goneau,
Madame Pap,
Madame MT,
Madame Jongerius,
Madame Cihat et
Madame Brugnoni
de Pandora.

Vernissage Madame Chose
et premier anniversaire
de Commissaires,
le jeudi 5 octobre à 18 h.
Madame Chose,
jusqu'à la fin de novembre.
5226, rue Saint-Laurent
514-274-4888

COMMISSAIRES

**DESIGN** David Guarnieri *Montréal, Canada*

**CREATIVE DIRECTION** Louis Gagnon

**DESIGN OFFICE** Paprika

**CLIENT** Commissaires, Montréal

**PRINCIPAL TYPE** Didot and Hairpin Type

**DIMENSIONS** 23 x 35 in. (58.4 x 88.9 cm)

**POSTER** 73

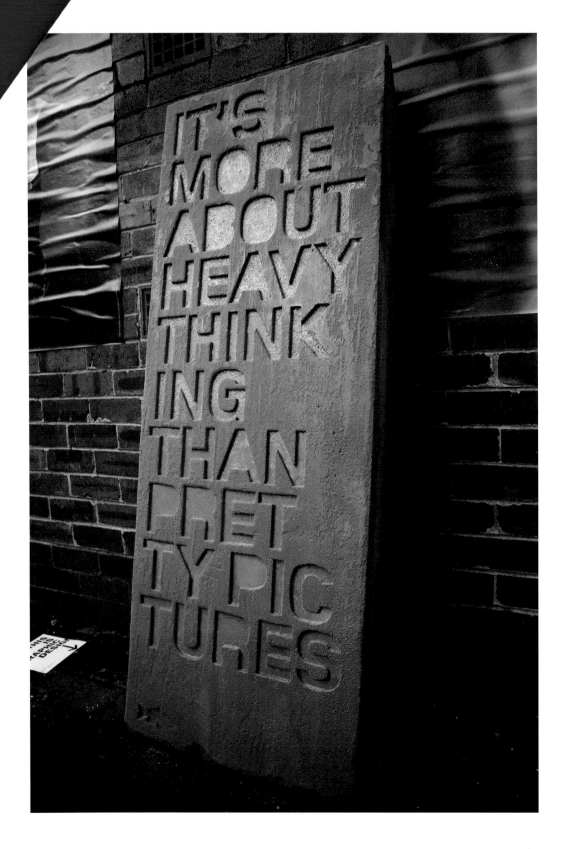

**DESIGN** Geordie McKenzie and Justin Smith
*Sydney, Australia*

**CREATIVE DIRECTION** Geordie McKenzie and
Justin Smith

**LETTERING** Geordie McKenzie and Justin Smith

**DESIGN OFFICE** Fish Associates

**CLIENT** AGDA – Sydney Design Week

**PRINCIPAL TYPE** Foundry Monoline

**DIMENSIONS** 23.6 x 63 in. (60 x 160 cm)

My whole life I've been
a thief—a good one.
And my whole life I've
never paid for what I've
done. Or so I thought

# hy I Steal

by Adam Stein
Photographs by Phillip Toledano

304 GQ.COM.MAR.06

---

**DESIGN** Thomas Alberty *New York, NY*

**ART DIRECTION** Ken DeLago

**DESIGN DIRECTION** Fred Woodward

**PUBLICATION** GQ Magazine

**PRINCIPAL TYPE** Titling Gothic

**DIMENSIONS** 15.6 x 11 in. (39.6 x 27.9 cm)

**TELEVISION COMMERCIAL**

**DESIGN** Michael Chang, Gabriel Dunne, Mark Kudsi, Matt Motal, Josh Nimoy, and Rob Resella *Venice, CA*

**ART DIRECTION** Mark Kudsi, Motion Theory *Venice, CA* and Ken Meyer, Wieden & Kennedy *Portland, OR*

**CREATIVE DIRECTION** Mathew Cullen, Motion Theory, and Hal Curtis, Wieden & Kennedy

**DESIGN OFFICE** Motion Theory

**CLIENT** Nike, Inc.

**PRINCIPAL TYPE** Frutiger

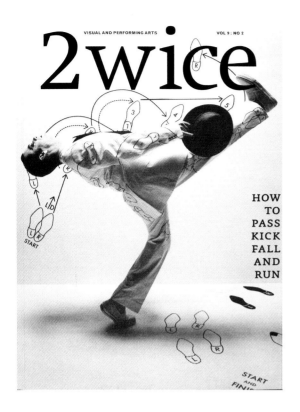

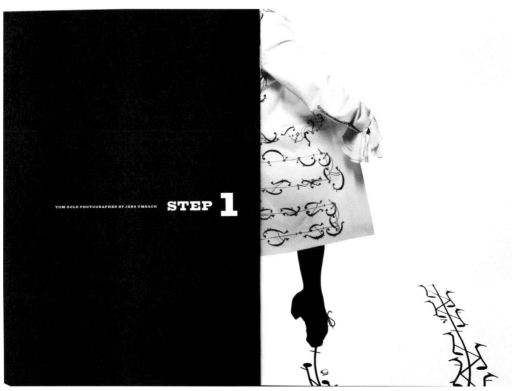

**DESIGN** Abbott Miller and Kristen Spilman
*New York, NY*

**ART DIRECTION** Abbott Miller

**PHOTOGRAPHY** Jens Umbach and
Katherine Wolkoff

**DESIGN OFFICE** Pentagram Design Inc.

**CLIENT** 2wice Arts Foundation

**PRINCIPAL TYPE** Giza and Fedra

**DIMENSIONS** 8.25 x 11.5 in. (21 x 29.2 cm)

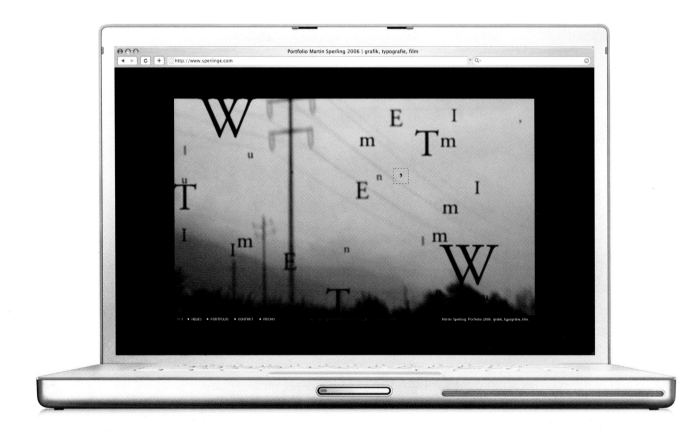

**STUDENT PROJECT**

**DESIGN** Martin Sperling *Kiel, Germany*

**SCHOOL** Muthesius Kunsthochschule Kiel

**PRINCIPAL TYPE** DIN 17SB, Adobe Garamond Pro, and Unibody 8

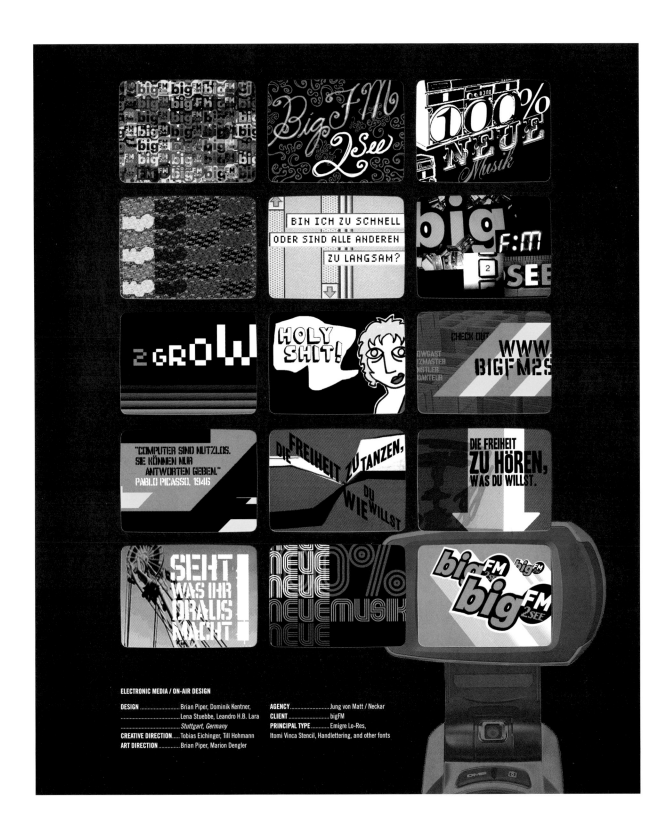

ELECTRONIC MEDIA / ON-AIR DESIGN

DESIGN ........................... Brian Piper, Dominik Kentner,
.............................. Lena Stuebbe, Leandro H.B. Lara
.............................. *Stuttgart, Germany*
CREATIVE DIRECTION ..... Tobias Eichinger, Till Hohmann
ART DIRECTION ............. Brian Piper, Marion Dengler

AGENCY ........................... Jung von Matt / Neckar
CLIENT ............................. bigFM
PRINCIPAL TYPE ............ Emigre Lo-Res,
Itomi Vinca Stencil, Handlettering, and other fonts

---

**DESIGN** Dominik Kentner, Leandro H.B. Lara, Brian Piper, and Lena Stuebbe *Stuttgart, Germany*

**ART DIRECTION** Brian Piper and Marion Dengler

**CREATIVE DIRECTION** Till Hohmann and Tobias Eichinger

**LETTERING** Brian Piper and Tobias Eichinger

**COPYWRITING** Philipp Mayer

**AGENCY** Jung von Matt

**CLIENT** bigFM PPG S.W. GmbH

**PRINCIPAL TYPE** Emigre Lo-Res, Vinca Stencil, and handlettering

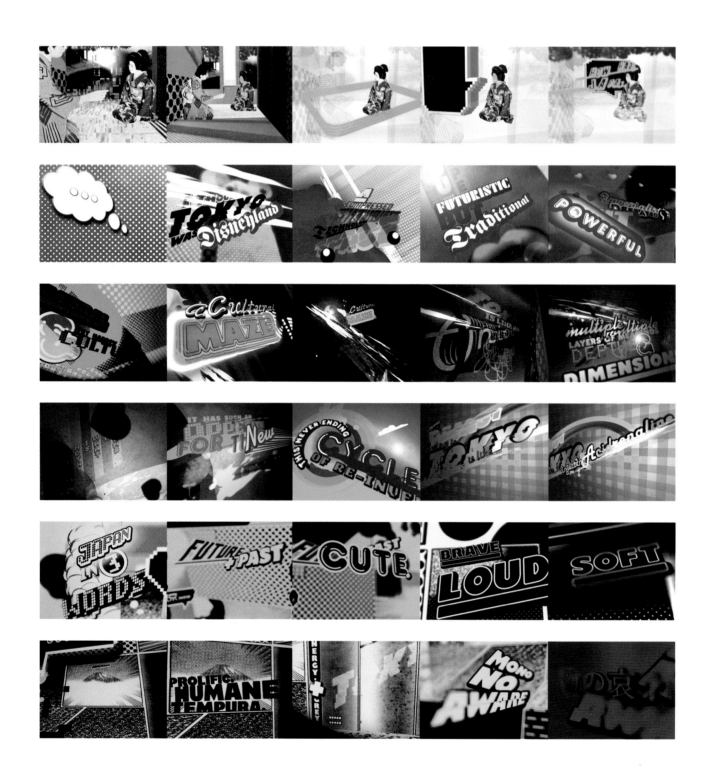

**TYPOGRAPHIC ANIMATION**

**DESIGN** Ryan Pescatore Frisk and Catelijne van Middelkoop *The Hague, The Netherlands*

**ART DIRECTION** Ryan Pescatore Frisk and Catelijne van Middelkoop

**CREATIVE DIRECTION** Ryan Pescatore Frisk and Catelijne van Middelkoop

**LETTERING** Ryan Pescatore Frisk and Catelijne van Middelkoop

**ANIMATION AND SOUND** Ryan Pescatore Frisk and Catelijne van Middelkoop

**STUDIO** Strange Attractors Design

**CLIENT** W + K Tokyo Lab, Tokyo, Japan

**PRINCIPAL TYPE** 2nd Row and Frankfurter

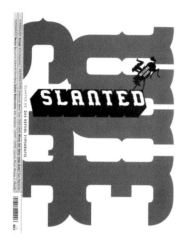

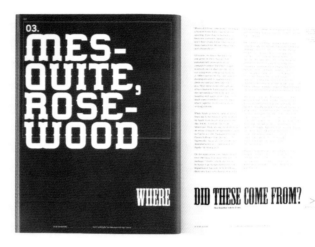

**DESIGN** Peter Brugger, Boris Kahl, Christoph Seiler, and Chris Steurer *Karlsruhe, Germany*

**ART DIRECTION** Florian Gaertner and Thomas Mettendorf

**CREATIVE DIRECTION** Lars Harmsen and Ulrich Weiss

**CHIEF EDITORS** Lars Harmsen and Thomas Mettendorf

**AGENCY** Finest/Magma Brand Design

**PRINCIPAL TYPE** Copy, Digibo, and Gringo

**DIMENSIONS** 8.1 x 10.1 in. (20.5 x 25.7 cm)

82 **EDITORIAL PUBLICATION**

**DESIGN** Sheila Cheng, Hye-Yeon Cho, Kelly Cree, Nan Googin, Charles Hannon, Austin Happel, Blake Harvey, Troy Hayes, Jeffrey Jones, Borami Kang, Adam Law, Gina Lee, Rob Mach, Jennifer Mahanay, Cara McKinley, Clint Miceli, Becky Nasadowski, and Ho-Mui Wong *Champaign, IL*

**ART DIRECTION** Jennifer Gunji

**CREATIVE DIRECTION** Jennifer Gunji

**EDITOR** Jodee Stanley *Urbana, IL*

**SCHOOL** University of Illinois at Urbana-Champaign, Department of English

**PRINCIPAL TYPE** Adobe Garamond Pro

**DIMENSIONS** 9 x 12 in. (22.9 x 30.5 cm)

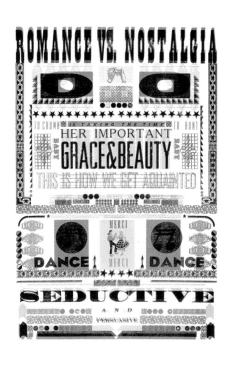

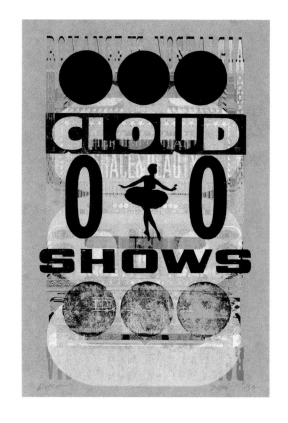

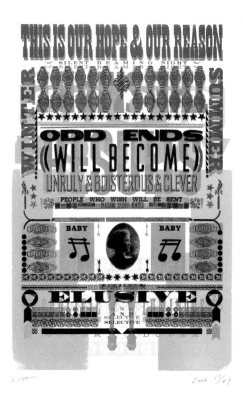

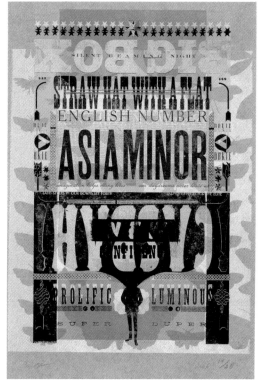

**DESIGN** Brady Vest *Kansas City, MO*

**CREATIVE DIRECTION** Brady Vest

**STUDIO** Hammerpress

**CLIENT** Houlihan's

**PRINCIPAL TYPE** Various wood and lead type

**DIMENSIONS** 14 x 22 in. (35.6 x 55.9 cm)

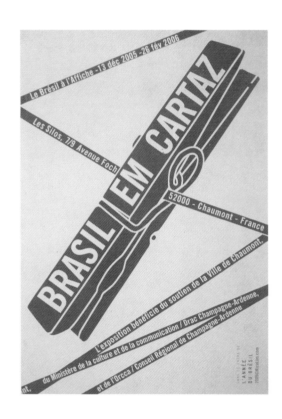

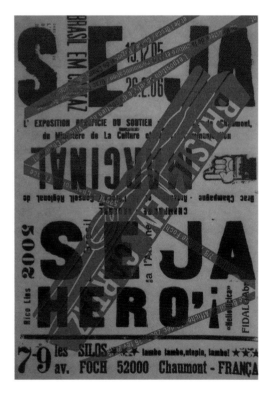

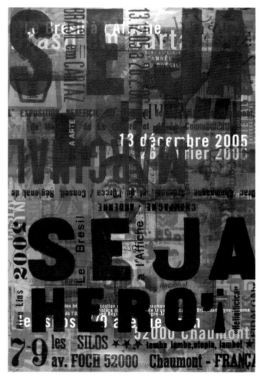

**POSTERS**

**DESIGN** Rico Lins *São Paolo, Brazil*

**ART DIRECTION** Rico Lins

**CREATIVE DIRECTION** Rico Lins

**LETTERPRESS PRINTER** Gráfica Fidalga

**SILKSCREEN PRINTER** Gráfica Cinelândia

**STUDIO** Rico Lins + Studio

**CLIENT** Brazil in Poster Project and Pôle Graphique *Chaumont, France*

**PRINCIPAL TYPE** Trade Gothic 18 and Trade Gothic 20

**DIMENSIONS** 26 x 37.8 in. (66 x 96 cm)

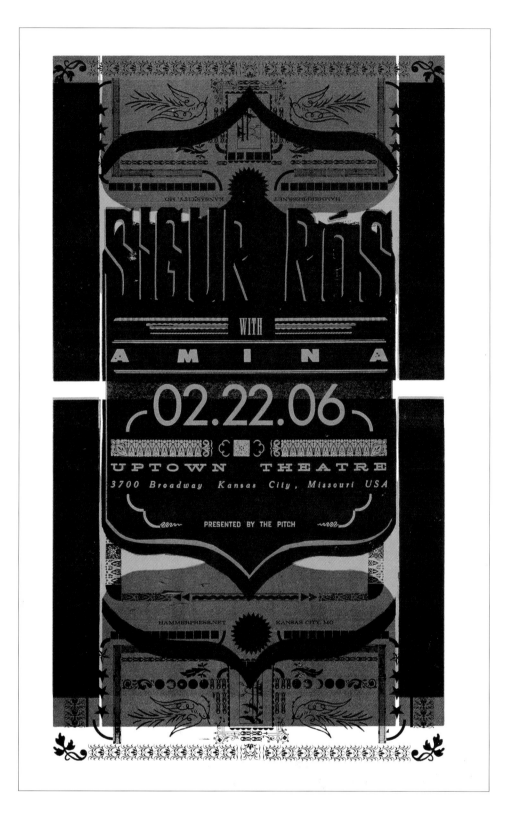

**DESIGN** Brady Vest *Kansas City, MO*

**STUDIO** Hammerpress

**CLIENT** eleven productions

**PRINCIPAL TYPE** Various wood and lead type

**DIMENSIONS** 15 x 26 in. (38.1 x 66 cm)

**POSTER**  85

**BOOK**

**DESIGN** Judith Schalansky *Berlin, Germany*

**CREATIVE DIRECTION** Judith Schalansky

**LETTERING** Judith Schalansky

**SCHOOL** Fachhochschule Potsdam

**CLIENT** Verlag Hermann Schmidt Mainz

**PRINCIPAL TYPE** FF Profile and 300 Blackletter fonts

**DIMENSIONS** 4.9 x 7.9 in. (12.4 x 20 cm)

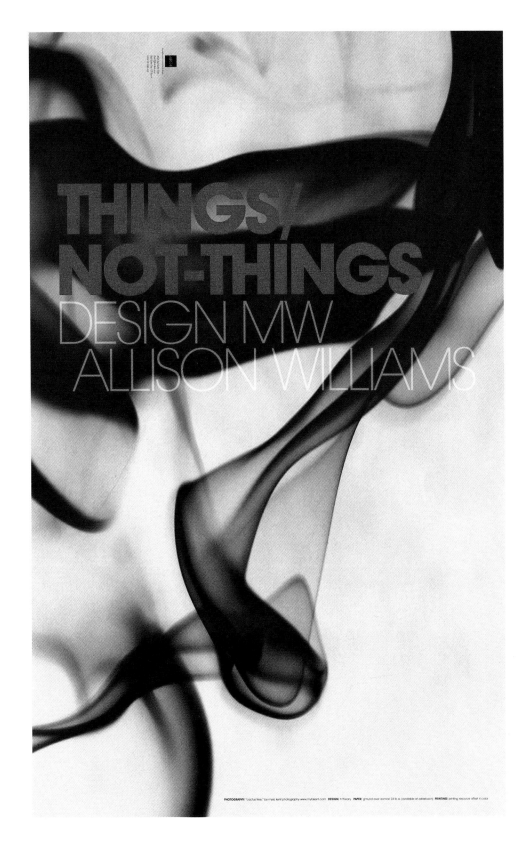

**DESIGN** Christian Hansen and Brad Dowdle
*Salt Lake City, UT*

**ART DIRECTION** Christian Hansen

**CREATIVE DIRECTION** Christian Hansen

**PHOTOGRAPHY** Myla Kent *Seattle, WA*

**CREATIVE CONSULTATION** Allison Williams,
design:mw *New York, NY*

**STUDIO** Hint Creative

**CLIENT** American Institute of Graphic Arts,
Salt Lake City Chapter

**PRINCIPAL TYPE** Avant Garde Gothic

**DIMENSIONS** 17.25 x 28.25 in. (43.8 x 71.8 cm)

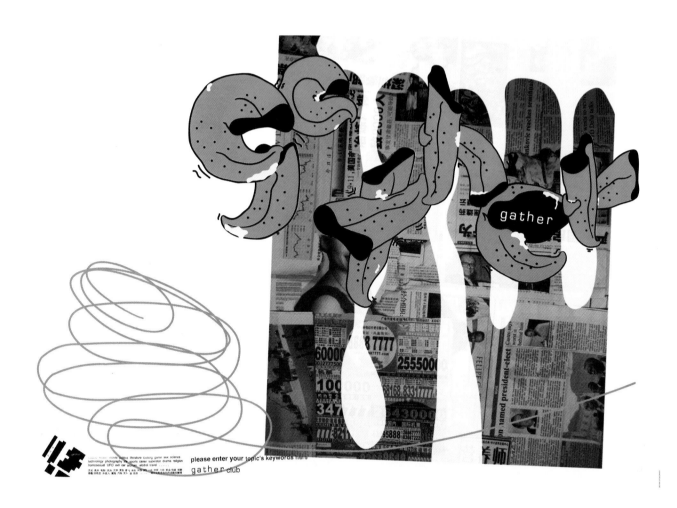

**DESIGN** Zhiwei Bai *Shenzhen, China*

**ART DIRECTION** Zhiwei Bai

**AGENCY** Bai Design Association

**CLEINT** Gather Club

**PRINCIPAL TYPE** Helvetica

**DIMENSIONS** 39.4 x 27.6 in. (100 x 70 cm)

**ART DIRECTION** Ricardo Beltran, Aaron Kapor, and Patrick Lin *Pasadena, CA*

**CONTRIBUTORS** Jenny Chu, Yuri Chung, Akiko Da Silva, Steven Hwang, Heui-Jin Jo, Ji Eun Kang, Nicole Lascu, Steven Lau, Ronald Lu, Christian Rocha, Eun Jin Sohn, and Pieter Vos

**CONTRIBUTING EDITOR** Yvan Martinez

**INSTRUCTOR** Joshua Trees

**SCHOOL** Art Center College of Design

**PRINCIPAL TYPE** Various

**DIMENSIONS** Flat: 11.5 x 18 in. (29.2 x 45.7 cm)
Folded: 11.5 x 9 in. (29.2 x 22.9 cm)

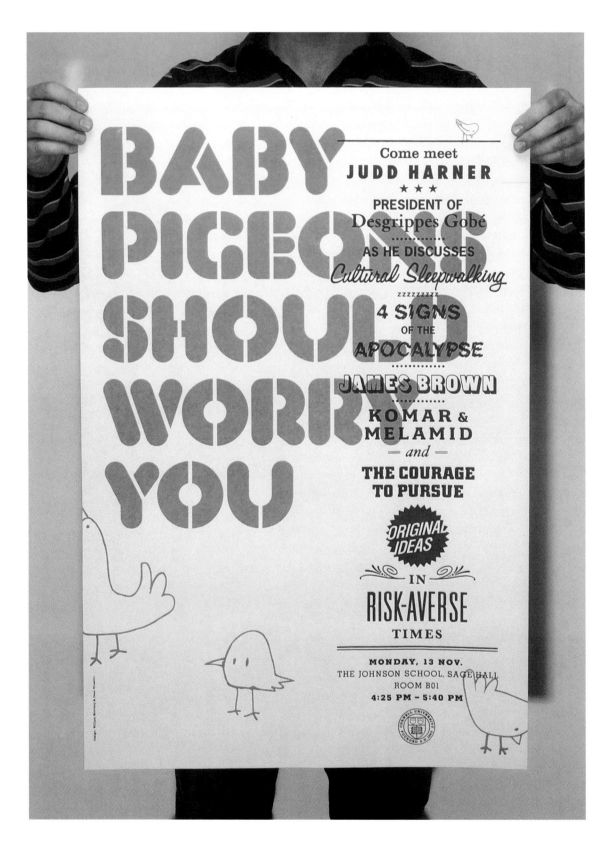

**POSTER**

**DESIGN** William Morrisey and Dean Nicastro
*New York, NY*

**ILLUSTRATION** William Morrisey

**AGENCY** Desgrippes Gobé

**CLIENT** Cornell University

**PRINCIPAL TYPE** Custom

**DIMENSIONS** 20 x 30 in. (50.8 x 76.2 cm)

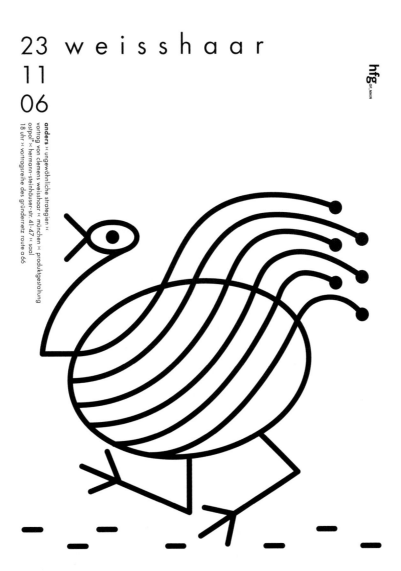

# 23 weisshaar
## 11
## 06

**anders** ⋊ ungewöhnliche strategien ⋊ vortrag von clemens weisshaar ⋊ münchen ⋊ produktgestaltung ostpol° ⋊ hermann-steinhäuser-str. 41-47 ⋊ saal 18 uhr ⋊ vortragsreihe des gründernetz route a 66

hfg OF MAIN

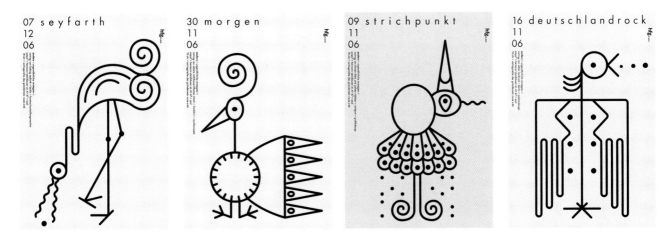

07 seyfarth
12
06

30 morgen
11
06

09 strichpunkt
11
06

16 deutschlandrock
11
06

**DESIGN** Klaus Hesse *Erkrath, Germany*

**DESIGN OFFICE** Hesse Design

**CLIENT** Ulrike Grünewald, Büro für Wissenstransfer, and HfG Offenbach

**PRINCIPAL TYPE** Architype Renner

**DIMENSIONS** 27.6 x 39.4 in. (70 x 100 cm)

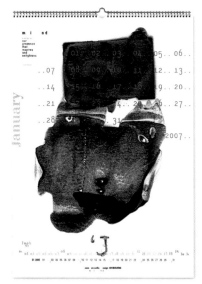

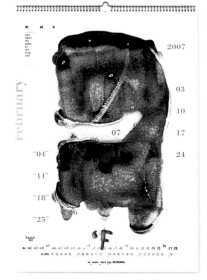

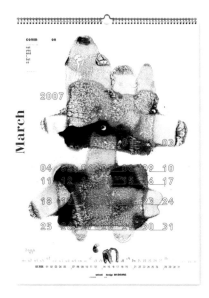

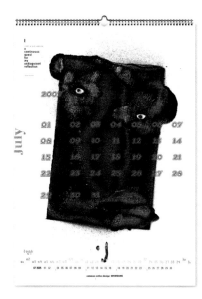

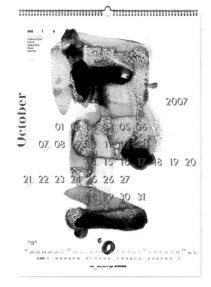

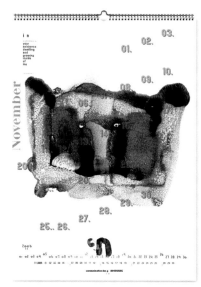

**92**  **CALENDAR**

**DESIGN** Park Kum-jun and You Na-won
*Seoul, Korea*

**ART DIRECTION** Park Kum-jun

**CREATIVE DIRECTION** Park Kum-jun

**LETTERING** Park Kum-jun

**ILLUSTRATION** Park Kum-jun

**COORDINATION** Jung Jong-in and Kim Jung-ran

**AGENCY** 601bisang

**PRINCIPAL TYPE** Various

**DIMENSIONS** 20.1 x 28.4 in. (51 x 72 cm)

**DESIGN** Brigitta Bungard *New York, NY*

**ART DIRECTION** John Farrar

**CREATIVE DIRECTION** David Israel

**AGENCY** Desgrippes Gobé

**CLIENT** AOL Red

94  **POSTER**

**DESIGN** Edwin Vollebergh *'s-Hertogenbosch, The Netherlands*

**CREATIVE DIRECTION** Edwin Vollebergh

**LETTERING** Edwin Vollebergh

**STUDIO** Studio Boot

**CLIENT** Kerlensky Zeefdruk

**PRINCIPAL TYPE** American Typewriter Bold and handlettering

**DIMENSIONS** 25.2 x 35.4 in. (64 x 90 cm)

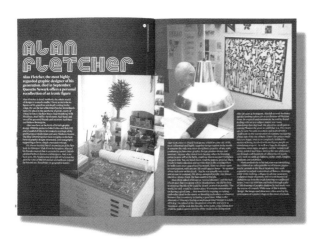

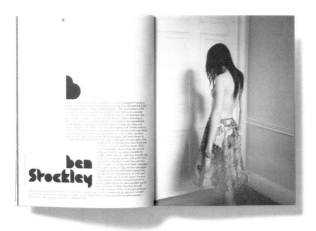
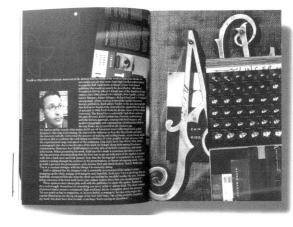

**DESIGN** Ben Backhouse, Anthony Donovan, and Vince Frost *Sydney, Australia*

**ART DIRECTION** Vince Frost

**CREATIVE DIRECTION** Vince Frost

**STUDIO** Frost Design

**CLIENT** D+AD

**PRINCIPAL TYPE** Mercury

**DIMENSIONS** 7.7 x 10 in. (19.5 x 25.5 cm)

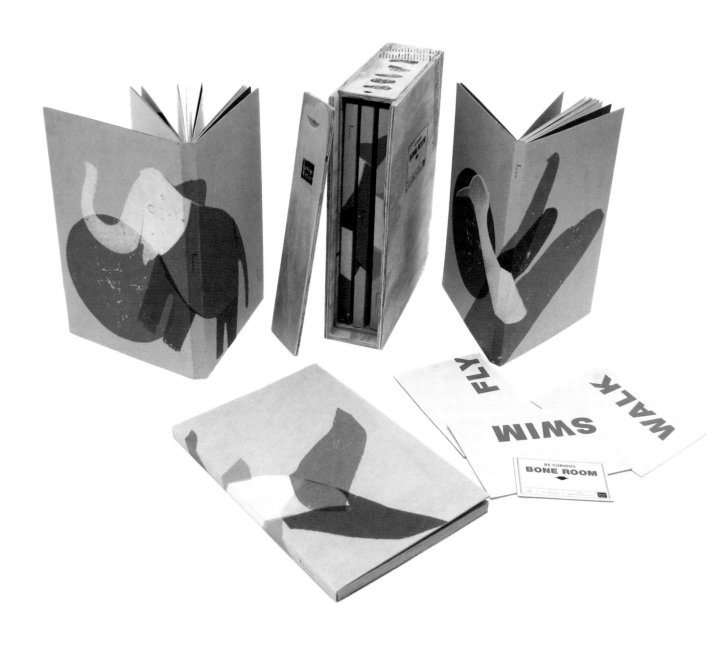

**STUDENT PROJECT**

**DESIGN** Priya Rajan *Sunnyvale, CA*

**INSTRUCTOR** Ed O'Brien

**SCHOOL** Academy of Art University

**PRINCIPAL TYPE** Trade Gothic

**DIMENSIONS** 6.25 x 9.5 in. (15.9 x 24.1 cm)

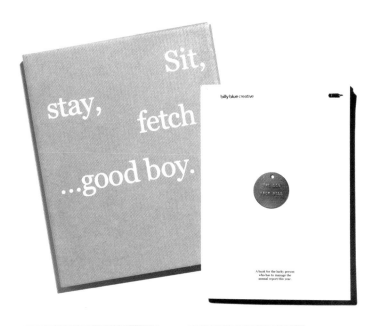

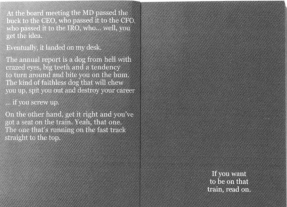

**DESIGN** Justin Smith *North Sydney, Australia*

**ART DIRECTION** Justin Smith

**CREATIVE DIRECTION** Justin Smith

**LETTERING** Justin Smith

**WRITING** Dean Thomas

**DESIGN OFFICE** Billy Blue Creative

**CLIENT** Billy Blue Group

**PRINCIPAL TYPE** Georgia and handlettering

**DIMENSIONS** 5.8 x 8.3 in. (14.8 x 21 cm)

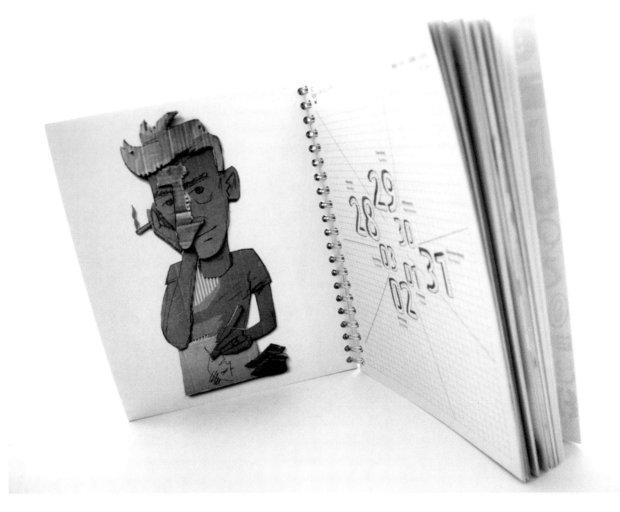

98    **CALENDAR**    **DESIGN** Nicola Janssen *Hamburg, Germany*

**CREATIVE DIRECTION** Elisabeth Plass and
Henning Otto

**DESIGN OFFICE** Eiga

**PRINCIPAL TYPE** Univers and handlettering

**DIMENSIONS** 6.1 x 7.3 in. (15.5 x 18.5 cm)

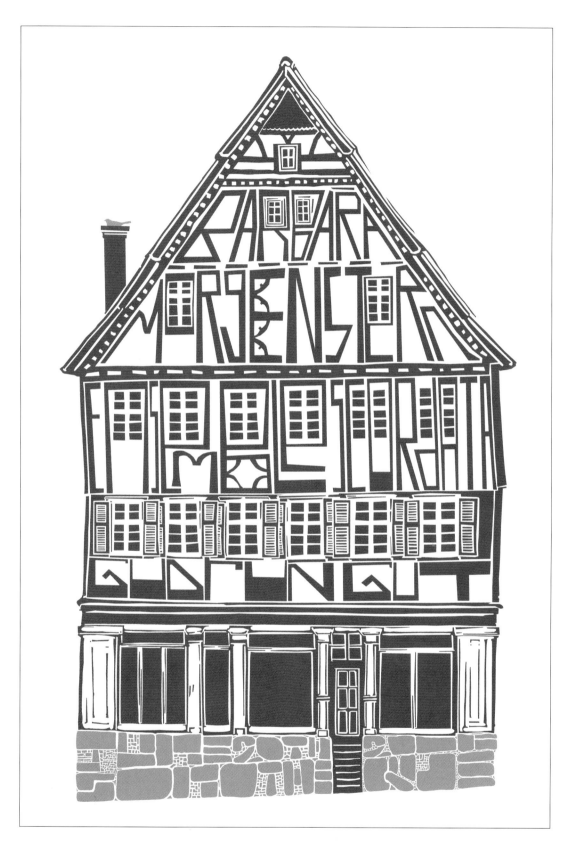

ART DIRECTION Hans Seeger *Wauwatosa, WI*

LETTERING Hans Seeger

CLIENT Barbara Morgenstern

PRINCIPAL TYPE Handlettering

DIMENSIONS 23 x 35 in. (58.4 x 88.9 cm)

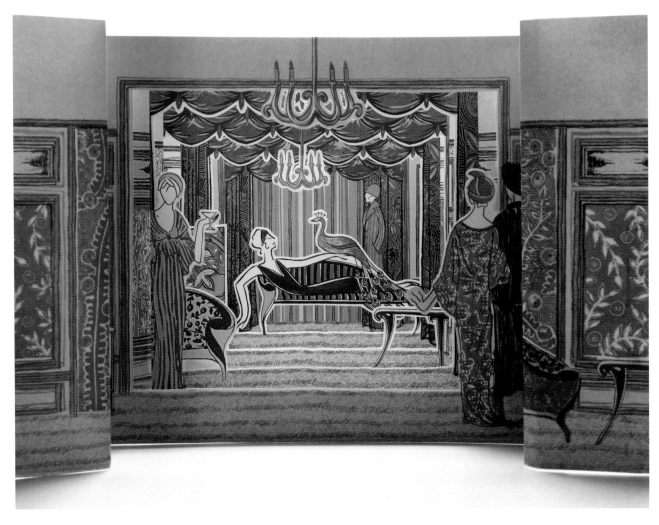

100    **INVITATION**

**DESIGN** Ignatius Hermawan Tanzil and
Novita Angka *Jakarta, Indonesia*

**ART DIRECTION** Ignatius Hermawan Tanzil

**CREATIVE DIRECTION** Ignatius Hermawan Tanzil

**LETTERING** Novita Angka

**DESIGN OFFICE** LeBoYe

**CLIENT** Sebastian Gunawan, Fashion Designer

**PRINCIPAL TYPE** Bulldog and handlettering

**DIMENSIONS** 7.1 x 8.9 in. (18 x 22.5 cm)

**DESIGN** Susanne Hoerner, Anika Marquardsen, and Felix Widmaier *Stuttgart, Germany*

**ART DIRECTION** Kirsten Dietz

**CREATIVE DIRECTION** Kirsten Dietz and Jochen Raedeker

**PHOTOGRAPHY** Oliver Jung, Christian Schmidt, and Niels Schubert

**AGENCY** Strichpunkt

**CLIENT** Papierfabrik Scheufelen GmbH + Co. KG

**PRINCIPAL TYPE** Univers and FF Scala

**DIMENSIONS** 7 x 9.5 in. (17.5 x 24 cm)

## LA LUNA DE
# METROPOLI
LA REVISTA DE OCIO PARA EL FIN DE SEMANA DE **EL MUNDO**. NÚMERO ESPECIAL. 8 DE DICIEMBRE DE 2006

SUPLEMENTO ESPECIAL. OCIO DE NAVIDAD. LAS MEJORES IDEAS PARA DISFRUTAR PLENAMENTE DE LOS ÚLTIMOS DÍAS DEL AÑO. FIESTAS: NOCHEBUENA, FIN DE AÑO Y REYES EN LOS MÁS ANIMADOS LOCALES DE NUESTRA COMUNIDAD. ESPECTÁCULOS: TEATRO, BAILE, CINE, CIRCO, MAGIA, DEPORTE... COMPRAS: CENTROS COMERCIALES, TIENDAS GOURMET, VINOTECAS... CENAS: RESTAURANTES, HOTELES Y SALAS DE FIESTA. NIÑOS: LAS MÁS ATRACTIVAS PROPUESTAS PARA EL OCIO INFANTIL

102 **MAGAZINE COVER**

**DESIGN** Rodrigo Sánchez *Madrid, Spain*

**ART DIRECTION** Rodrigo Sánchez

**CREATIVE DIRECTION** Carmelo Caderot

**PUBLICATION** El Mundo, Unidad Editorial S.A.

**PRINCIPAL TYPE** VAG Rounded and Giza

**DIMENSIONS** 7.9 x 11.2 in. (20 x 28.5 cm)

**DESIGN** Brian Crooks, Drew Freeman, Emma Goldsmith, Julia Hoffmann, Lenny Naar, and Paula Scher *New York, NY*

**ART DIRECTION** Paula Scher

**CREATIVE DIRECTION** George Mill

**EDITOR/PROJECT COORDINATOR** Nada Ray

**RESEACHER/PROJECT COORDINATOR** Jennifer Rittner

**CONTRIBUTING WRITERS** Richard Wilde and Lazar Dzamic

**DESIGN OFFICE** Pentagram Design Inc.

**CLIENT** Publikum Calendar

**PRINCIPAL TYPE** Times Roman, Times Cyrillic, Universe Roman, and Universe Cyrillic

**DIMENSIONS** 12 x 23.5 in. (30.5 x 59.7 cm)

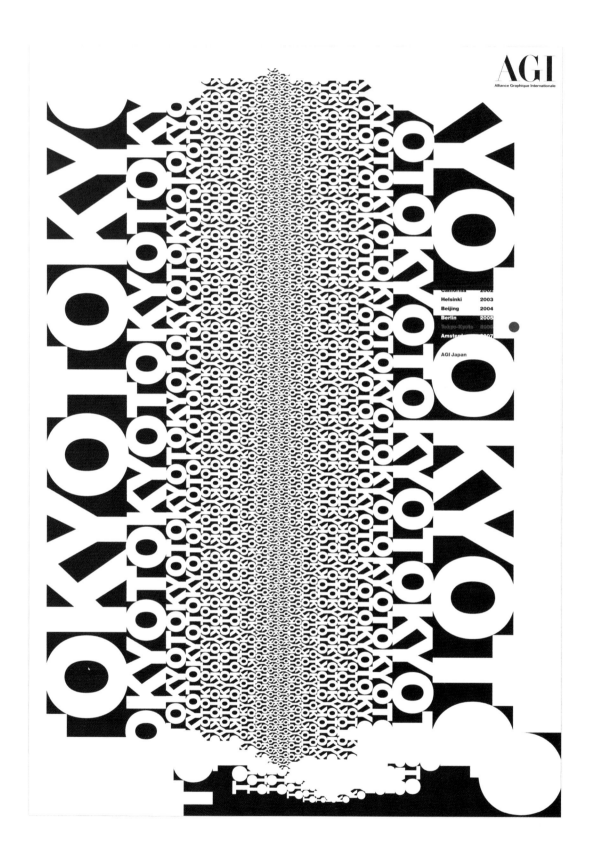

104    **POSTER**

**DESIGN** Shinnoske Sugisaki *Osaka, Japan*

**ART DIRECTION** Shinnoske Sugisaki

**AGENCY** Shinnoske Inc.

**CLEINT** Alliance Graphique Internationale (AGI)

**PRINCIPAL TYPE** Helvetica Neue 95 Black

**DIMENSIONS** 28.7 x 40.6 in. (72.8 x 103 cm)

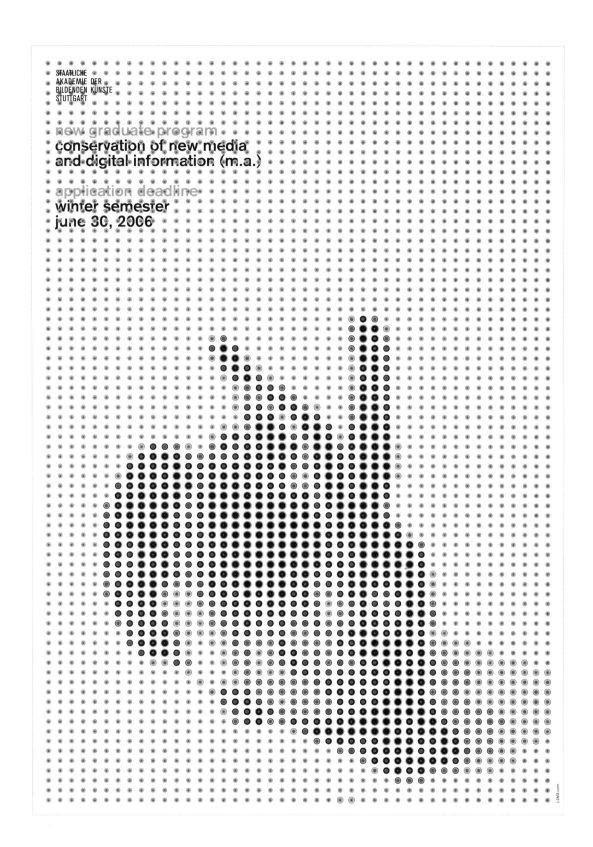

**DESIGN** Sascha Lobe and Dirk Wachowiak
*Stuttgart, Germany*

**DESIGN OFFICE** L2M3 Kommunikationsdesign GmbH

**CLIENT** Staatliche Akademie der Bildenden
Künste Stuttgart

**PRINCIPAL TYPE** Akzidenz Grotesk

**DIMENSIONS** 33.1 x 46.8 in. (84 x 118.8 cm)

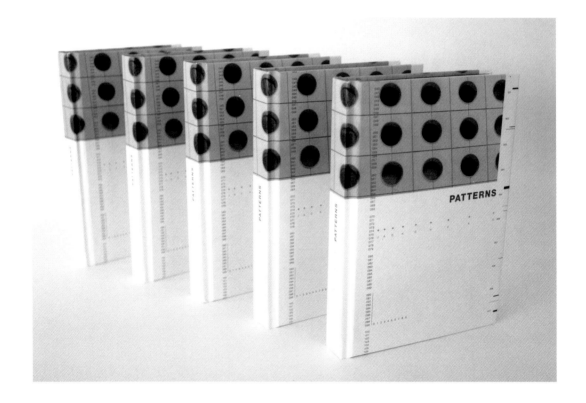

**STUDENT PROJECT**

**DESIGN** Jack Chung *Alameda, CA*

**PHOTOGRAPHY** Jack Chung

**INSTRUCTOR** Jennifer Sterling

**SCHOOL** Academy of Art University, San Francisco

**PRINCIPAL TYPE** Helvetica Neue

**DIMENSIONS** 6 x 8.5 in. (15.2 x 21.6 cm)

Sheet of stamps with repeated text: "2006 — 200 Jahre Blindenschule Berlin | 150 Jahre Stiftung Nikolauspflege — Deutschland 55" and faint "mit Händen sehen"

**DESIGN** Christof Gassner *Darmstadt, Germany*

**STUDIO** Christof Gassner

**CLIENT** Bundesministerium der Finanzen, Berlin

**PRINCIPAL TYPE** Frutiger

**DIMENSIONS** Stamp: 2.2 x 1.3 in. (5.5 x 3.3 cm)
Sheet: 5.4 x 7.7 in. (13.6 x 19.6 cm)

**STAMP** 107

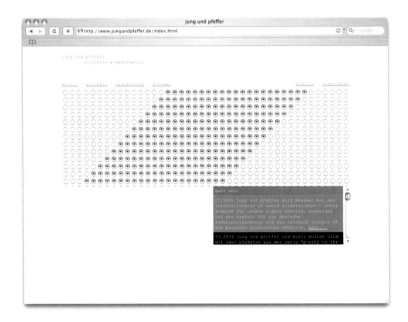

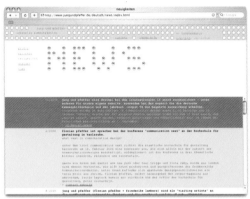

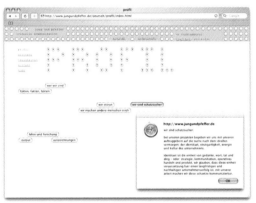

**DESIGN** Boris Mueller, Petra Michel, and Florian Pfeffer
*Bremen, Germany*

**DESIGN OFFICE** jung und pfeffer bremen/amsterdam:
visuelle kommunikation

**PRINCIPAL TYPE** Courier

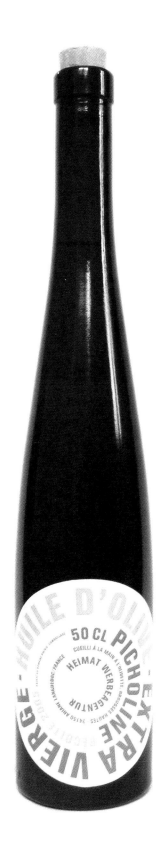

**ART DIRECTION** Anne-Lene Proff *Berlin, Germany*

**CREATIVE DIRECTION** Peter Bünnagel, Barbara Kotte, and Anne-Lene Proff

**AGENCY** scrollan

**CLIENT** Heimat Werbeagentur

**PRINCIPAL TYPE** Akzidenz Grotesk BQ Extra Bold Condensed

**DIMENSIONS** 3.5 x 3.5 in. (9 x 9 cm)

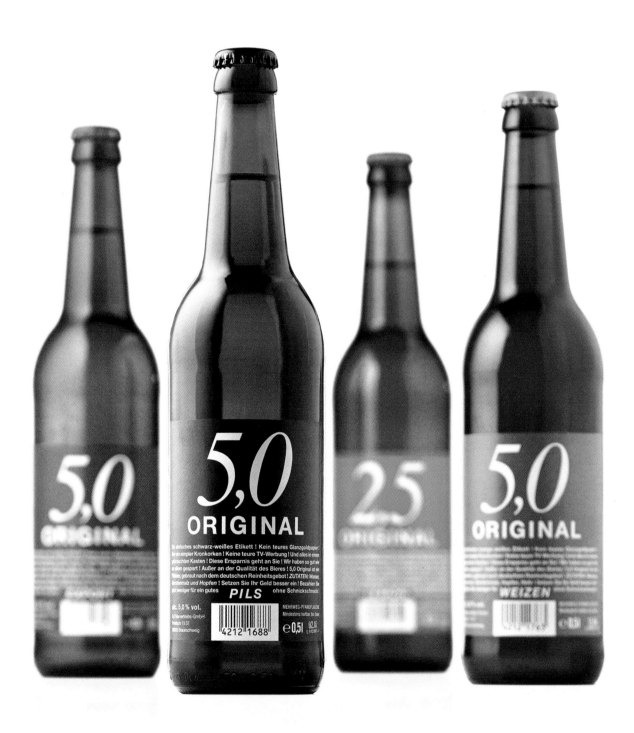

**PACKAGING**

**DESIGN** Inge-Marie Hansen, Kati Lust, Florian Schoffro, and Edgar Walthert *Hamburg, Germany*

**ART DIRECTION** Arne Schultchen

**CREATIVE DIRECTION** André Feldmann and Arne Schultchen

**DESIGN STUDIO** feldmann+schultchen design studios GmbH

**CLIENT** Carlsberg Group Germany

**PRINCIPAL TYPE** Helvetica Neue Fett, Helvetica Neue Fett Kursiv, and Times

**DIMENSIONS** Various

**DESIGN** Paula Scher and Drew Freeman
*New York, NY*

**ART DIRECTION** Paula Scher

**DESIGN OFFICE** Pentagram Design Inc.

**CLIENT** Grafx

**PRINCIPAL TYPE** Handlettering

**DIMENSIONS** 30 x 46 in. (76.2 x 116.8 cm)

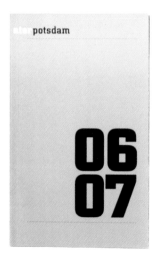

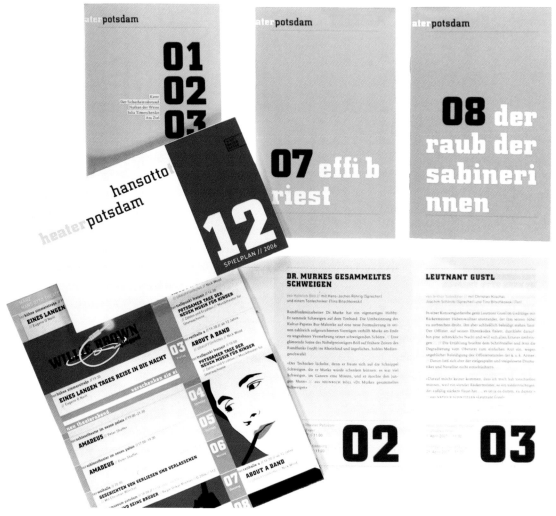

**DESIGN** Svenja von Döhlen, Borries Schwesinger, and Steffen Wierer *Berlin, Germany*

**ART DIRECTION** Svenja von Döhlen, Borries Schwesinger, and Steffen Wierer

**CREATIVE DIRECTION** Svenja von Döhlen, Borries Schwesinger, and Steffen Wierer

**DESIGN OFFICE** formdusche, Berlin

**CLIENT** Hans Otto Theater Potsdam GmbH

**PRINCIPAL TYPE** Berthold City, FF Din, and DTL Documenta

**DIMENSIONS** 3.9 x 6.5 in. (10 x 16.5 cm)

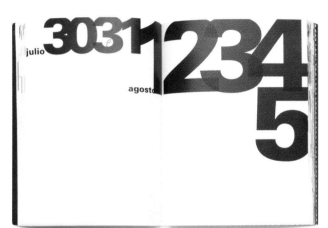

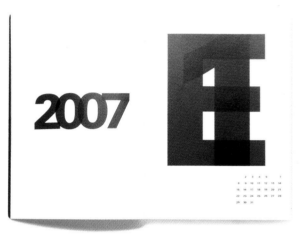

**DESIGN** Diego Mir, Ibán Ramón, and Daniel Requeni
*Valencia, Spain*

**ART DIRECTION** Ibán Ramón

**STUDIO** Estudio Ibán Ramón

**PRINCIPAL TYPE** Univers

**DIMENSIONS** 5.9 x 7.9 in. (15 x 20 cm)

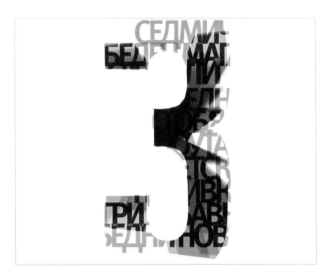
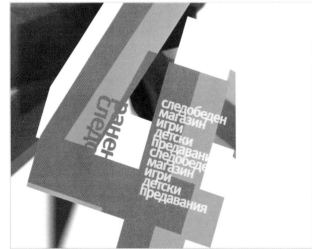
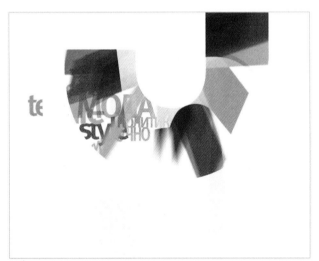

**CHANNEL
BRANDING**

**DESIGN** Maxim Ivanov *Sofia, Bulgaria*

**ART DIRECTION** Maxim Ivanov

**CREATIVE DIRECTION** Maxim Ivanov

**STUDIO** Topformstudio

**CLIENT** TV7

**PRINCIPAL TYPE** Meta Bold Cyrillic

**DESIGN** Susanna Aldrovandi *San Francisco, CA*

**INSTRUCTOR** Jennifer Sterling

**SCHOOL** Academy of Art University

**PRINCIPAL TYPE** Orator

**DIMENSIONS** 6 x 9 in. (15.2 x 22.9 cm)

Wilf Moss culture to culture
Address Forstrasse 184, 10115 Berlin, Germany
Telephone, Fax 0049.30.78.899.648, 0049.30.78.895.479
Mobile, Email 0049.179.569.7286, wilf.moss@snafu.de
Bank, Verbindung Dresdner Bank
Account, BLZ, Code 931 771 500, 100 800 00
Tax, Number 34/448/52128

Wilf Moss culture to culture
Address Forstrasse 184, 10115 Berlin, Germany
Telephone, Fax 0049.30.78.899.648, 0049.30.78.895.479
Mobile, Email 0049.179.569.7286, wilf.moss@snafu.de

Without You

Nothing
without you
but not the same

Nothing
without you
but perhaps less

Nothing
but less
and less

Perhaps not nothing
without you
but not much more   Erich Fried

Wilf Moss culture to culture
Address Forstrasse 184, 10115 Berlin, Germany
Telephone, Fax 0049.30.78.899.648, 0049.30.78.895.479
Mobile, Email 0049.179.569.7286, wilf.moss@snafu.de

116    STATIONERY    DESIGN Iris Fussenegger *Berlin, Germany*    CLIENT Wilf Moss – Culture to Culture

ART DIRECTION Fons Hickmann and Simon Gallus    PRINCIPAL TYPE Gravur

POET Erich Fried    DIMENSIONS Various

STUDIO Fons Hickmann m23

# amnesty AKTION

MITMACHEN
USBEKISTAN
Der krumme Krieg
gegen den Terror

ERFOLGE
Ihr Brief
kann Leben retten

MILLIONENSPENDE
Hollywoodstar hilft
ehemaligen Kindersoldaten

**NOCH IMMER
LASSEN
REGIERUNGEN
DIESER WELT
JUGENDLICHE**

HINRICHTEN. DIE HIER AUFGELISTETEN TEENAGER
UND VIELE MEHR, DEREN NAMEN ODER GENAUES ALTER
UNBEKANNT SIND, WURDEN ALLEIN IN DEN LETZTEN
FÜNFZEHN JAHREN ZUM TODE VERURTEILT. IN IHREM
NAMEN KÄMPFT AMNESTY INTERNATIONAL FÜR DIE
ABSCHAFFUNG DER TODESSTRAFE FÜR MINDERJÄHRIGE.
CHINA ZHAO LIN / GAO PAN DEMOKRATISCHE REPUBLIK
KONGO KASONGO IRAN KAZEM SHIRAFKAN / EBRAHIM
QORBANZADEH / JASEM ABRAHIMI / MEHRDAD YOUSEFI
/ MOHAMMAD ZADEH / SALMAN / ATEFEH RAJABI / IMAN
FAROKHI / ALI SAFARPOUR RAJABI / MAHMOUD A. / FARSHID
FARIGHI / ROSTAM TAJIK / MAJID SEGOUND JEMEN NASEER
MUNIR NASSER AL'KIRBI NIGERIA CHIEBORE ONUOHA
PAKISTAN SHAMUN MASIH / ALI SHER / MUTABAR KHAN
SAUDI ARABIEN SADEQ MAL-ALLAH USA DALTON PREJEAN /
JOHNNY GARRETT / CURTIS HARRIS / FREDERICK LASHLEY /
CHRISTOPHER BURGER / RUBEN CANTU / JOSEPH JOHN
CANNON / ROBERT ANTHONY CARTER / DWAYNE ALLEN
WRIGHT / SEAN SELLERS / STEVE ROACH / CHRIS THOMAS /
GLEN MCGINNIS / GARY GRAHAM / GERALD MITCHELL /
NAPOLEAN BEAZLEY / T.J. JONES / TORONTO PATTERSON /
SCOTT ALLEN HAIN

**ai**
amnesty international
FÜR DIE MENSCHENRECHTE

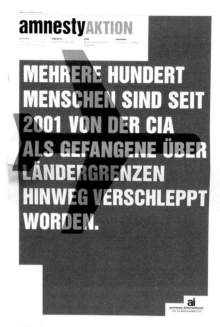

# amnesty AKTION

**MEHRERE HUNDERT
MENSCHEN SIND SEIT
2001 VON DER CIA
ALS GEFANGENE ÜBER
LÄNDERGRENZEN
HINWEG VERSCHLEPPT
WORDEN.**

**ai**
amnesty international

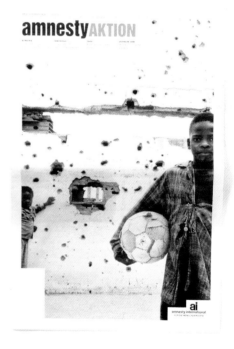

# amnesty AKTION

**ai**
amnesty international

---

**DESIGN** Franziska Morlok and Fons Hickmann
*Berlin, Germany*

**ART DIRECTION** Fons Hickmann, Gesine
Grotrian-Steinweg, and Franziska Morlok

**CREATIVE DIRECTION** Gesine Grotrian-Steinweg

**EDITING** Markus Beeko and Nina Tesenfitz

**STUDIO** Fons Hickmann m23

**CLIENT** Amnesty International

**PRINCIPAL TYPE** Rotation and Helvetica

**DIMENSIONS** 12.2 x 18.5 in. (31 x 47 cm)

**DESIGN** Jamie Calderon *San Francisco, CA*

**CREATIVE DIRECTION** Steve Tolleson

**ILLUSTRATION** Jamie Calderon

**DESIGN OFFICE** Tolleson Design

**CLIENT** Gmund Paper

**PRINCIPAL TYPE** NB55RMS Type Set and NB Transfer Type Set

**DIMENSIONS** 5.75 x 8.25 in. (14.6 x 21 cm)

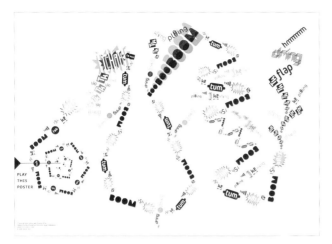

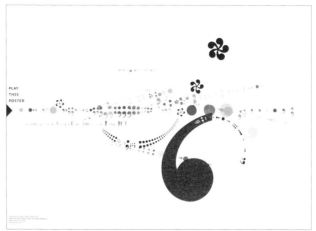

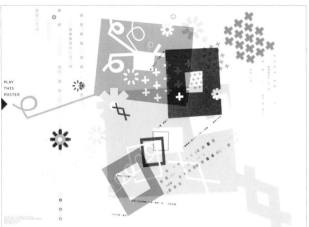

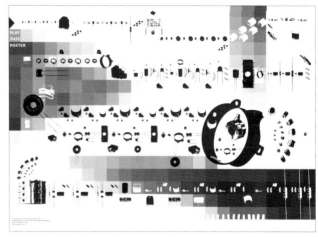

**DESIGN** David Benqué *Rotterdam, The Netherlands*

**PROFESSORS** Klaus Baumgartner, Gert Dumbar, and Jan-Willem Stas

**SCHOOL** Koninklijke Academie van Beeldende Kunsten, Den Haag

**PRINCIPAL TYPE** Auto, FF Cocon, FF Minimum, and Typophonics form-language

**DIMENSIONS** 27.6 x 19.7 in. (70 x 50 cm)

**STUDENT PROJECT** 119

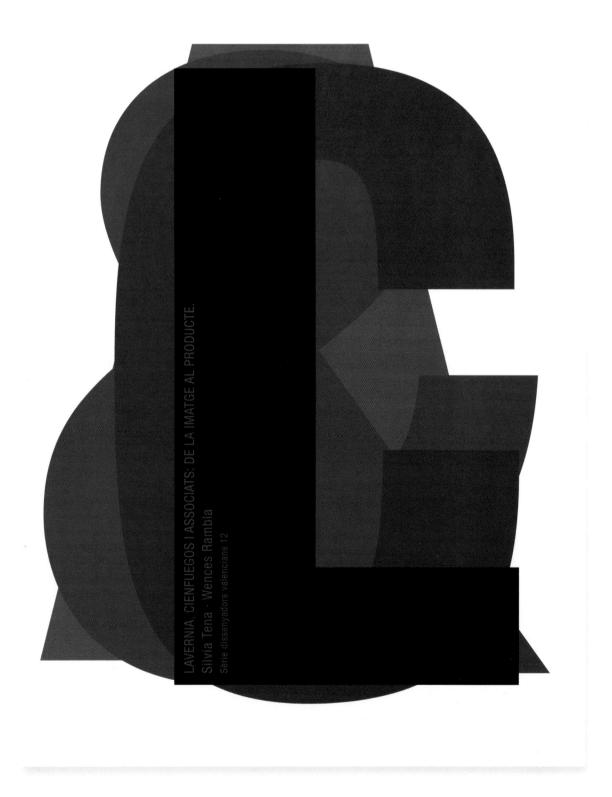

LAVERNIA, CIENFUEGOS I ASSOCIATS: DE LA IMATGE AL PRODUCTE.

Silvia Tena · Wences Rambla

Sèrie dissenyadors valencians 12

**BOOK
COVER**

**DESIGN** Alberto Cienfuegos *Valencia, Spain*

**ART DIRECTION** Nacho Lavernia and
Alberto Cienfuegos

**STUDIO** Lavernia, Cienfuegos & Asociados

**CLIENT** Universitat Jaume I

**PRINCIPAL TYPE** Helvetica Neue Heavy Condensed

**DIMENSIONS** 6.7 x 8.9 in. (17 x 22.5 cm)

**DESIGN** Melchior Imboden *Buochs, Switzerland*

**ART DIRECTION** Melchior Imboden

**CREATIVE DIRECTION** Melchior Imboden

**DESIGN STUDIO** Imboden

**CLIENT** DDD Galerie, Japan

**PRINCIPAL TYPE** Univers

**DIMENSIONS** 27.6 x 39.4 in. (70 x 100 cm)

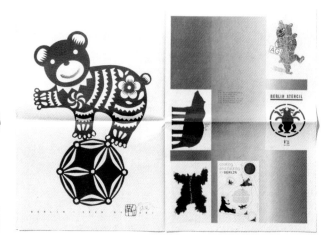

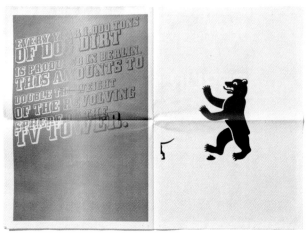

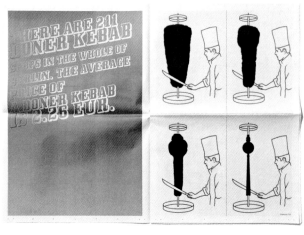

**DESIGN** Fons Hickmann and Barbara Baettig
*Berlin, Germany*

**ART DIRECTION** Barbara Baettig, Markus Buesges, and Fons Hickmann

**CREATIVE DIRECTION** Markus Buesges and Gesine Grotrian-Steinweg

**STUDIO** Fons Hickmann m23

**CLIENT** Alliance Graphique Internationale (AGI)

**PRINCIPAL TYPE** Bullpen

**DIMENSIONS** 13.8 x 19.7 in. (35 x 50 cm)

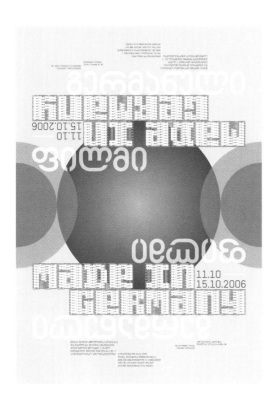

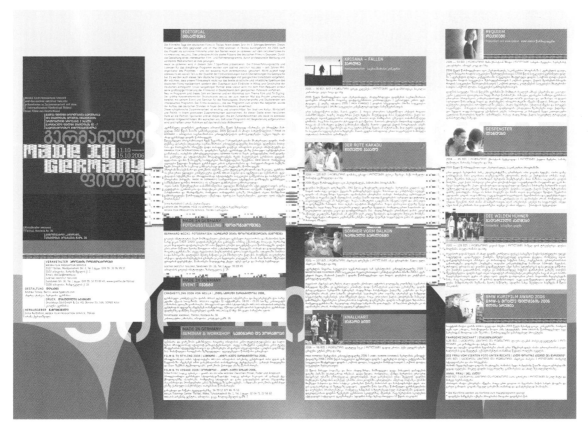

**DESIGN** Andrea Tinnes *Berlin, Germany*

**STUDIO** typecuts

**CLIENT** Medea: Film Production Service

**PRINCIPAL TYPE** AvazaMTavruli (customized), PTL Skopex Gothic, Type Jockey, and Wedding Sans

**DIMENSIONS** 33.1 x 23.4 in. (84 x 59.4 cm)

**POSTER** 123

**DESIGN** Melchior Imboden *Buochs, Switzerland*

**ART DIRECTION** Melchior Imboden

**CREATIVE DIRECTION** Melchior Imboden

**DESIGN STUDIO** Imboden

**CLIENT** Pool Event, Hergiswil

**PRINCIPAL TYPE** Eurostile

**DIMENSIONS** 35.6 x 50.4 in. (90.5 x 128 cm)

**DESIGN** Jennifer Barger *Miami Beach, FL*

**INSTRUCTOR** Barry Zaid

**SCHOOL** Miami Ad School

**PRINCIPAL TYPE** Myriad, News Gothic, and Rockwell

**DIMENSIONS** Various

**STUDENT PROJECT** 125

**BOOK**

**DESIGN** Kei Fujii, Hiroaki Nagai, and Makoto Ooi *Tokyo, Japan*

**ART DIRECTION** Hiroaki Nagai

**CALLIGRAPHY** Hiroaki Nagai

**PHOTOGRAPHY** Tamotsu Fujii

**COPYWRITING** Daisaku Fujiwara

**DESIGN OFFICE** N.G. Inc.

**CLIENT** Utsubo – Moon

**PRINCIPAL TYPE** Custom

**DIMENSIONS** 10.6 x 14.3 in. (27 x 36.3 cm)

DESIGN Julia Neuroth and Julia Mueller
*Amsterdam, The Netherlands*

STUDIO Julia & Julia

CLIENT Paperwaste magazine

PRINCIPAL TYPE Berliner Grotesk, Dutch, Filosofia, Futura, and Hiroshige

DIMENSIONS 9.25 x 12.25 in. (23.5 x 31.1 cm)

MAGAZINE 127

**DESIGN** Stephanie Yung *Toronto, Canada*

**ART DIRECTION** Stephanie Yung

**CREATIVE DIRECTION** Steve Mykolyn

**LETTERING** Stephanie Yung

**WRITING** Alexis Gropper

**TYPOGRAPHER/PRODUCTION ARTIST**
Brad Kumaraswamy

**ACCOUNT MANAGER** Jacinté Faria

**ACCOUNT DIRECTOR** Katherine Craig

**AGENCY PRINT PRODUCER** Michael Meades and
Bruce Ellis

**PRINTER** CJ Graphics

**AGENCY** TAXI CANADA INC.

**CLIENT** Canadian Film Centre

**PRINCIPAL TYPE** Kraftwerk and Stuyvesant Solid

**DIMENSIONS** Various

DESIGN Sara Golzari *Napa, CA*

CREATIVE DIRECTION David Schuemann

CALLIGRAPHY Georgia Deaver *San Francisco, CA*

ILLUSTRATION Antar Dayal *Santa Barbara, CA*

AGENCY CF Napa

CLIENT Crew Wine Company

PRINCIPAL TYPE Federal and handlettering

DIMENSIONS 4.1 x 3.3 in. (10.4 x 8.4 cm)

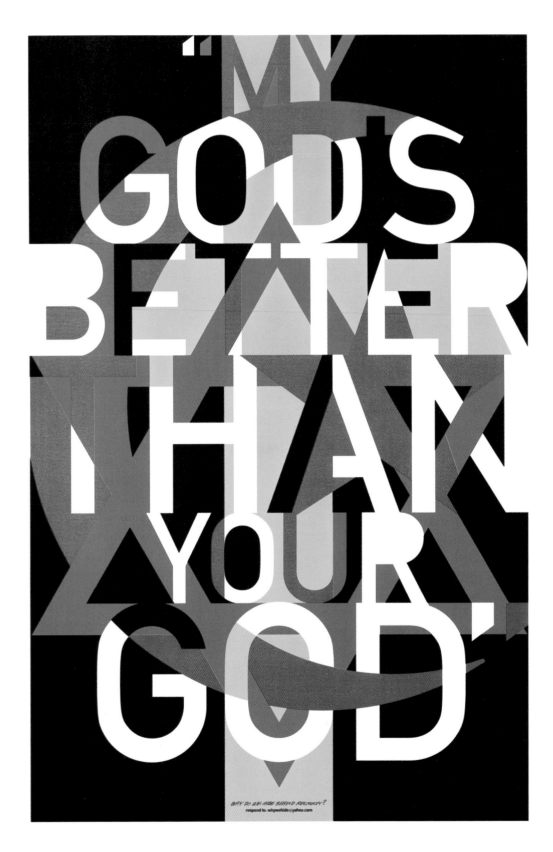

**POSTER**

**DESIGN** Ned Drew *New York, NY*

**ART DIRECTION** Ned Drew

**DESIGN OFFICE** The Design Consortium

**CLIENT** why we hide

**PRINCIPAL TYPE** DIN 1451 Mittelschrift

**DIMENSIONS** 11 x 17 in. (27.9 x 43.2 cm)

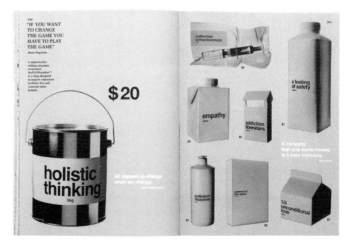

**ART DIRECTION** Katja Fössel and Ralf Herms
*Munich, Germany,* and *Ammerndorf, Germany*

**CREATIVE DIRECTION** Ralf Herms

**CONCEPT** Fritz T. Magistris *Vienna, Austria*

**DESIGN OFFICE** Rosebud, Inc.

**PRINCIPAL TYPE** Melior

**DIMENSIONS** 7.9 x 10.6 in. (20 x 27 cm)

**POSTER**

**DESIGN** Frantiska Bucher, Joerg Herz, and Sven Schlotfeldt *Munich, Germany*

**AGENCY** Coma AG

**CLIENT** Kochan & Partner

**PRINCIPAL TYPE** Logorinth

**DIMENSIONS** 22.8 x 31.5 in. (58 x 80 cm)

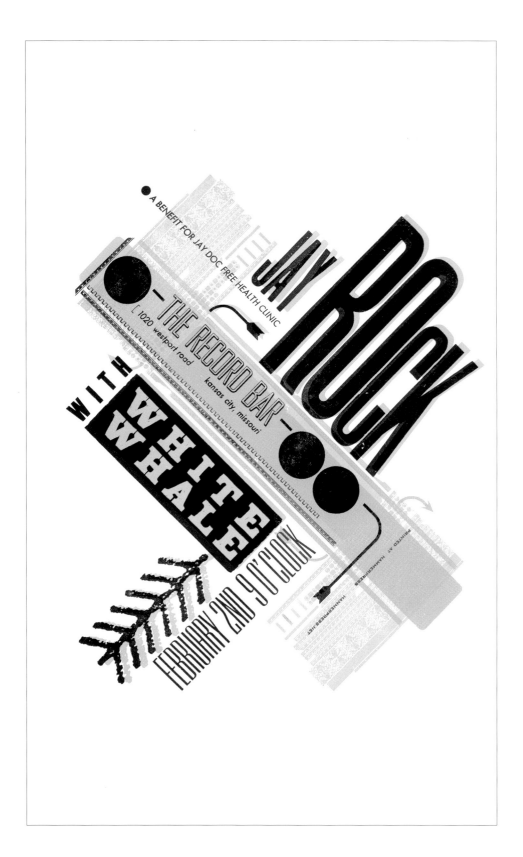

**DESIGN** Brady Vest *Kansas City, MO*

**STUDIO** Hammerpress

**CLIENT** Jay Doc Health Clinic

**PRINCIPAL TYPE** Various wood and lead type

**DIMENSIONS** 16 x 26 in. (40.6 x 66 cm)

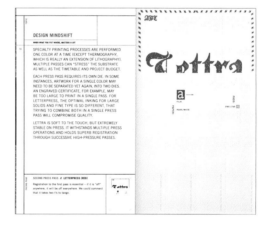

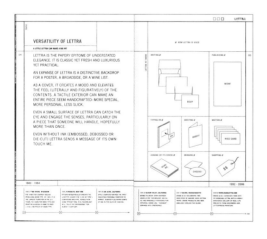

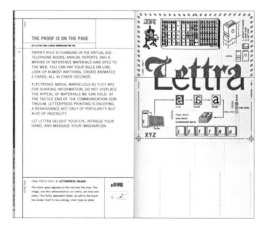

**134** **BROCHURE**

**DESIGN** Cody Dingle and Michael Osborne
*San Francisco, CA*

**CREATIVE DIRECTION** Michael Osborne

**COPYWRITING** Alyson Kuhn *Napa, CA*

**STUDIO** Michael Osborne Design

**CLIENT** Crane and Co.

**PRINCIPAL TYPE** Trade Gothic

**DIMENSIONS** 6 x 9.5 in. (15.3 x 24.1 cm)

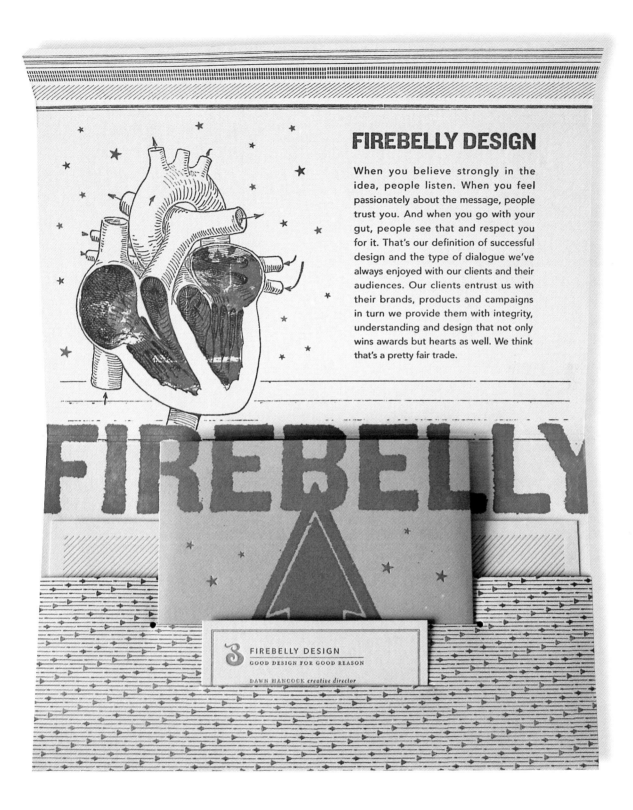

## FIREBELLY DESIGN

When you believe strongly in the idea, people listen. When you feel passionately about the message, people trust you. And when you go with your gut, people see that and respect you for it. That's our definition of successful design and the type of dialogue we've always enjoyed with our clients and their audiences. Our clients entrust us with their brands, products and campaigns in turn we provide them with integrity, understanding and design that not only wins awards but hearts as well. We think that's a pretty fair trade.

**DESIGN** Dawn Hancock and Aaron Shimer
*Chicago, IL*

**ART DIRECTION** Dawn Hancock

**CREATIVE DIRECTION** Dawn Hancock

**COPYWRITING** Antonio Garcia

**STUDIO** Firebelly Design

**PRINCIPAL TYPE** Avenir and Mrs. Eaves

**DIMENSIONS** 8.75 x 11.75 in. (22.2 x 29.9 cm)

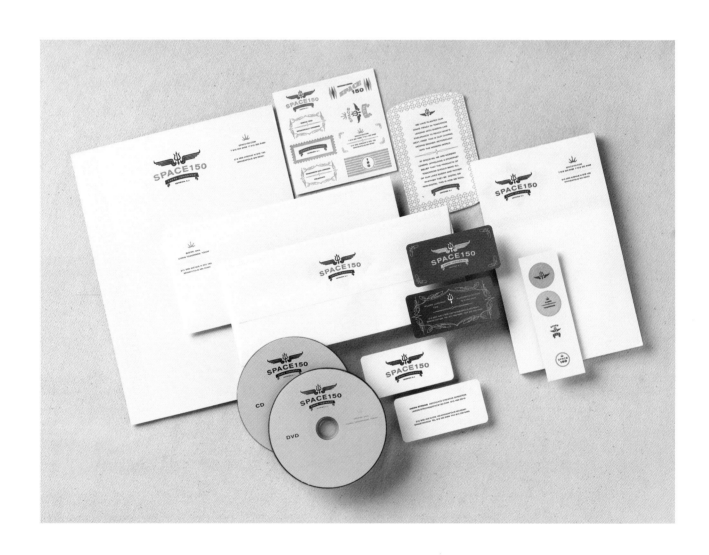

**CORPORATE IDENTITY**

**DESIGN** Ben Levitz *Minneapolis, MN*

**CREATIVE DIRECTION** Jason Strong

**COPYWRITING** Riley Kane

**AGENCY** space150

**PRINCIPAL TYPE** Akzidenz Grotesk Extended

**DIMENSIONS** Various

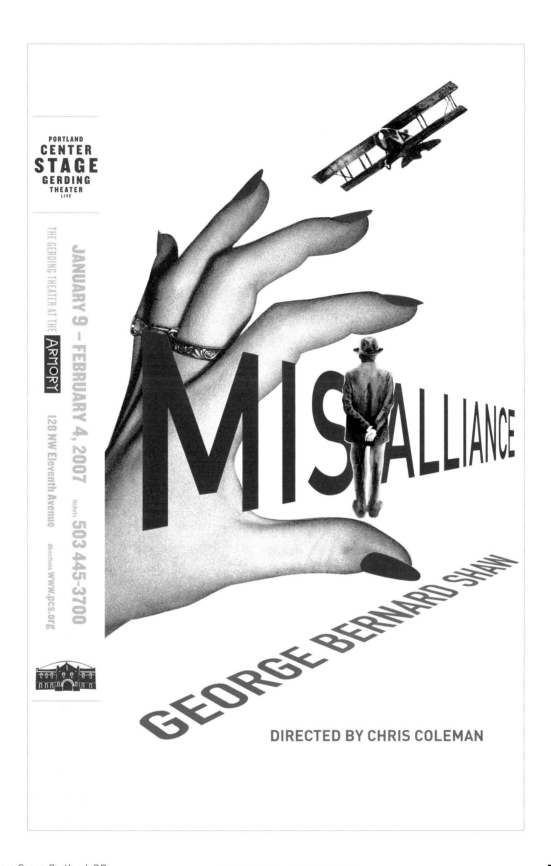

**DESIGN** Marc Cozza *Portland, OR*

**ART DIRECTION** Marc Cozza

**CREATIVE DIRECTION** Marc Cozza

**ILLUSTRATION** Rebecca Cohen

**STUDIO** Sandstrom Design

**CLIENT** Portland Center Stage

**PRINCIPAL TYPE** DIN Mittelschrift

**DIMENSIONS** 11 x 17 in. (27.9 x 43.2 cm)

LEE BUL
BRYAN CROCKETT
ROXY PAINE
PATRICIA PICCININI
ALYSON SHOTZ
JENNIFER STEINKAMP

UN
EAS y
NAT
URE

:TA
MO R
HO S
S

MARINA warner

**CATALOG**

**DESIGN** Eric Heiman, Madhavi Jagdish, and Amber Reed *San Francisco, CA*

**ART DIRECTION** Eric Heiman

**CREATIVE DIRECTION** Adam Brodsley and Eric Heiman

**DESIGN OFFICE** Volume Inc.

**CLIENT** Weatherspoon Art Museum

**PRINCIPAL TYPE** HFT Gotham and Proforma

**DIMENSIONS** 6 x 8 in. (15.2 x 20.3 cm)

QUEENCHRISTINA

IN A POP LANDSCAPE LITTERED WITH MACHINE-MADE POSEURS, CRAZY-PIPED **Christina Aguilera** IS THE REAL DEAL. BUT WILL MARRIED LIFE AND A STIRRING NEW ALBUM SOFTEN HER GLORIOUSLY RAUNCHY IMAGE? · BY **Chris Norris** · PHOTOGRAPHS BY **Michael Thompson**

160 · GQ

**DESIGN** Anton Iouklinovets *New York, NY*

**ART DIRECTION** Ken DeLago

**DESIGN DIRECTION** Fred Woodward

**PUBLICATION** GQ Magazine

**PRINCIPAL TYPE** Omnes

**DIMENSIONS** 15.6 x 11 in. (39.6 x 27.9 cm)

## HEATHER SWEET

DAS GESAMTKUNSTWERK DITA VON TEESE IRGENDWO ZWISCHEN ZWITTERHAFTER VOLLEROTIK, KLASSISCHER WEIBLICHKEIT UND MUTTERS KÜHLSCHRANK

Foto: Ruskin, Text: Reinhold Köhler

**DESIGN** Stefan Guzy *Berlin, Germany*

**ART DIRECTION** Stefan Guzy

**CREATIVE DIRECTION** Götz Offergeld

**ILLUSTRATION** Suse Schandelmaier and Björn Atldax *Berlin, Germany,* and *Stockholm, Sweden*

**LAYOUT** Jörg Walter

**DESIGN OFFICE** Zwölf Medien

**CLIENT** Liebling Verlag GmbH

**PRINCIPAL TYPE** Arnhem Blond, Arnhem Bold, Arnhem Italic, and TV Nord Condensed Bold

**DIMENSIONS** 12.4 x 18.5 in. (31.5 x 47 cm)

DESIGN Linda Ritoh *Osaka, Japan*

ART DIRECTION Linda Ritoh

CREATIVE DIRECTION Linda Ritoh

LETTERING Linda Ritoh

PHOTOGRAPHY Koichi Okuwaki and Yusei Ueda

SCULPTOR Linda Ritoh

DESIGN OFFICES Libido Inc. & Linda Graphia

CLIENT P Gallery SOCO

PRINCIPAL TYPE Garamond Regular and Shinseikaisyotai

DIMENSIONS 28.7 x 40.6 in. (72.8 x 103 cm)

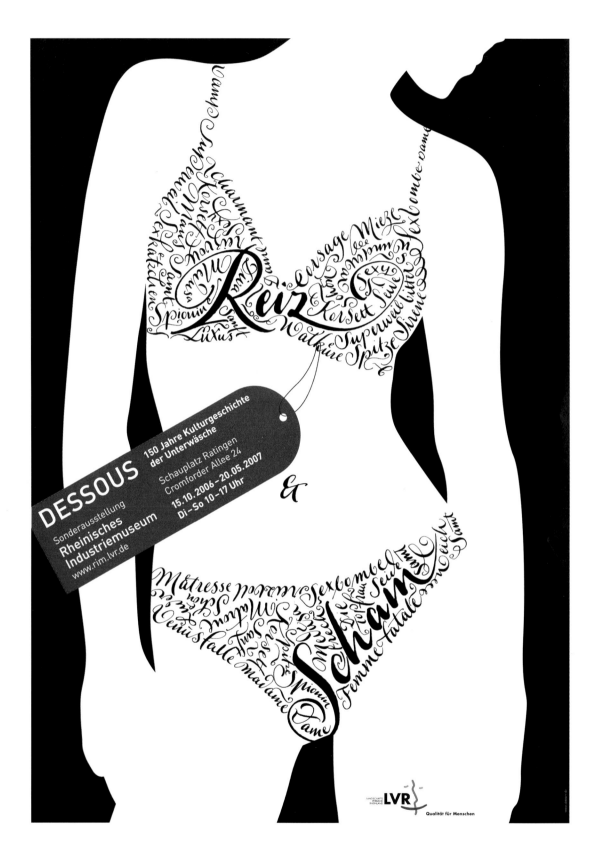

**DESIGN** Nadine Fliegen, Silke Löhmann, Anne Schmidt, and René Wynands *Bochum, Germany*

**ART DIRECTION** Silke Löhmann and René Wynands

**CREATIVE DIRECTION** Silke Löhmann and René Wynands

**CALLIGRAPHY** Petra BeiBe *Wiesbaden, Germany*

**DESIGN OFFICE** Oktober Kommunikationsdesign

**CLIENT** Rheinisches Industriemuseum (LVR)

**PRINCIPAL TYPE** FF Din and handlettering

**DIMENSIONS** 23.4 x 33.1 in. (59.4 x 84.1 cm)

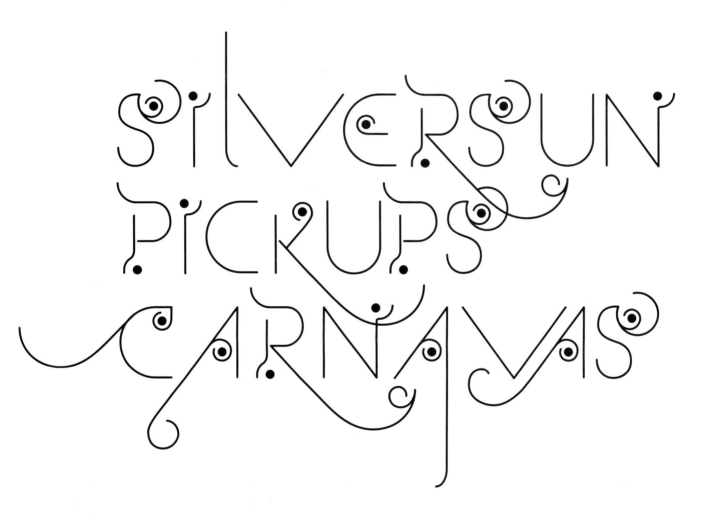

**DESIGN** Sara Cumings *Los Angeles, CA*

**STUDIO** Smog Design Inc.

**CLIENT** Dangerbird Records

**LOGOTYPE** 143

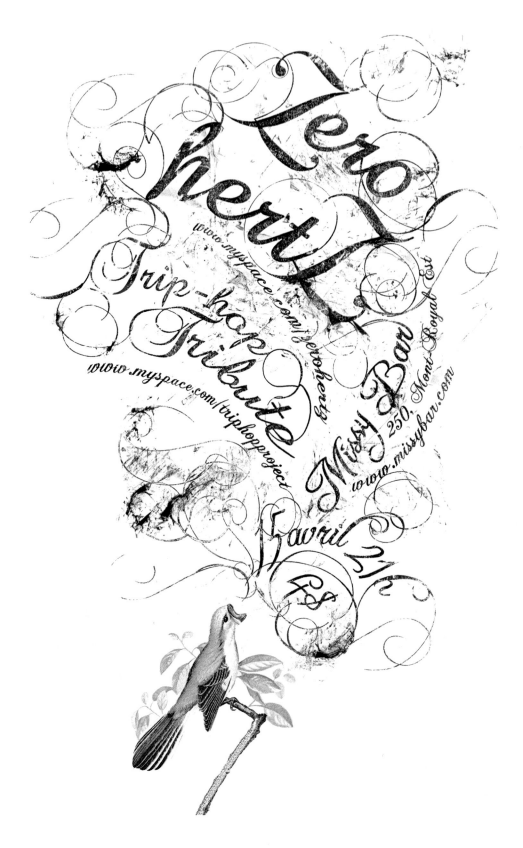

**POSTER**

**DESIGN** Jonathan Nicol *Montréal, Canada*

**CLIENT** Zero Hertz

**PRINCIPAL TYPE** Brock Script (modified),
Chopin Script (modified), and Freebooter Script
(modified)

**DIMENSIONS** 20 x 33 in. (50.8 x 83.8 cm)

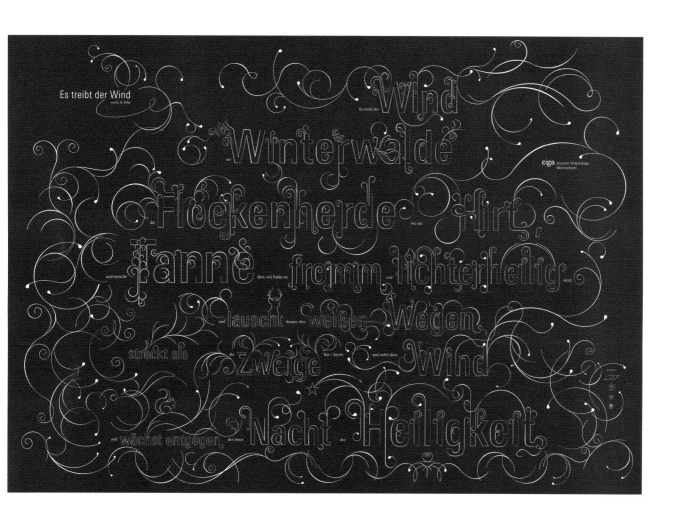

**DESIGN** Katrin Adamaszek *Hamburg, Germany*

**ART DIRECTION** Henning Otto

**CREATIVE DIRECTION** Elisabeth Plass

**DESIGN OFFICE** Eiga

**PRINCIPAL TYPE** Univers and handletteting

**DIMENSIONS** 33.1 x 23.4 in. (84.1 x 59.4 cm)

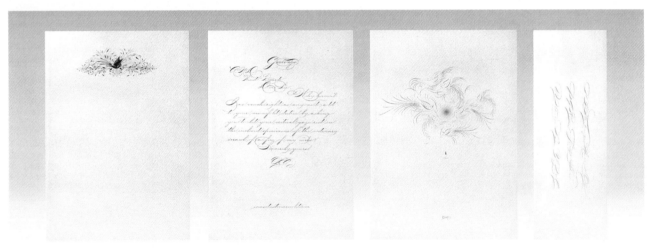

**146** **SELF-PROMOTION**

**DESIGN** Dustin E. Arnold *Los Angeles, CA*

**CREATIVE DIRECTION** Dustin E. Arnold

**CALLIGRAPHY** Dustin E. Arnold

**STUDIO** Dustin Edward Arnold

**PRINCIPAL TYPE** Adobe Garamond

**DIMENSIONS** 9.5 x 4.9 in. (24 x 12.5 cm)

MR & MRS
BRUCE CALDER BANKENSTEIN
REQUEST THE HONOR
of YOUR PRESENCE
at the MARRIAGE of their
DAUGHTER
JENNIFER LELAND
to
JEFFERSON EDWARD HEUER
SON OF
MR. & MRS. WILLIAM FREDERICK HEUER III

Saturday, the twenty-fourth of June
two thousand six
at four o'clock in the afternoon
at the Episcopal Church of Saint John the Baptist
York, Pennsylvania

Reception to follow at the Country Club of York

WWW.JEFFERSONHEUER.COM/WEDDING

RSVP

_____

NAME(S)

_____ WILL ATTEND          _____ DECLINE WITH REGRET

_____ FILET MIGNON & CRABCAKE

_____ CHICKEN FILLED WITH APPLE AND BRIE

PLEASE RESPOND BY MAY 20

**DESIGN** Jed Heuer and Jennifer Heuer
*Brooklyn, NY*

**LETTERING** Jed Heuer

**LETTERPRESS** Abbey Kuster-Prokell

**PRINCIPAL TYPE** Caslon, Sackers Gothic,
and handlettering

**DIMENSIONS** 5 x 10.6 in. (12.7 x 26.9 cm)

**INVITATION**   147

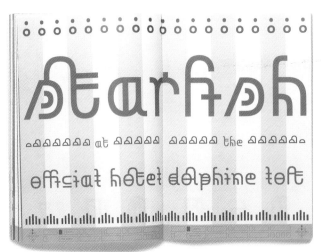

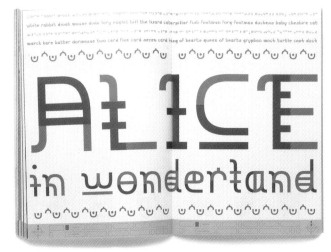

148 **STUDENT PROJECT**

**DESIGN** Stefanie Schwarz *Stuttgart, Germany*

**PROFESSORS** Michael Throm and Uli Cluss

**SCHOOL** Hochschule Pforzheim

**PRINCIPAL TYPE** Polymorph

**DIMENSIONS** 6.9 x 9.8 in. (17.5 x 25 cm)

**DESIGN** Ben Horner *Chattanooga, TN*

**CREATIVE DIRECTION** Michael Hendrix

**DESIGN OFFICE** Tricycle, Inc.

**CLIENT** Opus Carpets

**PRINCIPAL TYPE** InterFacer

**LOGOTYPE** 149

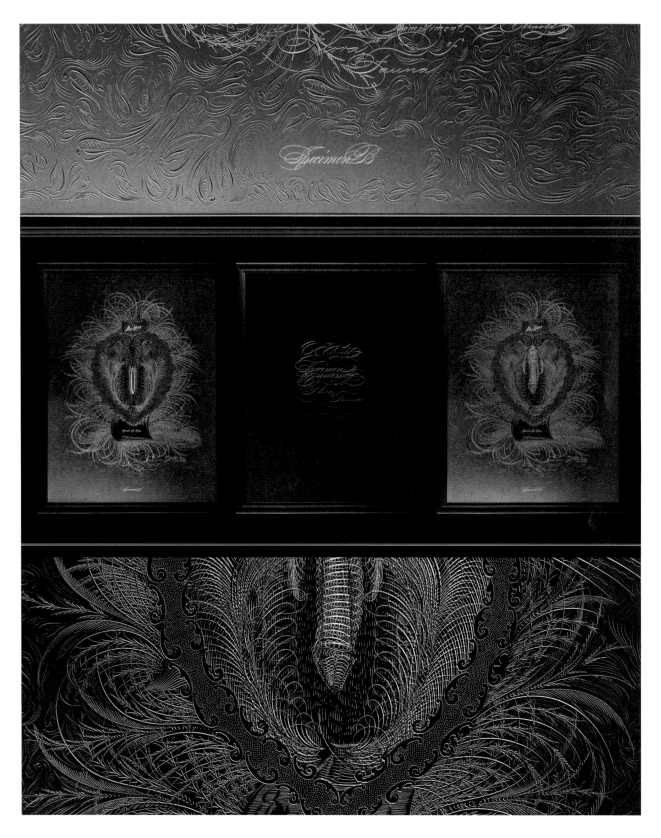

**DISPLAY**

**DESIGN** Dustin E. Arnold *Los Angeles, CA*

**CREATIVE DIRECTION** Dustin E. Arnold

**CALLIGRAPHY** Dustin E. Arnold

**STUDIO** Dustin Edward Arnold

**CLIENT** Eman Korcero

**PRINCIPAL TYPE** Handlettering

**DIMENSIONS** 46.1 x 59.8 in. (117 x 152 cm)

JAN 14 '06

is for nathan

DESIGN Dennis Garcia *San Diego, CA*

PRINTER Hal Truschke

DESIGN OFFICE Miriello Grafico

PRINCIPAL TYPE News 702, Rosewood, Sabon, and Trade Gothic

DIMENSIONS 4.75 x 6.5 in. (12.1 x 16.5 cm)

Flat 5H, Block 6
Villa Tiara, Tuen Mun
Hong Kong, China

pazu@leekaling.com
mobiles
86 1371515515
852 61266660

**CORPORATE
IDENTITY**

**DESIGN** Pazu Lee Ka Ling *Hong Kong, China*

**ART DIRECTION** Pazu Lee Ka Ling

**CREATIVE DIRECTION** Pazu Lee Ka Ling

**LETTERING** Pazu Lee Ka Ling

**PRINCIPAL TYPE** Custom

**DIMENSIONS** Various

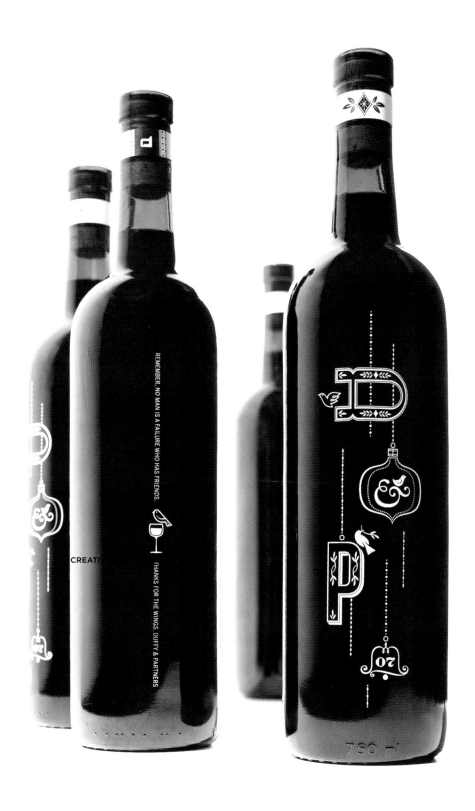

Text visible on bottles:

REMEMBER, NO MAN IS A FAILURE WHO HAS FRIENDS.

THANKS FOR THE WINGS. DUFFY & PARTNERS

CREATI

D & P
07

750 ml

**DESIGN** Brad Surcey *Minneapolis, MN*

**CREATIVE DIRECTION** Dan Olson

**LETTERING** Brad Surcey

**DESIGN OFFICE** Duffy & Partners

**PRINCIPAL TYPE** Benton Sans, HTF Depot, and handlettering

**DIMENSIONS** 3 X 12.25 in. (7.6 x 31.1 cm)

154   **POSTER**

**DESIGN** Christina Clugston, Rafael Esquer, and Nikhil Mitter *New York, NY*

**ART DIRECTION** Rafael Esquer

**CREATIVE DIRECTION** Rafael Esquer

**LETTERING** Rafael Esquer and Christina Clugston

**3-D ARTIST** Tim Wilder

**STUDIO** Alfalfa

**CLIENT** American Institute of Graphic Arts

**PRINCIPAL TYPE** Handlettering

**DIMENSIONS** 36 x 24 in. (91.4 x 61 cm)

**DESIGN** Kazuto Nakamura and
Tomokazu Yamada *Hiroshima, Japan*

**ART DIRECTION** Kazuto Nakamura

**CREATIVE DIRECTION** Kazuto Nakamura

**COPYWRITING** Tomiko Nakamura

**DESIGN OFFICE** Penguin Graphics

**CLIENT** Eve Group Co., Ltd.

**PRINCIPAL TYPE** ITC Garamond Light

**DIMENSIONS** 28.7 x 40.6 in. (72.8 x 103 cm)

wolfgang müller »elfen im schlafsack« 01.11.05

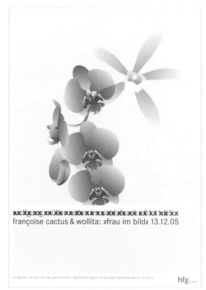

françoise cactus & wollita: »frau im bild« 13.12.05

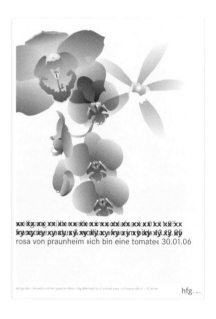

rosa von praunheim »ich bin eine tomate« 30.01.06

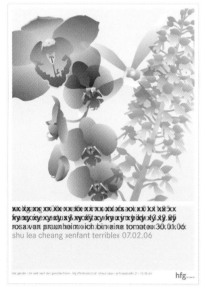

rosa von praunheim »ich bin eine tomate« 30.01.06
shu lea cheang »enfant terrible« 07.02.06

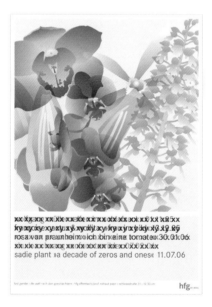

rosa von praunheim »ich bin eine tomate« 30.01.06
sadie plant »a decade of zeros and ones« 11.07.06

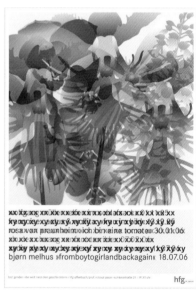

rosa von praunheim »ich bin eine tomate« 30.01.06
bjørn melhus »fromboytogirlandbackagain« 18.07.06

**DESIGN** Klaus Hesse and Benjamin Schulte
*Erkrath, Germany*

**DESIGN OFFICE** Hesse Design

**CLIENT** Prof. Rotraut Pape and HfG Offenbach

**PRINCIPAL TYPE** Corporate S

**DIMENSIONS** 27.6 x 39.4 in. (70 x 100 cm)

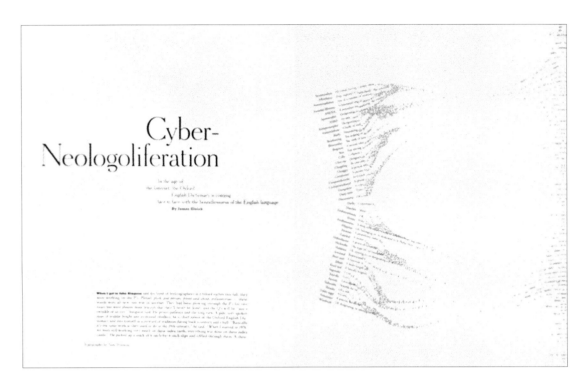

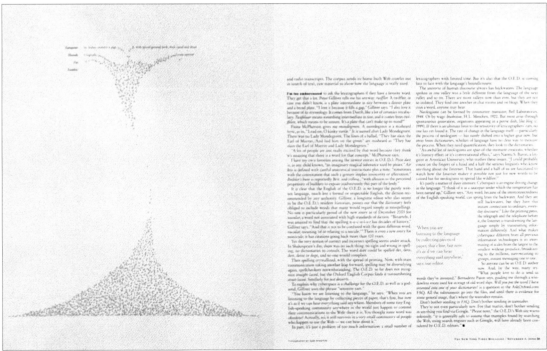

**DESIGN** Gail Bichler *New York, NY*

**ART DIRECTION** Arem Duplessis

**CREATIVE DIRECTION** Janet Froelich

**LETTERING** Sam Winston

**PUBLICATION** The New York Times Magazine

**PRINCIPAL TYPE** Cheltenham NYT Semi Light and Stymie NYT Extra Bold

**DIMENSIONS** 19.5 x 11.5 in. (49.5 x 29.2 cm)

**DESIGN** Todd Richards and Erik Adams
*San Francisco, CA*

**ART DIRECTION** Bill Cahan, Todd Richards
*San Francisco, CA*, and Steve Frykholm *Zeeland, MI*

**CREATIVE DIRECTION** Bill Cahan

**PHOTOGRAPHY** Robert Canfield, Brian Carter,
Dwight Eschliman, Colin Faulkner, Vivienne Flesher,
Hans Gissinger, Tim Griffith, Nadav Kander,
Catherine Ledner, Michael Martin, Nathan Perkel,
Andy Sacks, Robert Schlatter, Heimo Schmidt,
Andreas Vesalius, Scott Wyatt, and Nigel Young

**ILLUSTRATION** Melanie Boone, Brian Carter, Olaf Hajek,
Joseph Hart, Brian Rea, Artemio Rodriguez,
Blair Thornley, and Sam Weber

**COPYWRITING** Beth Bedsole, Brian Carter, Amie Duham
Pamela Erbe, Cynthia Kemper, Nancy Ramsey,
Linton Weeks, and Debra Wierenga

**AGENCY** Cahan & Associates

**CLEINT** Herman Miller

**PRINCIPAL TYPE** Helvetica and Sabon

**DIMENSIONS** 9.25 x 11.75 in. (23.5 x 29.9 cm)

**DESIGN** Rafael Esquer *New York, NY*

**LETTERING** Rafael Esquer

**STUDIO** Alfalfa

**CLIENT** American Institute of Graphic Arts/New York, Times Square Alliance, and Worldstudio Foundation

**PRINCIPAL TYPE** Handlettering

**DIMENSIONS** 36 x 84 in. (91.4 x 213.4 cm)

**BANNER**  159

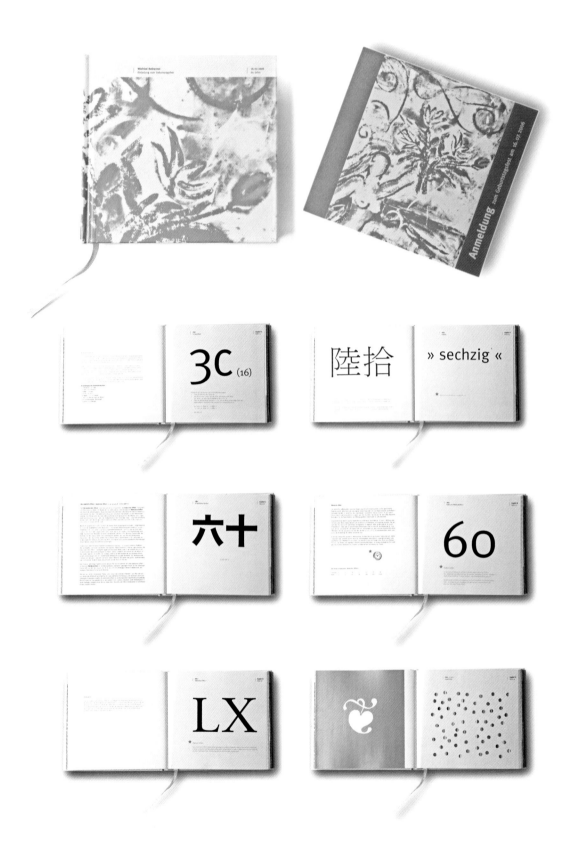

**BOOK**

**DESIGN** Anja Patricia Helm *Düsseldorf, Germany*

**ART DIRECTION** Anja Patricia Helm

**CREATIVE DIRECTION** Anja Patricia Helm

**LETTERING** Anja Patricia Helm

**AGENCY** 745 agentur für gestaltung

**CLIENT** Winfried Rothermel, ColorDruck

**PRINCIPAL TYPE** Meta and Sabon

**DIMENSIONS** 5 x 4.7 in. (12.6 x 12 cm)

How to think — and not think — about the unspoken issue of the Second Nuclear Age.
**By Noah Feldman**

**DESIGN** Gail Bichler *New York, NY*

**ART DIRECTION** Arem Duplessis

**CREATIVE DIRECTION** Janet Froelich

**LETTERING** James Victore

**PUBLICATION** The New York Times Magazine

**PRINCIPAL TYPE** Cheltenham NYT Extra Light, Stymie NYT Extra Bold, and handlettering

**DIMENSIONS** 9.5 x 11.5 in. (24.1 x 29.2 cm)

**BROCHURE**

**DESIGN** Matt Willey *London, England*

**CREATIVE DIRECTION** Matt Willey

**PHOTOGRAPHY** Giles Revell

**STUDIO** Studio 8 Design

**CLIENT** Rainforest Action Network (RAN)

**PRINCIPAL TYPE** Avant Garde, ITC Lubalin Graph, and Proforma

**DIMENSIONS** 6.3 x 8.7 in. (16 x 22 cm)

**DESIGN** Lizania Cruz, Daniel Gneiding, and Alana McCann *Philadelphia, PA*

**ART DIRECTION** Carolyn Keer

**DESIGN OFFICE** Anthropologie

**PRINCIPAL TYPE** Various

**DIMENSIONS** 14 x 14 in. (35.6 x 35.6 cm)

164 **STUDENT PROJECT**

**DESIGN** Tamara Gildengers Connolly
*Brooklyn, NY*

**INSTRUCTOR** Gail Anderson

**SCHOOL** School of Visual Arts

**PRINCIPAL TYPE** Bauhaus, Bodoni, Clarendon, Cooper, Futura, and Helvetica Rounded

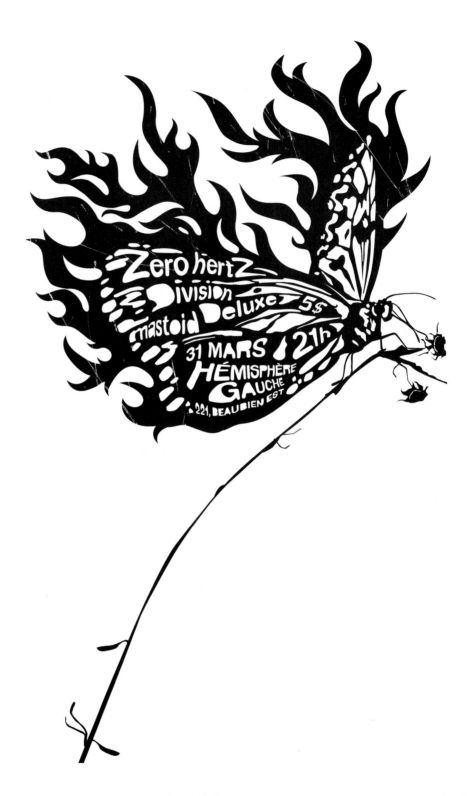

**DESIGN** Sarah Fullerton, Myllenda Lay, Daniel Lock, Eng Su, Jodie Wightman, and Ed Wright
*London, England*

**CREATIVE DIRECTION** Alan Dye, Nick Finney, and Ben Stott

**STUDIO** NB: Studio

**CLIENT** International Society of Typographic Designers

**PRINCIPAL TYPE** Trade Gothic

**DIMENSIONS** 60.2 x 40 in. (153 x 101.5 cm)

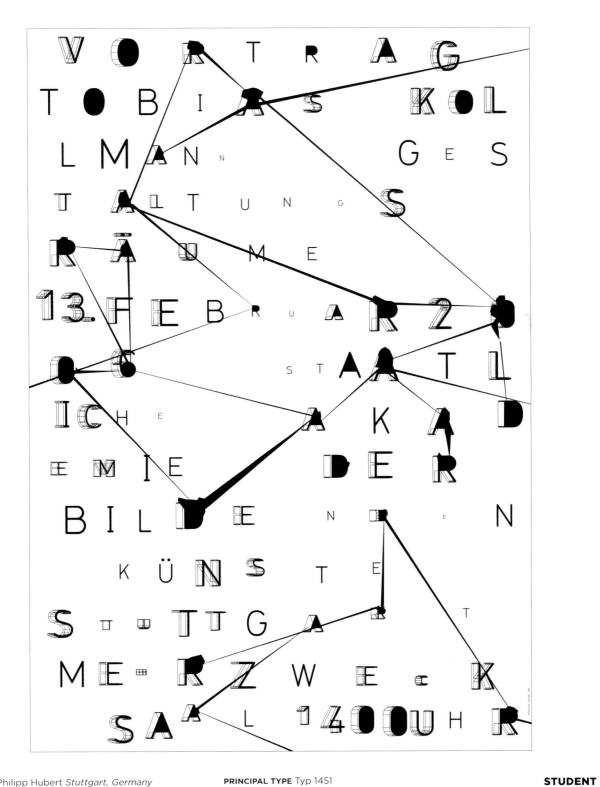

**DESIGN** Philipp Hubert *Stuttgart, Germany*

**PROFESSOR** Niklaus Troxler

**SCHOOL** Staatliche Akademie der Bildenden
Künste Stuttgart

**PRINCIPAL TYPE** Typ 1451

**DIMENSIONS** 23.4 x 33.1 in. (59.4 x 84.1 cm)

**STUDENT
PROJECT**   167

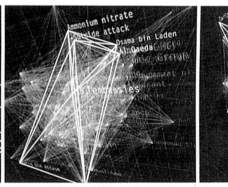

## Open-Source Spying

The nation's
intelligence
agencies are giving
their cold-war era
computer systems
a makeover.

But will blogs and
wikis really
help open uncover
terrorist plots?

By Clive Thompson

Illustrations by Lisa Strausfeld and James Nick Sears, Pentagram

168 **MAGAZINE
COVER AND
SPREAD**

**DESIGN** Jeff Glendenning *New York, NY*

**ART DIRECTION** Arem Duplessis

**CREATIVE DIRECTION** Janet Froelich

**LETTERING** Lisa Strausfeld and James Nick Sears,
Pentagram Design Inc.

**MAGAZINE** The New York Times Magazine

**PRINCIPAL TYPE** Stymie NYT Extra Bold

**DIMENSIONS** 9.5 x 11.5 in. (24.1 x 29.2 cm)

**DESIGN** Clare Sheffield and David Germain
*London, England*

**CREATIVE DIRECTION** Garrick Hamm

**LETTERING** David Germain

**DESIGN OFFICE** Williams Murray Hamm

**CLIENT** Fortnum & Mason

**PRINCIPAL TYPE** Custom

**DIMENSIONS** Various

**LOGOTYPE**

**DESIGN** Eric Chan and Iris Yu *Hong Kong, China*

**ART DIRECTION** Eric Chan and Iris Yu

**CREATIVE DIRECTION** Eric Chan

**DESIGN OFFICE** Eric Chan Design Co., Ltd.

**CLIENT** il bello

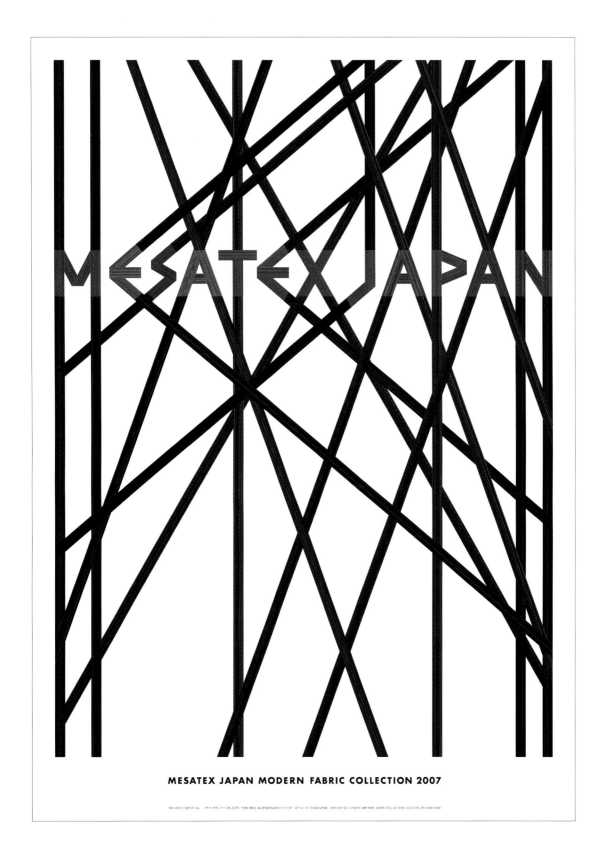

MESATEX JAPAN MODERN FABRIC COLLECTION 2007

MESATEX JAPAN Inc.

**DESIGN** Ohsugi Gaku and Iwabuchi *Tokyo, Japan*

**ART DIRECTION** Ohsugi Gaku

**DESIGN OFFICE** 702 Design Works Inc.

**CLIENT** MESATEX JAPAN Inc.

**PRINCIPAL TYPE** Custom

**DIMENSIONS** 28.7 x 40.6 in. (72.8 x 103 cm)

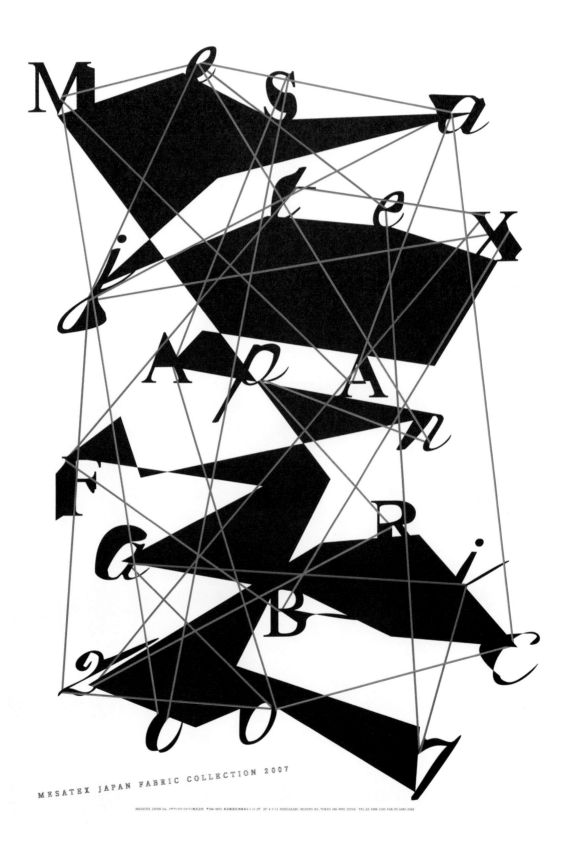

MESATEX JAPAN FABRIC COLLECTION 2007

MESATEX JAPAN Inc. メサテックス・ジャパン株式会社  〒106-0031 東京都港区西麻布4-1-11 2F  2F 4-1-11 NISHIAZABU, MINATO-KU, TOKYO 106-0031 JAPAN  TEL.03-3486-1545 FAX.03-3486-2462

**DESIGN** Sunaga Eiji and Ohsugi Gaku
*Tokyo, Japan*

**ART DIRECTION** Ohsugi Gaku

**DESIGN OFFICE** 702 Design Works Inc.

**CLIENT** MESATEX JAPAN Inc.

**PRINCIPAL TYPE** Custom

**DIMENSIONS** 28.7 x 40.6 in. (72.8  x 103 cm)

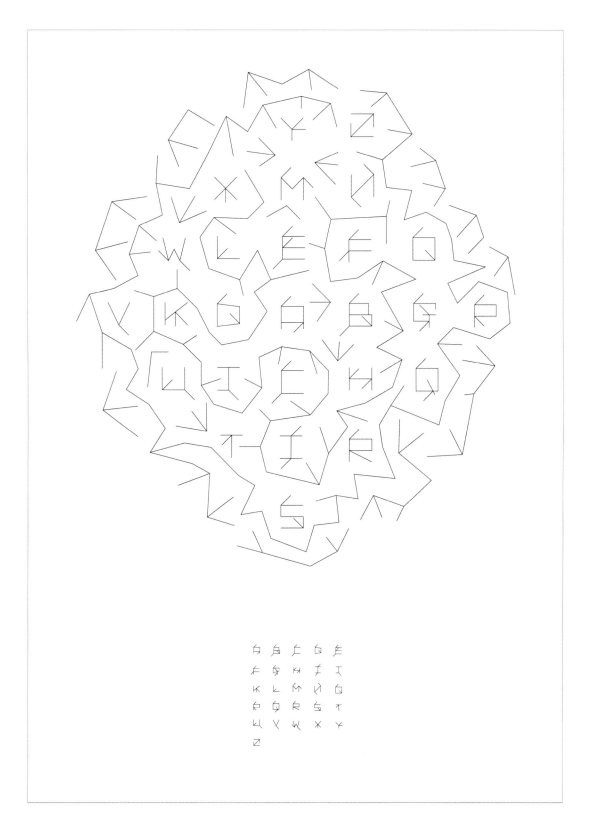

**DESIGN** Michihito Sasaki *Osaka, Japan*

**ART DIRECTION** Michihito Sasaki

**CREATIVE DIRECTION** Michihito Sasaki

**CALLIGRAPHY** Michihito Sasaki

**AGENCY** ADSEVEN CO., LTD.

**CLIENT** SEKI SOKEN CO., LTD.

**PRINCIPAL TYPE** Handlettering

**DIMENSIONS** 28.7 x 40.6 in. (72.8 x 103 cm)

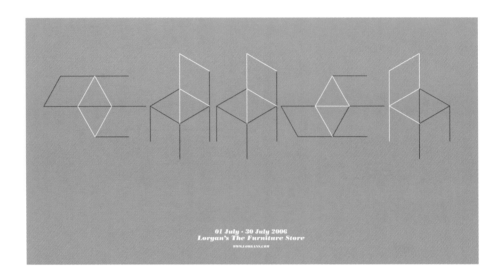

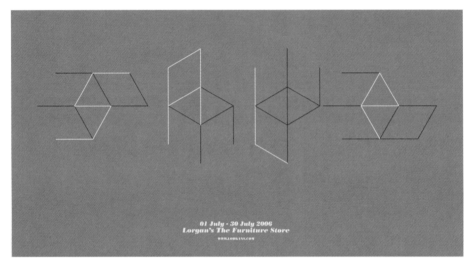

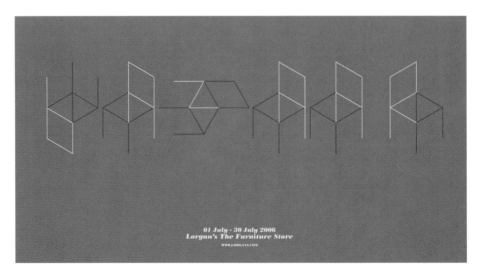

**DESIGN** Roy Poh and Pann Lim *Singapore*

**ART DIRECTION** Roy Poh and Pann Lim

**CREATIVE DIRECTION** Roy Poh and Pann Lim

**LETTERING** Roy Poh and Pann Lim

**WRITING** Eugene Tan

**AGENCY** Kinetic Singapore

**CLIENT** Lorgan

**PRINCIPAL TYPE** Handlettering

**DIMENSIONS** 35.4 x 15.8 in. (90 x 40 cm)

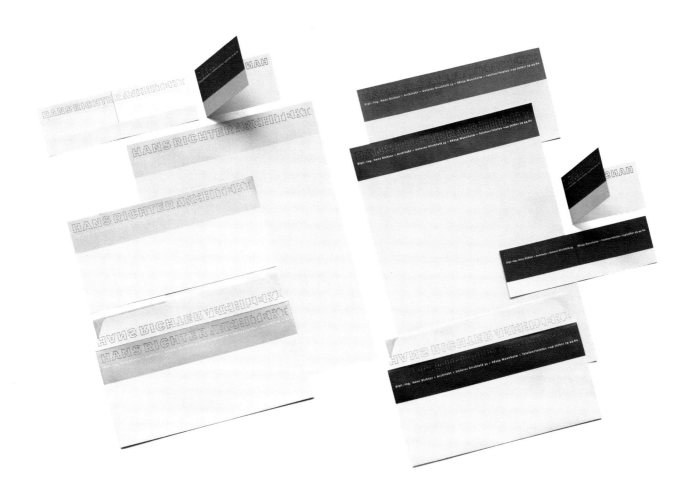

**DESIGN** Armin Lindauer *Mannheim, Germany*

**LETTERING** Armin Lindauer

**STUDIO** Armin Lindauer

**CLIENT** Hans Richter

**PRINCIPAL TYPE** Akzidenz Grotesk BQ-Super,
Thesis Mix 8, and handlettering

**DIMENSIONS** Various

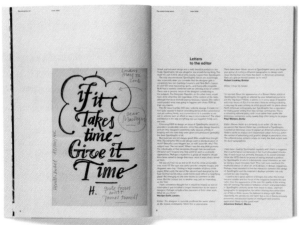

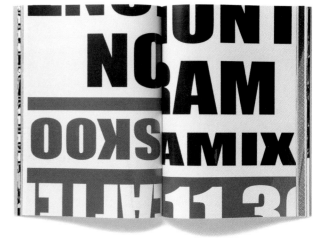

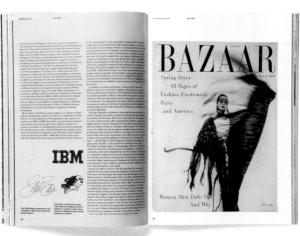

**DESIGN** Paul Belford and David Jury
*London, England*

**DESIGN OFFICE** This is Real Art

**CLIENT** International Society of Typographic Designers

**PRINCIPAL TYPE** Akzidenz Grotesk

**DIMENSIONS** 8.3 x 11.7 in. (21 x 29.7 cm)

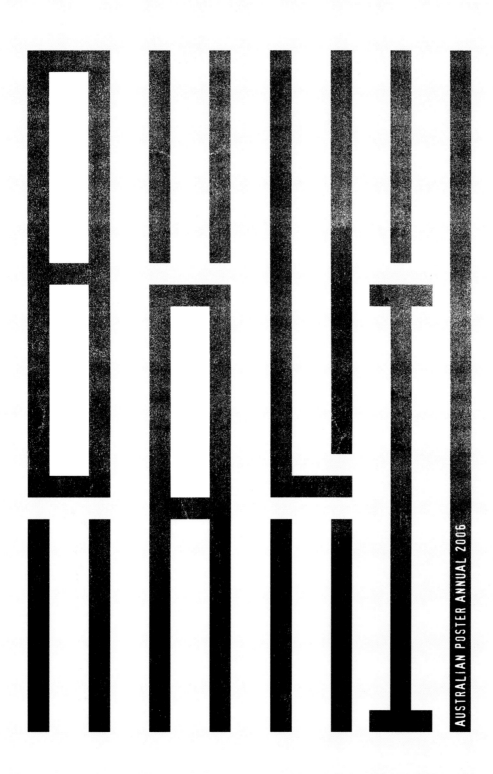

AUSTRALIAN POSTER ANNUAL 2006

**DESIGN** Glenn Kynnersley *Richmond, Australia*

**ART DIRECTION** Glenn Kynnersley

**CREATIVE DIRECTION** Glenn Kynnersley

**LETTERING** Glenn Kynnersley

**DESIGN OFFICE** Blenheim Design Partners

**CLIENT** National Design Centre

**PRINCIPAL TYPE** Handlettering

**DIMENSIONS** 33.1 x 46.8 in. (84.1 x 118.9 cm)

**POSTER** 177

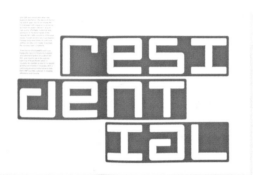

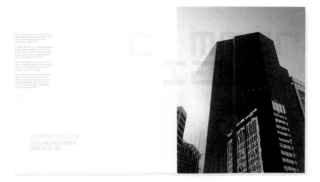

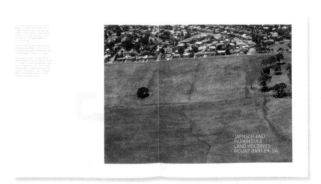

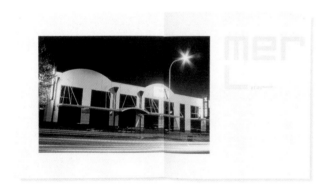

**178**    **BROCHURE**

**DESIGN** Anthony Deleo *Adelaide, Australia*

**ART DIRECTION** Anthony Deleo and Scott Carslake

**CREATIVE DIRECTION** Anthony Deleo

**PHOTOGRAPHY** Toby Richardson

**DESIGN OFFICE** Voice

**CLIENT** Daycorp Pty. Ltd.

**PRINCIPAL TYPE** Daycorp Display and Interstate

**DIMENSIONS** 9.9 x 10.6 in. (25.2 x 26.9 cm)

**FH.**

Freelance Hotline

K. (A)

Freelance Hotline / Hohenzollernstraße 81 / 80796 München

1/3

(F M)

---

**FH.**

Freelance Hotline

W.          K.

**www.freelancehotline.com**     Hohenzollernstraße 81 / 80796 München
Tel.: 089 . 65 28 34 / Fax: 089 . 65 20 74

mail@freelancehotline.com

Freelance Hotline GmbH
Geschäftsführer:
Hans-Jürgen Staudt
Amtsgericht München
HRB. 131 196

---

**FH.**

Freelance Hotline

N.          K.

**Hans-Jürgen Staudt**     Tel.: 089 . 65 28 34

staudt@freelancehotline.com
www.freelancehotline.com

---

**FH.**

Freelance Hotline

W.          K.

**www.freelancehotline.com**     Hohenzollernstraße 81 / 80796 München
Tel.: 089 . 65 28 34 / Fax: 089 . 65 20 74

mail@freelancehotline.com

Freelance Hotline GmbH
Geschäftsführer:
Hans-Jürgen Staudt
Amtsgericht München
HRB. 131 196

Rechnungsnummer          Honorar

Zeitraum          Umfang / Dauer

Nettohonorar
zzgl.     MwSt.

Bruttohonorar

Provision (          des Nettohonorars)
zzgl.     MwSt.

Bruttoprovision

4/4

Rechnungsendbetrag

Der Betrag wurde auf Ihr Konto überwiesen:

Kontonummer          BLZ          Betrag

Vielen Dank für die Zusammenarbeit!

---

**DESIGN** Carolin Sommer and Patrick Vallée
*Munich, Germany*

**DESIGN OFFICE** Sommer Vallée u. Partner

**CLIENT** Freelance Hotline GmbH

**PRINCIPAL TYPE** Helvetica Neue

**DIMENSIONS** Various

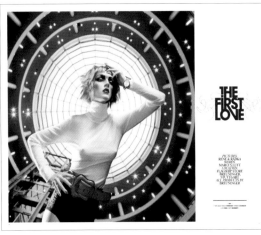

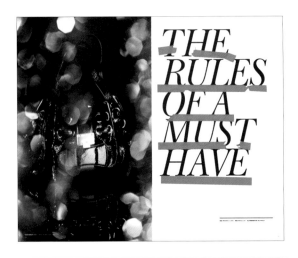

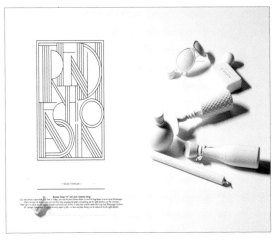

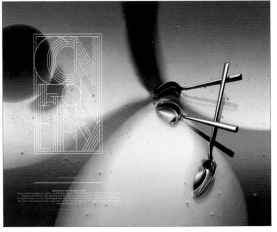

**DESIGN** Eva Bergauer, Steffen Granz, Julia Guther, and Alexandra Lucatello *Hamburg, Germany*

**ART DIRECTION** Paul Neulinger

**CREATIVE DIRECTION** Johannes Plass

**DESIGN OFFICE** Mutabor Design GmbH

**CLIENT** E. Breuninger GmbH & Co.

**PRINCIPAL TYPE** ITC Avant Garde and ITC New Baskerville

**DIMENSIONS** 11 x 15.8 in. (28 x 40.2 cm)

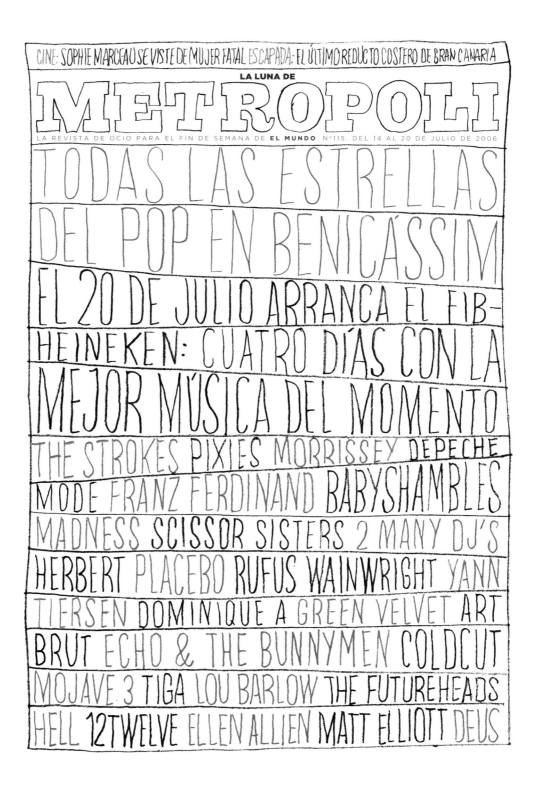

**DESIGN** Rodrigo Sánchez *Madrid, Spain*

**ART DIRECTION** Rodrigo Sánchez

**CREATIVE DIRECTION** Carmelo Caderot

**CALLIGRAPHY** Rodrigo Sánchez

**PUBLICATION** El Mundo, Unidad Editorial S.A.

**PRINCIPAL TYPE** Handlettering

**DIMENSIONS** 7.9 x 11.2 in. (20 x 28.5 cm)

**MAGAZINE
COVER**

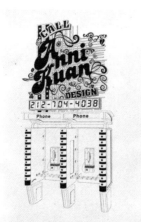
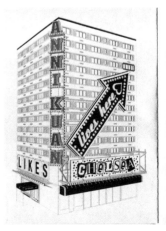
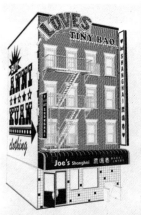

**DESIGN** Stephan Walter *Zurich, Switzerland*

**CREATIVE DIRECTION** Stefan Sagmeister
*New York, NY*

**LETTERING** Stephan Walter

**DESIGN OFFICE** Sagmeister Inc.

**CLIENT** Anni Kuan Design

**PRINCIPAL TYPE** Handlettering

**DIMENSIONS** 16 x 23 in. (40.6 x 58.4 cm)

**DESIGN** Gail Bichler *New York, NY*

**LETTERING** Darren Booth *Ste. Anne De Bellevue, Canada*

**CLIENT** The New York Times Magazine

**PRINCIPAL TYPE** Handlettering

**DIMENSIONS** 8.5 x 11 in. (21.6 x 27.9 cm)

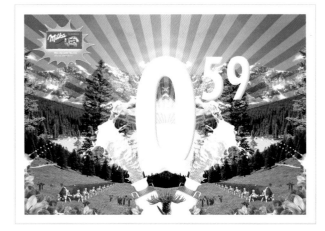

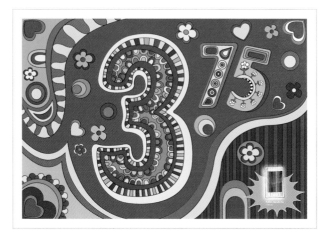

184    **ADVERTISING**

**DESIGN** Simon Huke *Frankfurt, Germany*

**ART DIRECTION** Simon Huke

**CREATIVE DIRECTION** Helmut Himmler

**CALLIGRAPHY** Simon Huke

**AGENCY** Ogilvy Frankfurt

**CLIENT** Globus SB Warenhaus, Germany

**PRINCIPAL TYPE** Futura Bold Condensed

**DIMENSIONS** Various

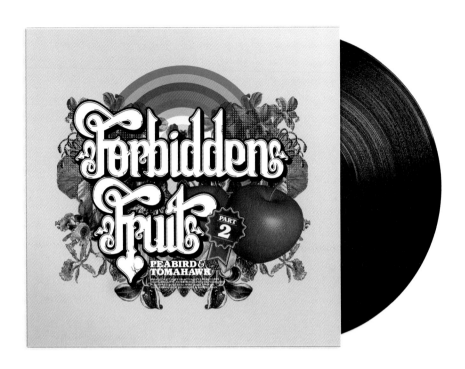

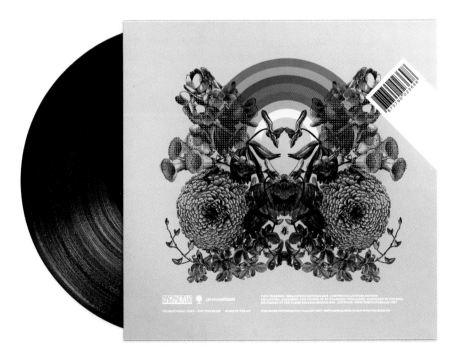

ART DIRECTION Clemens Baldermann
*Munich, Germany*

LETTERING Clemens Baldermann

STUDIO The Purple Haze

CLIENT Sellwell Records

PRINCIPAL TYPE BT Cooper and handlettering

DIMENSIONS 12.4 x 12.4 in. (31.5 x 31.5 cm)

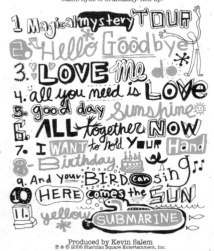

Come along on a magically mysterious tour of The Beatles' world, with poems and
Beatles facts for everyone, illustrated and sung by kids, with a little
help from their friends Rachael Yamagata, Marshall Crenshaw, The Bangles and
Jason Lytle of Grandaddy. Roll up!

1 Magical mystery TOUR
2. Hello Goodbye
3. LOVE Me do
4. all you need is LOVE
5. good day sunshine
6. ALL together NOW
7. I WANT to hold Your Hand
8. Birthday
9. And Your BIRD can sing
10 HERE comes the SUN
11. yellow SUBMARINE

Produced by Kevin Salem
℗ & © 2006 Sheridan Square Entertainment, Inc.

ISBN 1-4243-1410-0

All Together NOW
BEATLES Stuff for Kids of all ages

All Together NOW
BEATLES Stuff for Kids Of all Ages
A Magically Mysterious Story Book and 11 Song CD

**ART DIRECTION** David Calderley, V2 Records
*New York, NY*

**LETTERING** Nate Williams, Magnet Reps
*Blaine, WA*

**ILLUSTRATION** Nate Williams, Magnet Reps

**CLIENT** Little Monster Records

**PRINCIPAL TYPE** ITC American Typewriter and
handlettering

**DIMENSIONS** 5.5 x 5.5 in. (14 x 14 cm)

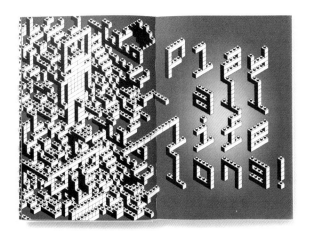

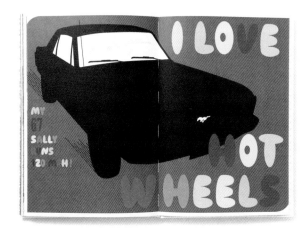

**DESIGN** Markus Koll *Hamburg, Germany*

**PROFESSORS** Manfred Vogel and
Peter Wippermann

**SCHOOL** University of Duisburg, Essen

**PRINCIPAL TYPE** Filosofia and Bello

**DIMENSIONS** 7.7 x 11 in. (19.5 x 28 cm)

Lawyers solve problems.

CVLS was an ingenious solution to a pervasive problem.

4

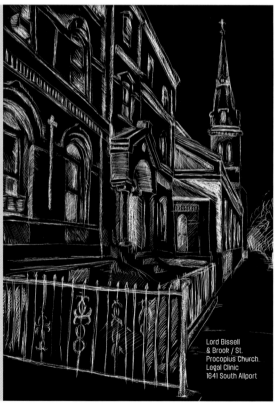

Lord Bissell
& Brook / St.
Procopius Church
Legal Clinic
1641 South Allport

**ANNUAL REPORT**

**DESIGN** Tim Bruce *Chicago, IL*

**CREATIVE DIRECTION** Tim Bruce

**LETTERING** Tim Bruce

**PHOTOGRAPHY** Tony Armour

**DESIGN OFFICE** Lowercase Inc.

**CLIENT** Chicago Volunteer Legal Services

**PRINCIPAL TYPE** Elephant and handlettering

**DIMENSIONS** 4.5 x 6.25 in. (11.4 x 15.9 cm)

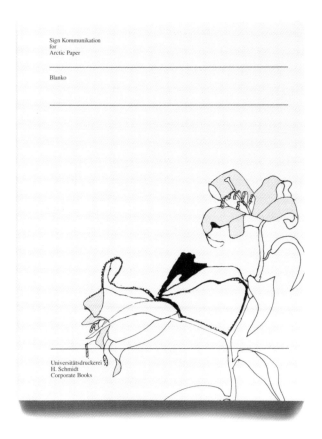

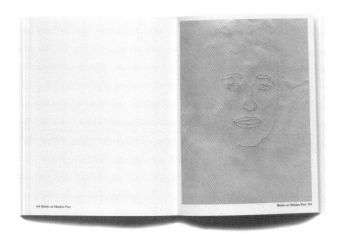

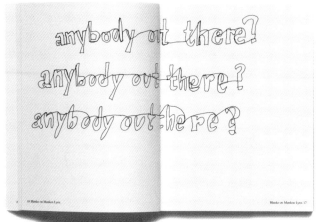

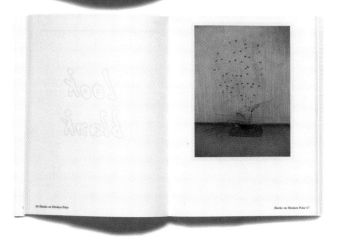

DESIGN Antonia Henschel, Karl N. Henschel,
Jörn Hofmann, and Martin Kaufmann
*Frankfurt, Germany*

ART DIRECTION Antonia Henschel

CREATIVE DIRECTION Antonia Henschel

LETTERING Antonia Henschel

PHOTOGRAPHY Kiril Golovchenko *Mainz, Germany*

AGENCY Sign Kommunikation GmbH

CLIENT Arctic Paper Deutschland

PRINCIPAL TYPE Times and handlettering

DIMENSIONS 7.9x 10.2 in. (20 x 26 cm)

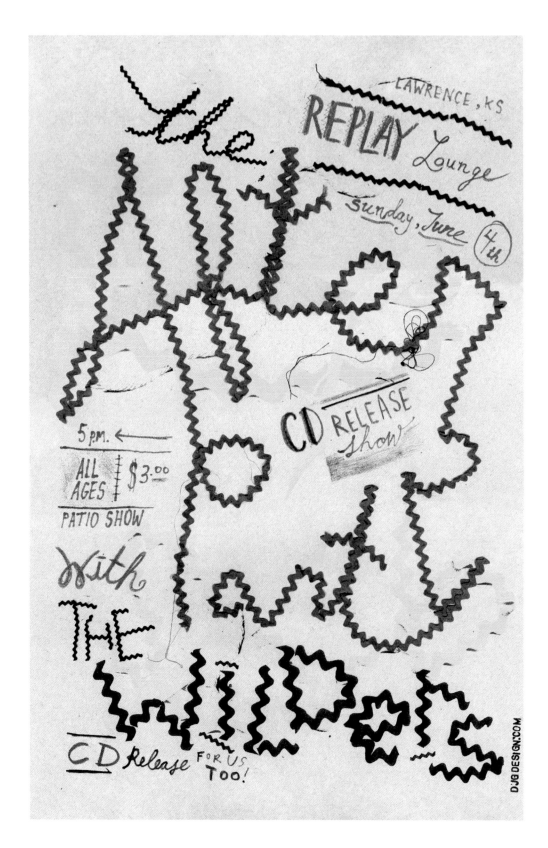

190 **POSTER**

**DESIGN** Danny J. Gibson *Kansas City, MO*

**ART DIRECTION** Danny J. Gibson

**CREATIVE DIRECTION** Danny J. Gibson

**LETTERING** Danny J. Gibson

**COPYWRITING** Amie Nelson and Danny J. Gibson

**DESIGN OFFICE** DJG Design

**CLIENT** Amie Nelson, The Afterparty

**PRINCIPAL TYPE** Handlettering

**DIMENSIONS** 12 x 18 in. (30.5 x 45.7 cm)

¹if *(conj)*

iiif|

DESIGN Michael Darmanin and Ian Freman
*New York, NY*

CREATIVE DIRECTION Jakob Trollbäck and
Joe Wright

LETTERING Michael Darmanin and Ian Freman

PRODUCERS Marisa Fiechter and
Melissa August-Levin

STUDIO Trollbäck & Company

CLIENT MetLife and Foote, Cone & Belding

PRINCIPAL TYPE Handlettering

TELEVISION   191
COMMERCIAL

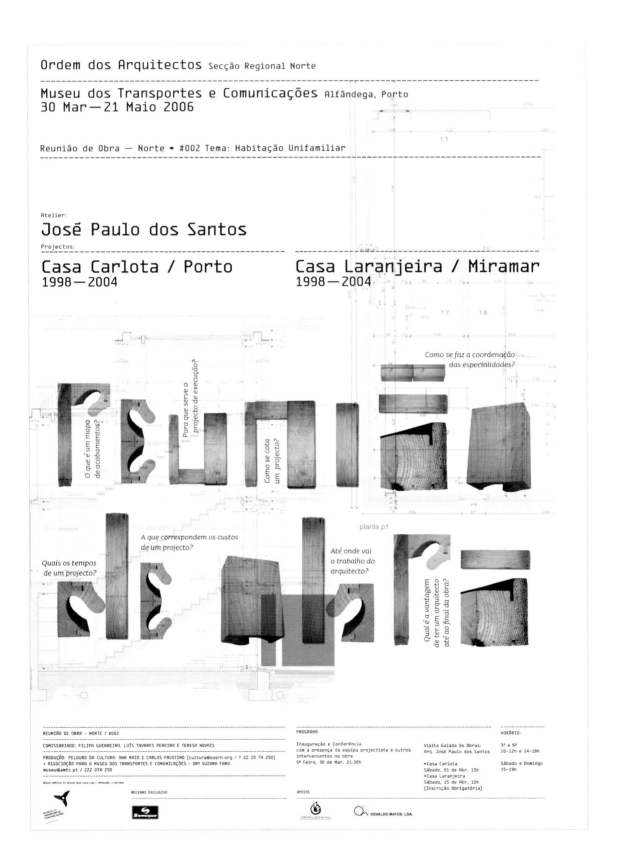

**DESIGN** Liliana Pinto, Lizá Defossez Ramalho, and Artur Rebelo *Porto, Portugal*

**ART DIRECTION** Lizá Defossez Ramalho and Artur Rebelo

**CREATIVE DIRECTION** Lizá Defossez Ramalho and Artur Rebelo

**STUDIO** R2 Design

**CLIENT** Ordem dos Arquitectos Secção Regional Norte

**PRINCIPAL TYPE** Bs Monofaked, Lettering Reunião de Obra No2, and Sauna

**DIMENSIONS** 47.2  x 70.9 in. (120 x 180 cm)

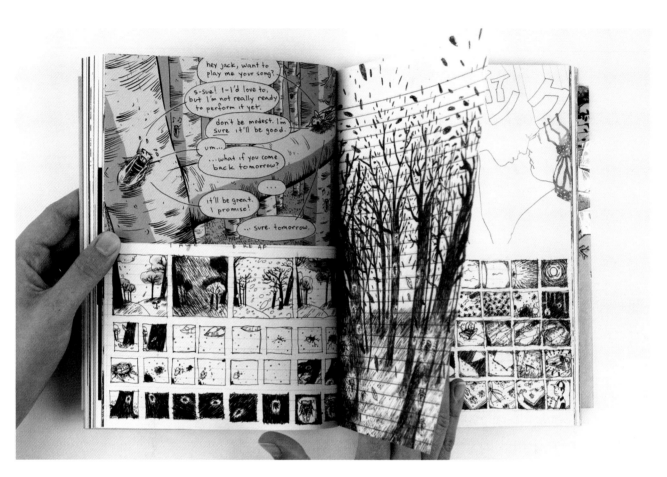

**ART DIRECTION** Zareen Ali-Khan, Ara Devejian, Jen Kraemer Montgomery, Tiffany Powell, Stephen Serrato, and Will Wright *Pasadena, CA*

**ASSOCIATE DESIGNERS** So Yung An, Matthew Boyd, Henry Chen, Cheri Chung, Lucy Devins, Jason Fryer, Agata Gotfryd, Sharon Hsieh, Cindy Hu, Ayumi Ito, River Jukes-Hudson, Saphierrina Moellias, Kunio Ogo, Oak Son, Darryl Suoninen, Hovin Wang, and Rob Zamboni

**PHOTOGRAPHY AND ILLUSTRATION** Mari Araki, Jen Berger, Sue Blanchard, Matt Boyd, Josh Cochran, Heather Culp, Jay Dominy, Ross Everton, Carolyn Fong, Gary Garay, Agata Gotfryd, Claire Harlan, Jessica Haye, Clark Hsiao, Nathan Huang, River Jukes-Hudson, Brooke Kent, Mimi Ko, Kristen Kong, Youshi Li, Fei Lu, Kun Che Lu, Jacob McGraw-Mickelson,

Alexa Miller, Andrea Offermann, Zachary Rossman, Brian Rush, Gretchen Ryan, Stephen Serrato, Oak Son, Charchi Stinson, Carlos Tarrats, Katrina Umber, Hovin Wang, and Will Wright

**PHOTO EDITOR** Jessica Haye

**INSTRUCTORS** Sean Dungan, James Fish, Jason Holley, Lisa Wagner, and Benjamin Weissman

**SCHOOL** Art Center College of Design

**PRINCIPAL TYPE** Bickham Script, Egyptienne 55, Minion, and Trade Gothic

**DIMENSIONS** Book: 6.6 x 9.6 in. (16.8 x 24.4 cm) Poster: 25.5 x 39 in. (64.8 x 99.1 cm)

**STUDENT PROJECT** 193

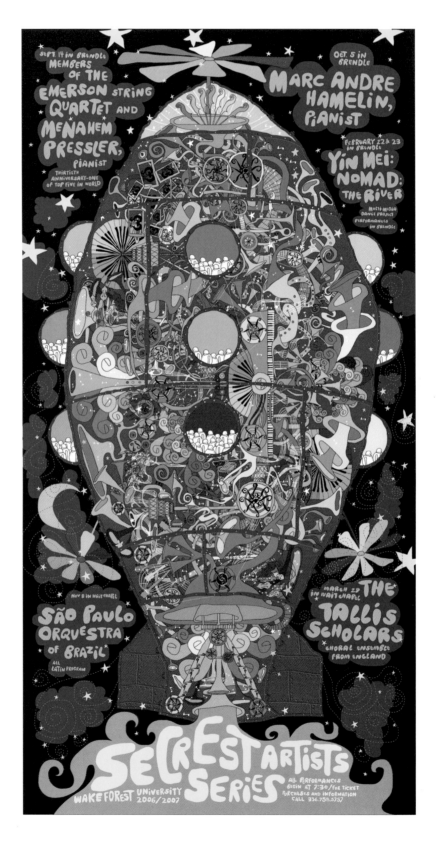

194 **POSTER**

**DESIGN** Billington Q. Hackley IV
*Winston-Salem, NC*

**ART DIRECTION** Hayes Henderson

**LETTERING** Billington Q. Hackley IV

**DESIGN OFFICE** HENDERSONBROMSTEADART

**CLIENT** Secrest Artists Series, Wake Forest University

**PRINCIPAL TYPE** Handlettering

**DIMENSIONS** 16.5 x 32.5 in. (41.9 x 82.6 cm)

**DESIGN** Brent Piper *Winston-Salem, NC*

**ART DIRECTION** Brent Piper

**CREATIVE DIRECTION** Hayes Henderson

**LETTERING** Brent Piper

**DESIGN OFFICE** HENDERSONBROMSTEADART

**CLIENT** Downtown Arts District Association (DADA)

**PRINCIPAL TYPE** Handlettering

**DIMENSIONS** 16.5 x 25.5 in. (41.9 x 64.8 cm)

**POSTER** 195

196    **POSTER**

**DESIGN** Marc Cozza *Portland, OR*

**ART DIRECTION** Marc Cozza

**CREATIVE DIRECTION** Marc Cozza

**ILLUSTRATION** Howell Golson

**STUDIO** Sandstrom Design

**CLIENT** Portland Center Stage

**PRINCIPAL TYPE** HTF Knockout Welterweight and HTF Knockout Full Welterweight

**DIMENSIONS** 11 x 17 in. (27.9 x 43.2 cm)

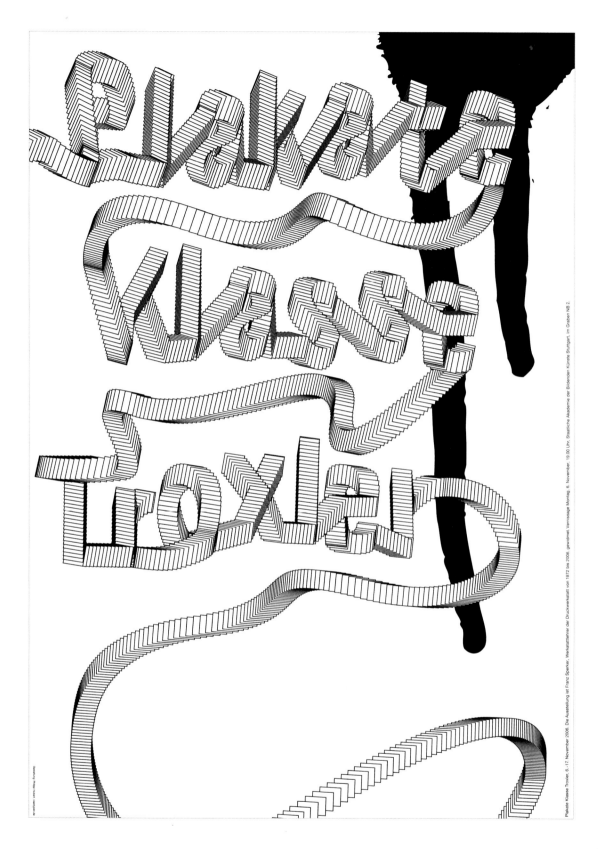

**DESIGN** Philipp Hubert *Stuttgart, Germany*

**PROFESSOR** Niklaus Troxler

**SCHOOL** Staatliche Akademie der Bildenden Künste Stuttgart

**PRINCIPAL TYPE** Custom

**DIMENSIONS** 23.4 x 33.1 in. (59.4 x 84.1 cm)

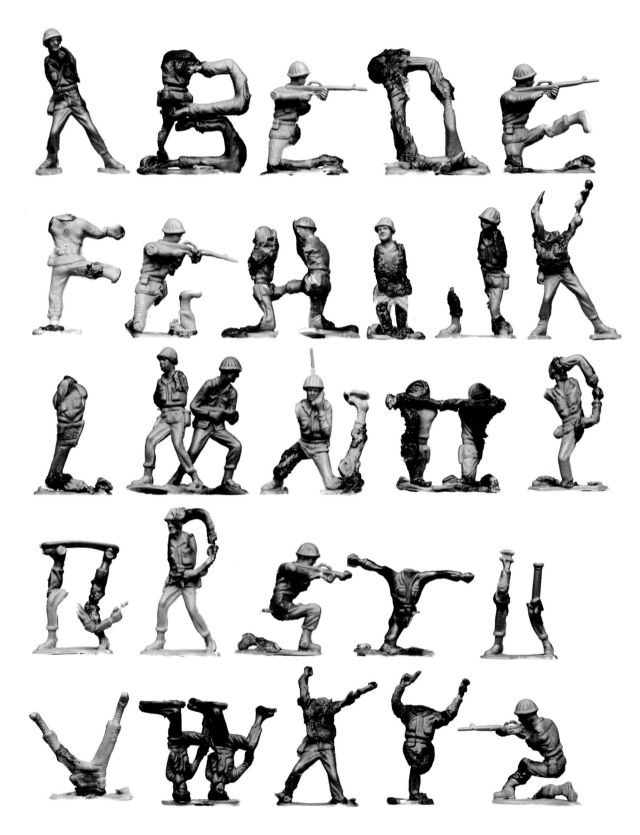

198 **STUDENT PROJECT**

**DESIGN** Oliver Munday *Baltimore, MD*

**INSTRUCTORS** Bruce Willen and Nolen Strals

**SCHOOL** Maryland Institute College of Art

**PRINCIPAL TYPE** Custom

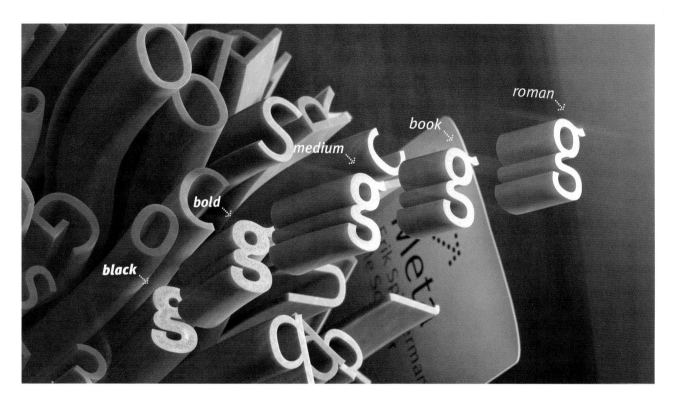

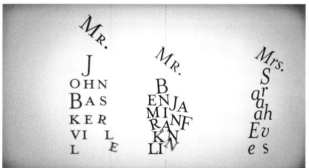  

**DESIGN** Arne Brennecke, Nazgol Emami, Sebastian Gimmel, Yasemin Heimann, Johanna May, Sandra Prescher, Miriam Valentini, and Tobias Wienholt *Wuppertal, Germany*

**ART DIRECTION** Arne Brennecke, Nazgol Emami, Sebastian Gimmel, Yasemin Heimann, Johanna May, Sandra Prescher, Miriam Valentini, and Tobias Wienholt

**PROFESSOR** Ralf Lobeck

**EXAMINERS** Professors Heribert Birnbach and Ralf Lobeck

**SCHOOL** Bergische Universitaet Wuppertal

**WEBSITE** www.ralflobeck.de

**PRINCIPAL TYPE** Various

Der Rektor der Hochschule Mannheim und der Präsident des Vereins
der Freunde laden Sie hiermit herzlich ein zum Hochschultag 2006
der Hochschule Mannheim, Montag, den 20. November 2006, 16 Uhr
Gebäude 13, Mensa

Begrüßung: Prof. Dr. h.c. Dietmar von Hoyningen-Huene, Rektor
Musik: Quartett des Kurpfälzischen Kammerorchesters
Preisverleihung an Absolventen und Studierende der Hochschule
Mannheim

Ehrungen

**DESIGN** Armin Lindauer *Mannheim, Germany*

**LETTERING** Armin Lindauer

**STUDIO** Armin Lindauer

**CLIENT** Hochschule Mannheim

**PRINCIPAL TYPE** Frutiger and Impact (modified)

**DIMENSIONS** 23.4 x 33.1 in. (59.4 x 84.1 cm)

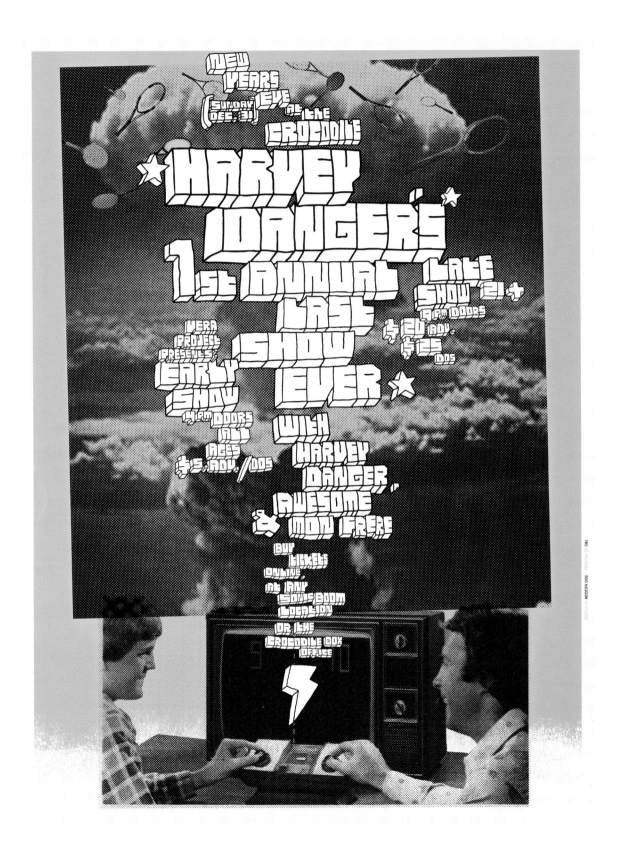

**DESIGN** Robert Zwiebel *Seattle, WA*

**ART DIRECTION** Robert Zwiebel

**LETTERING** Robert Zwiebel

**STUDIO** Modern Dog Design Co.

**CLIENT** The Crocodile Cafe

**PRINCIPAL TYPE** Handlettering

**DIMENSIONS** 18 x 24 in. (45.7 x 61 cm)

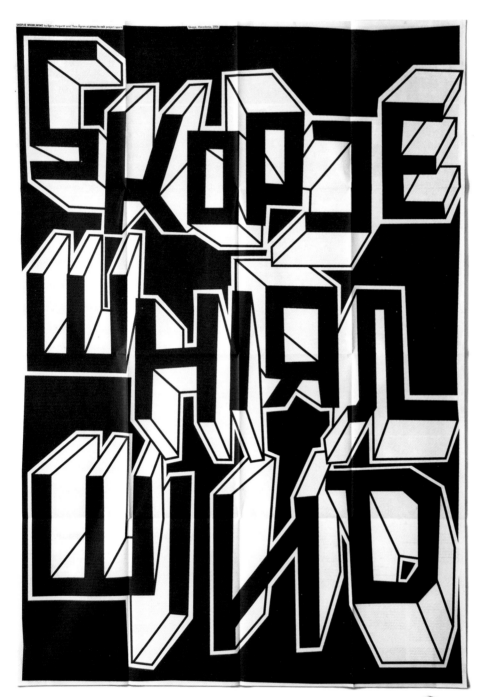

**POSTER**

**DESIGN** Ariane Spanier *Berlin, Germany*

**ART DIRECTION** Ariane Spanier

**STUDIO** Ariane Spanier Graphic Design

**CLIENT** press to exit project space,
Skopje, Macedonia

**PRINCIPAL TYPE** Custom

**DIMENSIONS** 27.6 x 39.4 in. (70 x 100 cm)

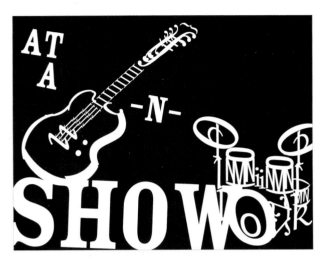

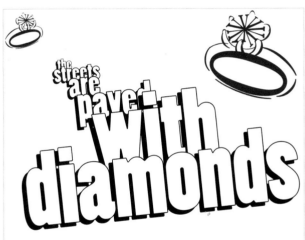

**DESIGN** Joshua Hester *Brooklyn, NY*

**COMPOSERS** They Might Be Giants and Cub
*Brooklyn, NY,* and *Vancouver, Canada*

**INSTRUCTOR** Gail Anderson

**SCHOOL** School of Visual Arts

**PRINCIPAL TYPE** Adobe Caslon Pro, ITC Franklin Gothic,
Giddyup, and Motter Corpus

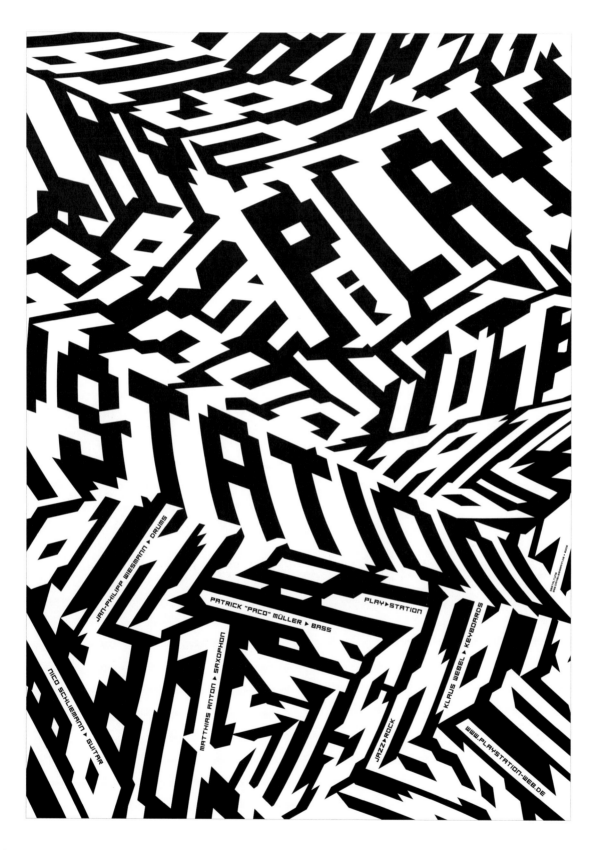

204 **STUDENT PROJECT**

**DESIGN** Daniel Wiesmann *Stuttgart, Germany*

**LETTERING** Daniel Wiesmann

**PROFESSORS** Niklaus Troxler and Gerwin Schmidt

**SCHOOL** Staatliche Akademie der Bildenden Künste Stuttgart

**CLIENT** Playstation, Patrick S. Mueller

**PRINCIPAL TYPE** Poca Regular and handlettering

**DIMENSIONS** 23.4 x 33.1 in. (59.4 x 84.1 cm)

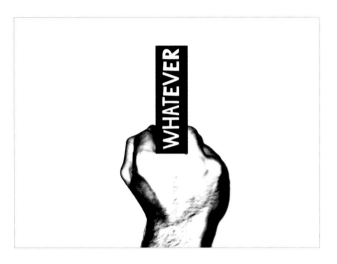

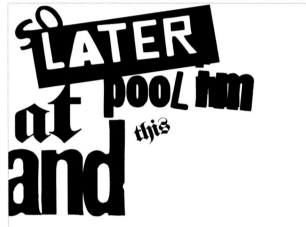

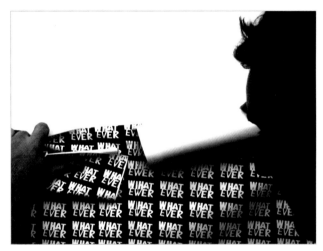

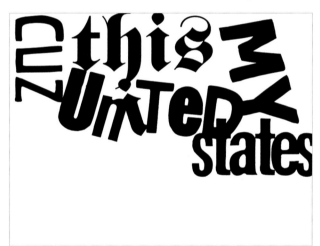

**DESIGN** Michael D. Roma *New York, NY*

**COMPOSER** Liam Lynch

**INSTRUCTOR** Gail Anderson

**SCHOOL** School of Visual Arts

**PRINCIPLE TYPE** Archive Tinted, Palace Script, Pintor, and Toronto Gothic

**STUDENT PROJECT** 205

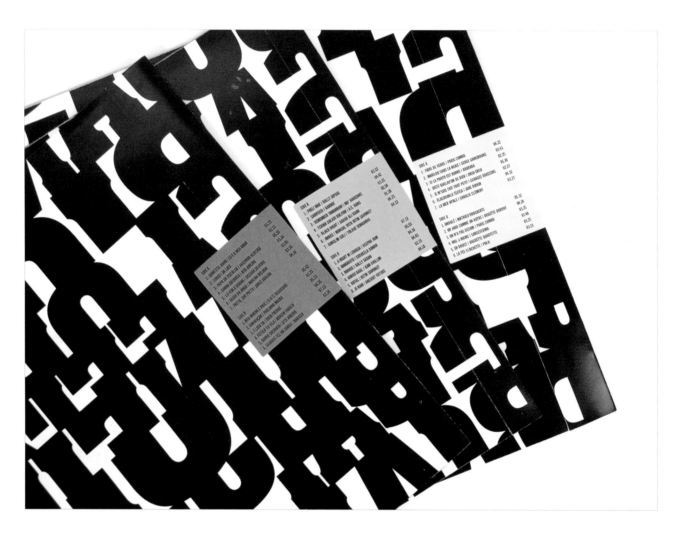

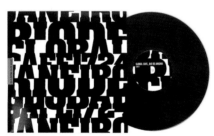 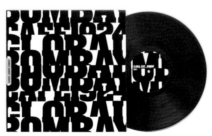 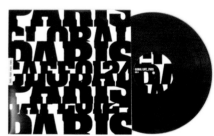

**STUDENT PROJECT**

**DESIGN** Jiyoon Lee *New York, NY*

**INSTRUCTOR** Mike Joyce

**SCHOOL** School of Visual Arts

**PRINCIPAL TYPE** Aachen Bold and Franklin Gothic

**DIMENSIONS** 12 x 12 in. (30.5 x 30.5 cm)

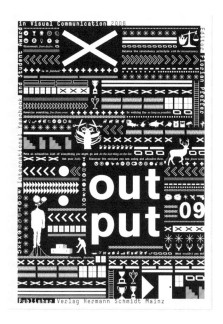

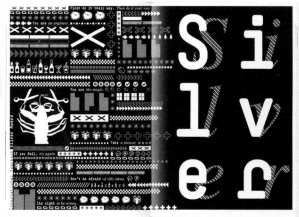

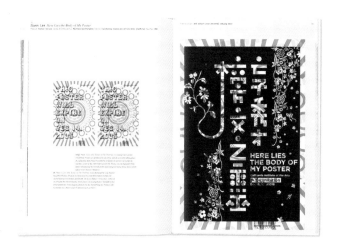

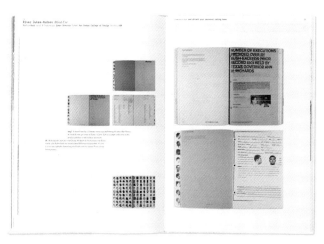

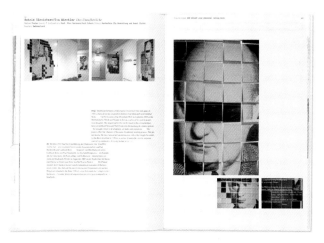

**DESIGN** Andrea C. Schaffors *Bremen, Germany*

**ART DIRECTION** Florian Pfeffer

**CREATIVE DIRECTION** Florian Pfeffer

**DESIGN OFFICE** jung und pfeffer: visuelle kommunikation

**CLIENT** :output foundation, Amsterdam

**PRINCIPAL TYPE** Simple and Times

**DIMENSIONS** 9.1 x 13 in. (23 x 33 cm)

**STUDENT PROJECT**

**DESIGN** Daniel Wiesmann *Stuttgart, Germany*

**PROFESSORS** Niklaus Troxler and Uli Cluss

**SCHOOL** Staatliche Akademie der Bildenden Künste Stuttgart

**PRINCIPAL TYPE** Monotype Grotesque

**DIMENSIONS** 16.5 x 23.4 in. (42 x 59.4 cm)

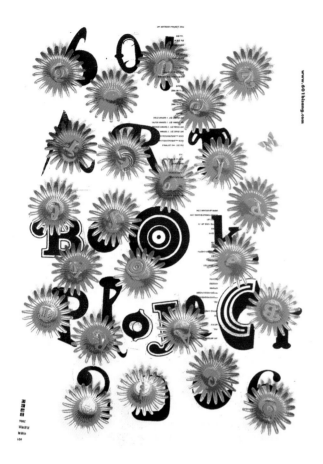

**DESIGN** Park Kum-jun and You Na-won
*Seoul, Korea*

**ART DIRECTION** Park Kum-jun

**CREATIVE DIRECTION** Park Kum-jun

**PHOTOGRAPHY** Jang Suk-joon

**COORDINATION** Jung Jong-in

**AGENCY** 601bisang

**PRINCIPAL TYPE** DIN Bold and FuturTBold

**DIMENSIONS** 30.6 x 43 in. (77.8 x 109.3 cm)

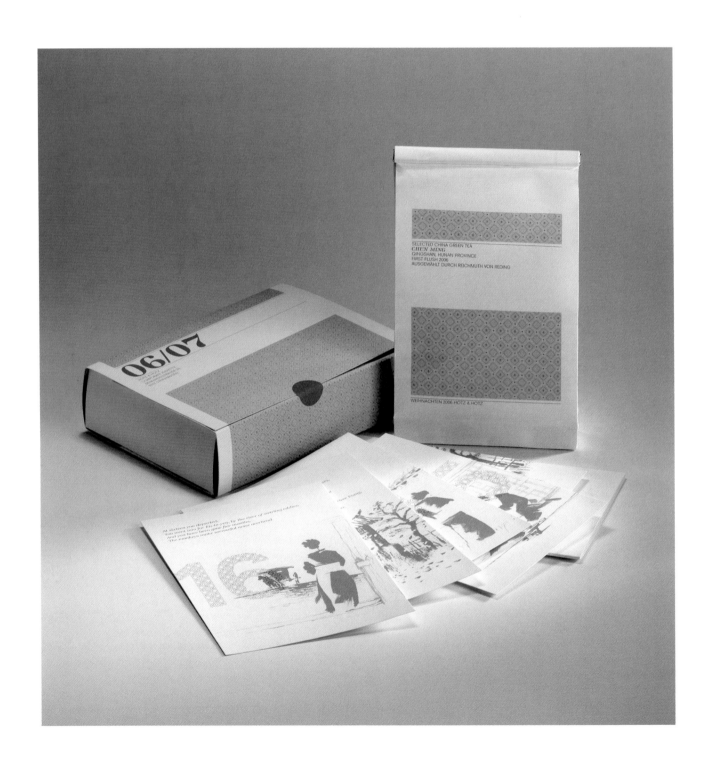

210 **SELF-PROMOTION**

**DESIGN** Roman Imhof *Steinhausen, Switzerland*

**ART DIRECTION** Roman Imhof

**ILLUSTRATION** Herbert Seybold

**AGENCY** Hotz & Hotz

**PRINCIPAL TYPE** ITC Zapf International and Neuzeit Semi Book

**DIMENSIONS** 6.3 x 4.6 x 1.5 in. (16 x 11.6 x 3.8 cm)

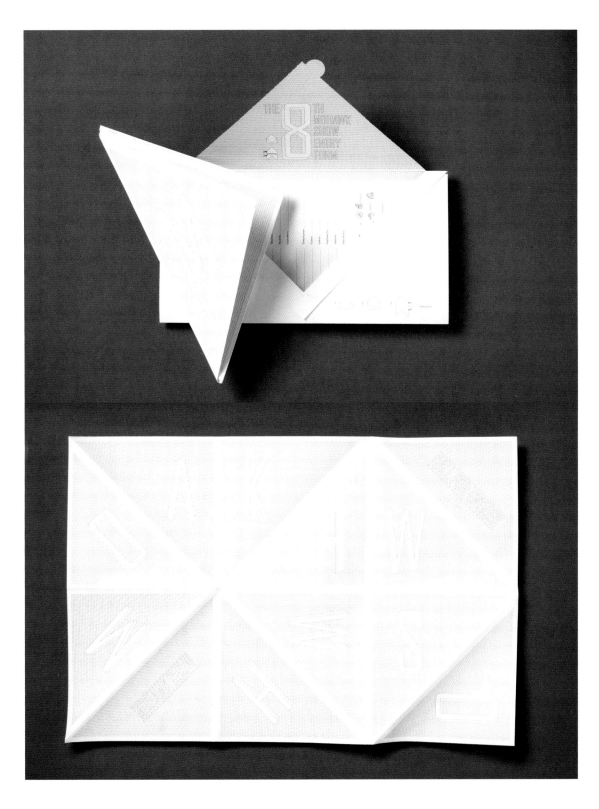

**DESIGN** Paula Scher and Julia Hoffmann
*New York, NY*

**ART DIRECTION** Paula Scher

**DESIGN OFFICE** Pentagram Design Inc.

**CLIENT** Mohawk Fine Papers

**PRINCIPAL TYPE** FB Agency and Nobel

**DIMENSIONS** 11.5 x 6 in. (29.2 x 15.2 cm)

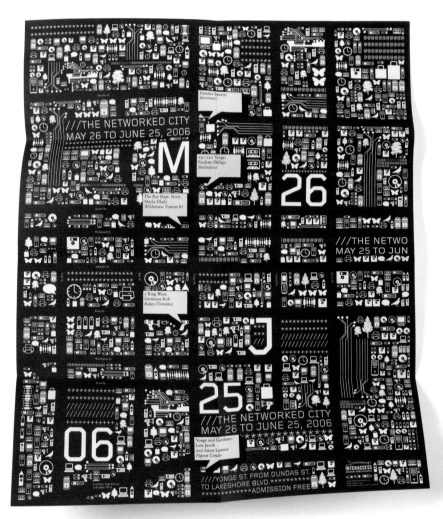

212 **BROCHURE**

**DESIGN** Fidel Peña and Claire Dawson
*Toronto, Canada*

**ART DIRECTION** Fidel Peña and Claire Dawson

**CREATIVE DIRECTION** Fidel Peña and Claire Dawson

**DESIGN OFFICE** Underline Studio

**CLIENT** InterAccess Electronic Media Arts Centre

**PRINCIPAL TYPE** Sabon and Foundry Gridnik

**DIMENSIONS** Folded: 5 x 8 in. (12.7 x 20.3 cm)
Flat: 16 x 19.75 in. (40.6 x 50.2 cm)

**DESIGN** Catelijne van Middelkoop and
Ryan Pescatore Frisk *The Hague, The Netherlands*

**ART DIRECTION** Catelijne van Middelkoop and
Ryan Pescatore Frisk

**CREATIVE DIRECTION** Catelijne van Middelkoop
and Ryan Pescatore Frisk

**STUDIO** Strange Attractors Design

**CLIENT** De Lloods

**PRINCIPAL TYPE** 2nd Row

**DIMENSIONS** Various

**DESIGN** Ian Warner *Berlin, Germany*

**ART DIRECTION** Ian Warner

**CREATIVE DIRECTION** Ian Warner

**DESIGN OFFICE** blotto design

**CLIENT** Eichborn Berlin

**PRINCIPAL TYPE** FF Bau, Berliner Grotesk, Dolly, Nobel, Serapion Pro, Tribute, and Van Dijck

**DIMENSIONS** 5.4 x 8.5 in. (13.7 x 21.5 cm)

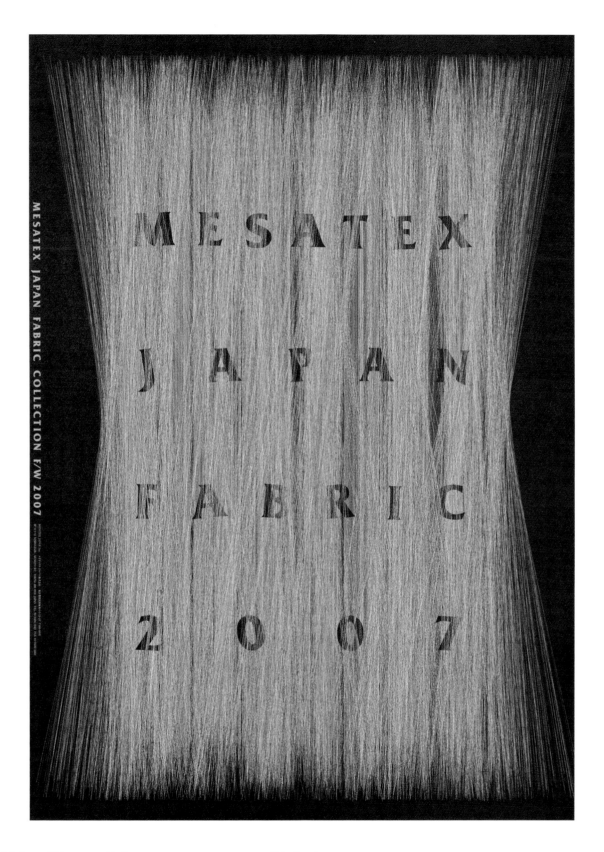

**DESIGN** Ohsugi Gaku and Matsumura Yuriko
*Tokyo, Japan*

**ART DIRECTION** Ohsugi Gaku

**DESIGN OFFICE** 702 Design Works, Inc.

**CLIENT** MESATEX JAPAN Inc.

**PRINCIPAL TYPE** Friz Quadrata

**DIMENSIONS** 28.7 x 40.6 in. (72.8 x 103 cm)

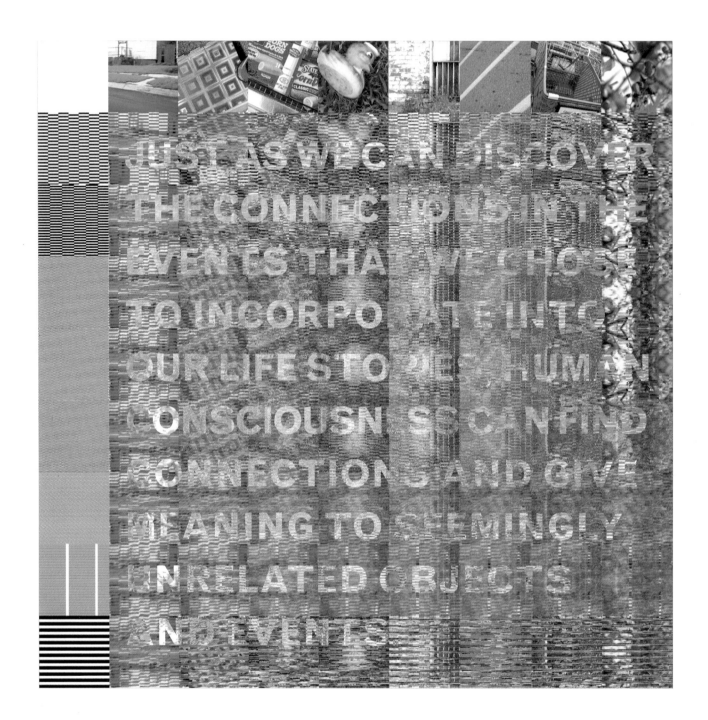

JUST AS WE CAN DISCOVER THE CONNECTIONS IN THE EVENTS THAT WE CHOSE TO INCORPORATE INTO OUR LIFE STORIES, HUMAN CONSCIOUSNESS CAN FIND CONNECTIONS AND GIVE MEANING TO SEEMINGLY UNRELATED OBJECTS AND EVENTS

**STUDENT PROJECT**

**DESIGN** Jessica Sheeran *Detroit, MI*

**INSTRUCTOR** Doug Kisor

**SCHOOL** College for Creative Studies

**PRINCIPAL TYPE** Monotype Grotesque

**DIMENSIONS** 55 x 55 in. (139.7 x 139.7 cm)

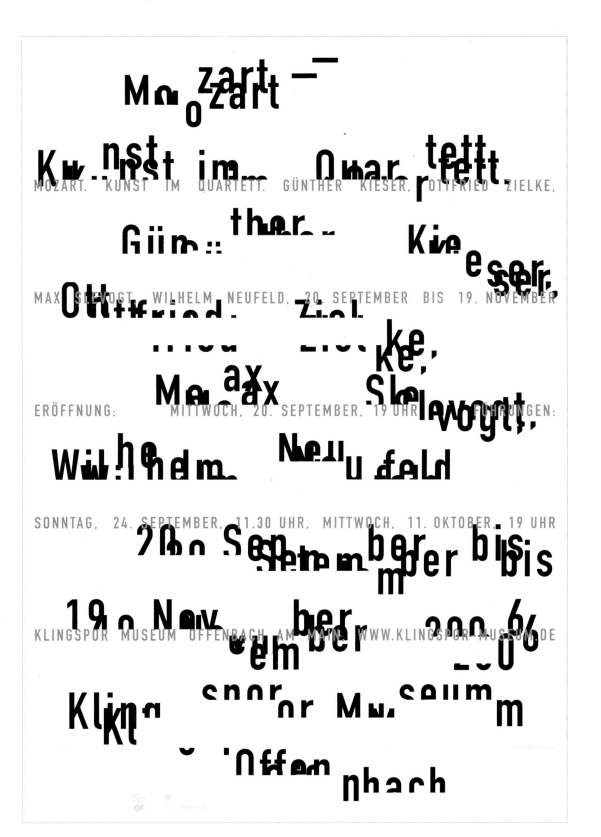

**DESIGN** Uwe Loesch *Erkrath, Germany*

**DESIGN STUDIO** Uwe Loesch

**CLIENT** Klingspor Museum Offenbach am Main

**PRINCIPAL TYPE** DIN Eng

**DIMENSIONS** 23.4 x 33.1 in. (59.4 x 84 cm)

**DESIGN** Zempaku Suzuki and Yoshihiro Sugimoto
*Tokyo, Japan*

**ART DIRECTION** Zempaku Suzuki

**LETTERING** Zempaku Suzuki

**COPYWRITING** Shinobu Matsuzuka *Tokyo, Japan*,
and Nob Ogasawara *Port Moody, Canada*

**STUDIO** BBI Studio Inc.

**CLIENT** Tenth International Triennial of the Political
Poster Show

**PRINCIPAL TYPE** Handlettering

**DIMENSIONS** 28.7 x 40.6 in. (72.8 x 103 cm)

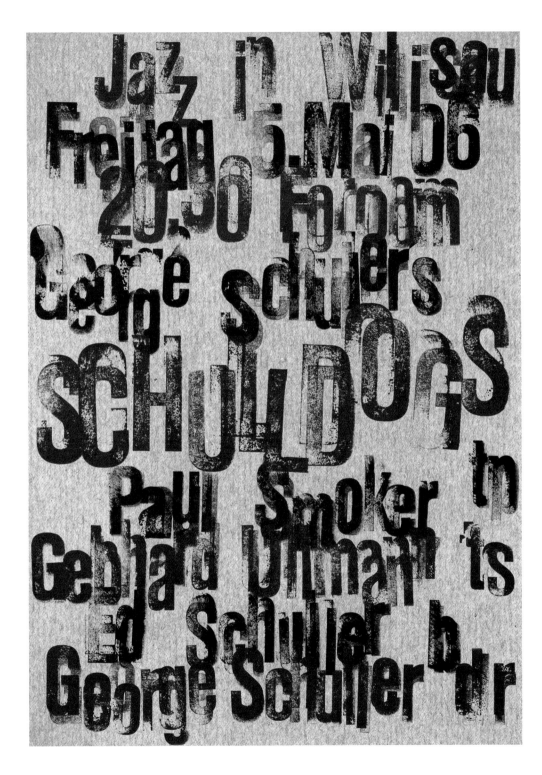

**DESIGN** Niklaus Troxler *Willisau, Switzerland*

**CREATIVE DIRECTION** Niklaus Troxler

**LETTERING** Niklaus Troxler

**STUDIO** Niklaus Troxler Design

**CLIENT** Jazz in Willisau

**PRINCIPAL TYPE** Rubber stamped letters

**DIMENSIONS** 35.4 x 50.4 in. (90 x 128 cm)

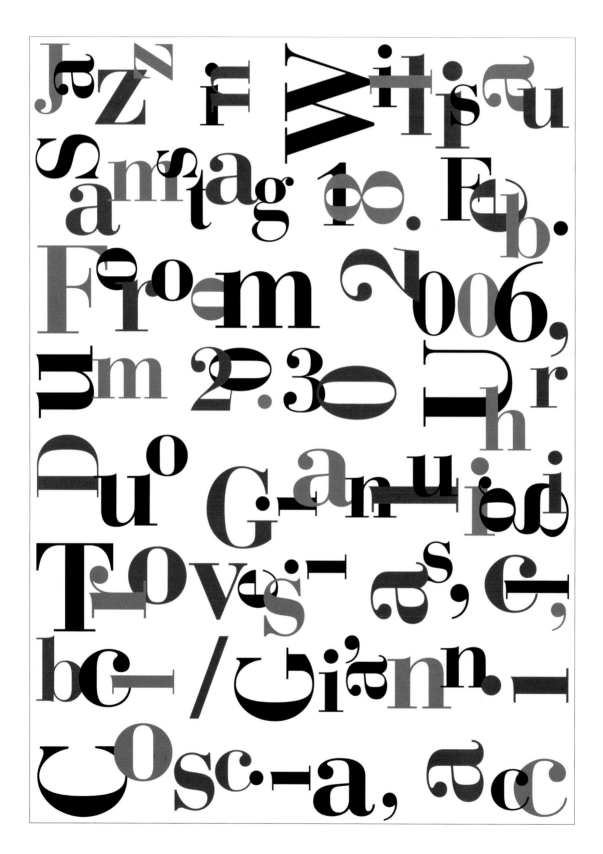

**POSTER**

**DESIGN** Niklaus Troxler *Willisau, Switzerland*

**CREATIVE DIRECTION** Niklaus Troxler

**LETTERING** Niklaus Troxler

**STUDIO** Niklaus Troxler Design

**CLIENT** Jazz in Willisau

**PRINCIPAL TYPE** Bauer Bodoni Bold

**DIMENSIONS** 35.4 x 50.4 in. (90 x 128 cm)

# QUARTET: FOUR LITERARY WALKS THROUGH THE V&A 27.01.06

**DESIGN** Matt Willey and Zoë Bather
*London, England*

**CREATIVE DIRECTION** Matt Willey and Zoë Bather

**STUDIO** Studio 8 Design

**CLIENT** Victoria and Albert Museum

**PRINCIPAL TYPE** Blender, Bodoni, and Proforma

**DIMENSIONS** 10 x 12 in. (25.5 x 30.5 cm)

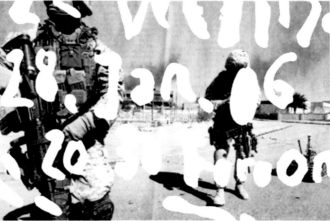

DESIGN Niklaus Troxler *Willisau, Switzerland*

CREATIVE DIRECTION Niklaus Troxler

LETTERING Niklaus Troxler

STUDIO Niklaus Troxler Design

CLIENT Jazz in Willisau

PRINCIPAL TYPE Handlettering

DIMENSIONS 35.4 x 50.4 in. (90 x 128 cm)

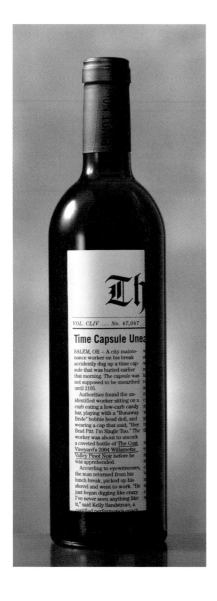 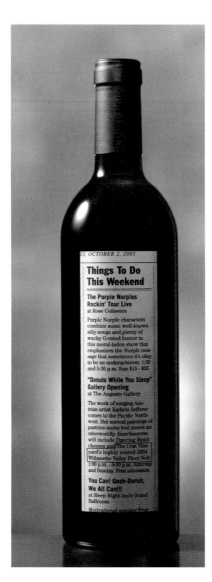 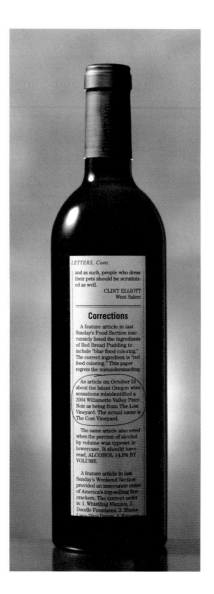

**DESIGN** Steve Sandstrom and Starlee Matz
*Portland, OR*

**ART DIRECTION** Steve Sandstrom

**CREATIVE DIRECTION** Steve Sandstrom

**COPYWRITING** Lane Foard *San Francisco, CA*

**STUDIO** Sandstrom Design

**CLIENT** The Cost Vineyard

**PRINCIPAL TYPE** Century

**DIMENSIONS** 2.1 x 6.5 in. (5.3 x 16.5 cm)

**DESIGN** Robert Majzels and Jim Roberts
*Toronto, Canada*

**TYPESETTING STUDIO** Moveable Inc.

**PRINCIPAL TYPE** Figural and Legacy Sans

**DIMENSIONS** 9 x 11.5 in. (22.9 x 29.2 cm)

**DESIGN** Iván Castro, Ricardo Feriche, and Rocio Hidalgo *Barcelona, Spain*

**ART DIRECTION** Rocio Hidalgo

**CREATIVE DIRECTION** Ricardo Feriche

**DESIGN OFFICE** Feriche Black S.L.

**CLIENT** le cool

**PRINCIPAL TYPE** Akzidenz Grotesk BT, Eldorado, Galliard BT, and Giza

**DIMENSIONS** 4.7 x 6.1 in. (12 x 15.6 cm)

**DESIGN** Andreas Trogisch *Berlin, Germany*

**ART DIRECTION** Andreas Trogisch

**CREATIVE DIRECTION** Andreas Trogisch

**DESIGN OFFICE** blotto design

**CLIENT** Edition Imorde

**PRINCIPAL TYPE** Tribute and Fago

**DIMENSIONS** 9.6 x 13.2 in. (24.3 x 33.4 cm)

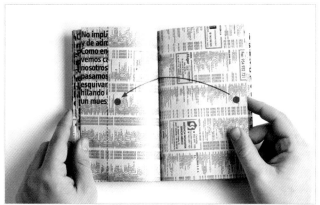
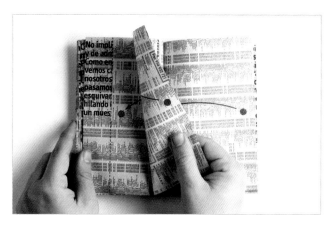

**DESIGN** Dídac Ballester *Valencia, Spain*

**DESIGN OFFICE** Estudi Dídac Ballester

**CLIENT** BDM Impressors

**PRINCIPAL TYPE** FF Info Text

**DIMENSIONS** 4.9 x 7.1 in. (12.5 x 18 cm)

**TYPE ANIMATION**

**DESIGN** Denis Dulude *Montréal, Canada*

**ART DIRECTION** Denis Dulude

**VOICE** Julien Dulude

**STUDIO** Dulude Design

**CLIENT** Minute Moments, Moment Factory

**PRINCIPAL TYPE** FF Trixie

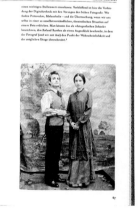

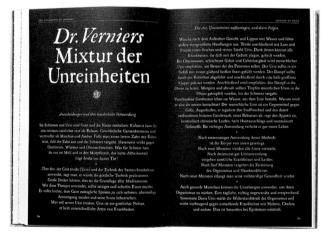

**DESIGN** Torsten Jahnke and Jens Reitemeyer
*Hamburg, Germany*

**ART DIRECTION** Torsten Jahnke and
Jens Reitemeyer

**CREATIVE DIRECTION** Torsten Jahnke and
Jens Reitemeyer

**DESIGN OFFICE** Jahnke/Reitemeyer

**CLIENT** Kunstverein, Hamburg and Foksal Gallery
Foundation

**PRINCIPAL TYPE** Walbaum Text Pro and Regula

**DIMENSIONS** 6.7 x 9.4 in. (17 x 23.8 cm)

230 **CATALOG**

**DESIGN** Zoë Bather, Matt Curtis, and Matt Willey
*London, England*

**CREATIVE DIRECTION** Zoë Bather and Matt Willey

**CALLIGRAPHY** Douglas Bevans

**STUDIO** Studio 8 Design

**CLIENT** Nota Bene

**PRINCIPAL TYPE** Didot, New Caledonia, and Stymie

**DIMENSIONS** 6.3 x 9.25 in. (16 x 23.5 cm)

**DESIGN** Jacket: Cristina Ottolini
Interior: Matteo Bologna *New York, NY*

**ART DIRECTION** Matteo Bologna

**CREATIVE DIRECTION** Matteo Bologna

**CALLIGRAPHY** Matteo Bologna

**DESIGN OFFICE** Mucca Design Corp.

**CLIENT** HarperCollins Publishers

**PRINCIPAL TYPE** Decora and Infidelity

**DIMENSIONS** 5.1 x 7.4 in. (13 x 18.8 cm)

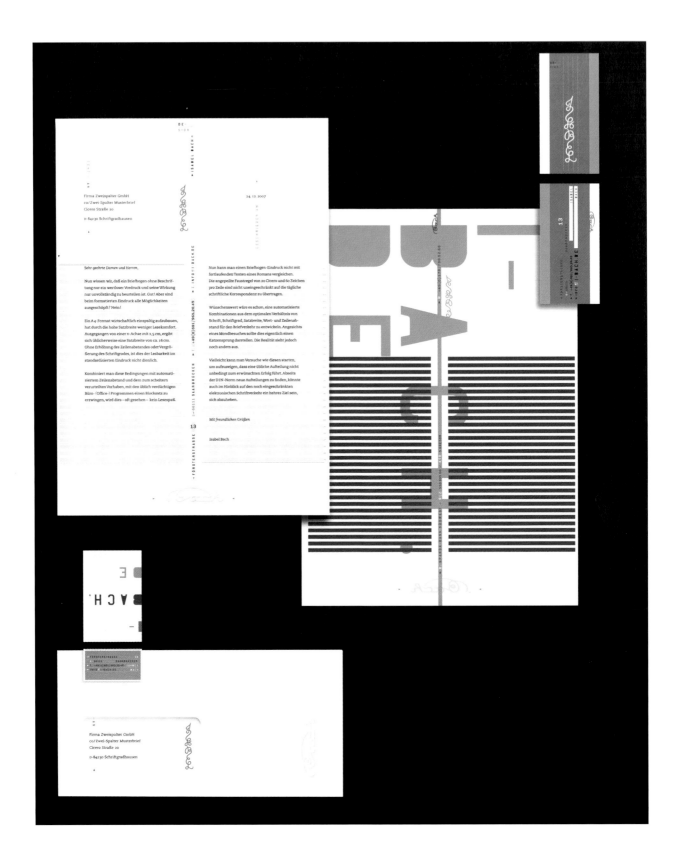

**CORPORATE IDENTITY**

**DESIGN** Patrick Bittner *Saarbrücken, Germany*

**ART DIRECTION** Patrick Bittner

**CREATIVE DIRECTION** Patrick Bittner

**CLIENT** Isabel Bach

**PRINCIPAL TYPE** Groteske Drei

**DIMENSIONS** Various

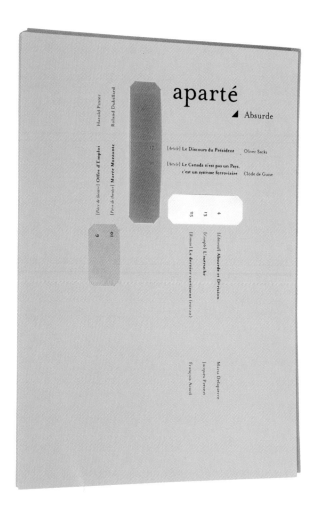

**DESIGN** Catherine Légaré *Montréal, Canada*

**INSTRUCTOR** Judith Poirier

**SCHOOL** École de design, UQAM

**PRINCIPAL TYPE** Mrs. Eaves

**DIMENSIONS** 7.75 x 11 in. (19.7 x 27.9 cm)

**STUDENT PROJECT** 233

**DESIGN** Sabrina Behringer *Karlsruhe, Germany*

**ART DIRECTION** Marijane Covic and
Florian Gaertner

**CREATIVE DIRECTION** Lars Harmsen

**AGENCY** Finest/Magma Brand Design

**CLIENT** Sportswear International

**PRINCIPAL TYPE** Blender, PT Sewed, PT 21,
and PT 22

**DIMENSIONS** 7.7 x 9.8 in. (19.5 x 25 cm)

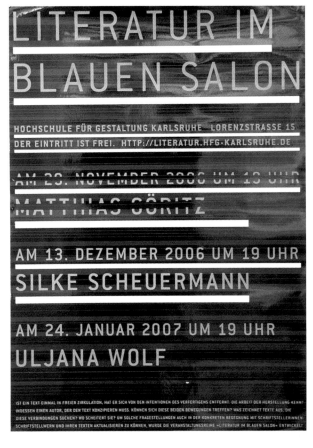

**DESIGN** Asher2xGoldstein *Karlsruhe, Germany*

**PROFESSOR** Uli Sanwald

**SCHOOL** Staatliche Hochschule für Gestaltung
Karlsruhe

**CLIENT** Dr. Stephan Krass

**PRINCIPAL TYPE** Conduit

**DIMENSIONS** 19.7 x 27.6 in. (50 x 70 cm)

**DESIGN** Mark Geer *Houston, TX*

**ART DIRECTION** Mark Geer

**PHOTOGRAPHY** Robb Kendrick *Laredo, Texas*

**DESIGN OFFICE** Geer Design, Inc

**CLIENT** Texas A&M Foundation

**PRINCIPAL TYPE** Adobe Garamond and Foundry Gridnik

**DIMENSIONS** 8 x 10 in. (20.3 x 25.4 cm)

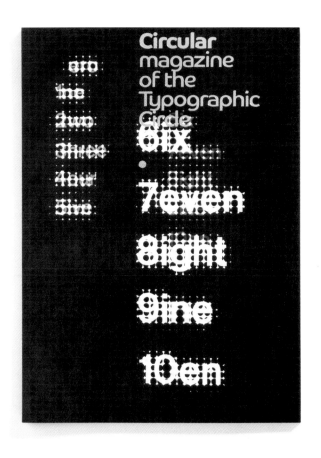

From the very first edition, published back in 1954, the annual of The Type Directors Club has acted as a snapshot of the prevailing trends in type design. In doing so, it serves as a record of decades of fascinating changes in the use of type on posters, books, advertising and more. Since the late 1990s, the Circle has been instrumental in bringing the Annual's accompanying exhibition of work to the UK. In this article, the committee enjoy a sneak preview of TDC51, and present their pick of the jury's selection.

**ART DIRECTION** Domenic Lippa *London, England*

**AGENCY** Pentagram Design Ltd.

**CLIENT** The Typographic Circle

**PRINCIPAL TYPE** Co Text and Co Headline

**DIMENSIONS** 9.4 x 13.1 in. (23.8 x 33.3 cm)

SURFACE TENSION
SUPPLEMENT
Nº 1

EDITED BY
KEN EHRLICH & BRANDON LABELLE

**DESIGN** James W. Moore and Penny Pehl
*Los Angeles, CA*

**CREATIVE DIRECTION** James W. Moore and
Penny Pehl

**STUDIO** Tenderling

**CLIENT** Errant Bodies Press

**PRINCIPAL TYPE** Apex Sans and Apex Serif

**DIMENSIONS** 6 x 9 in. (15.2 x 22.9 cm)

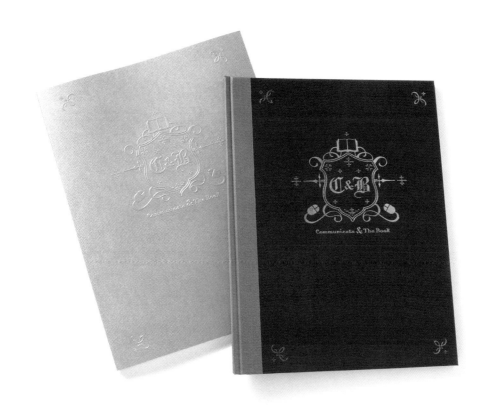

**DESIGN** Lindsey Gice *Minneapolis, MN*

**ART DIRECTION** Lindsey Gice

**CREATIVE DIRECTION** Cheryl Watson

**CLIENT** Graphiculture

**PRINCIPAL TYPE** Cochin, Dalliance, Old English, SF Pixelate, and custom

**DIMENSION** 11 x 15 in. (27.9 x 38.1 cm)

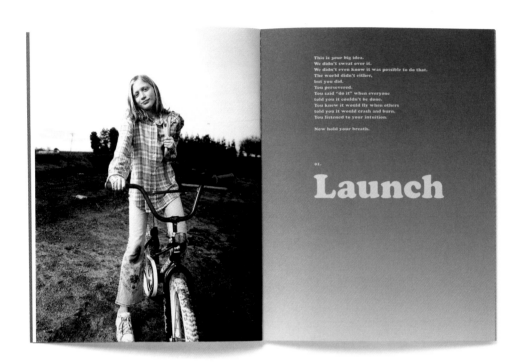

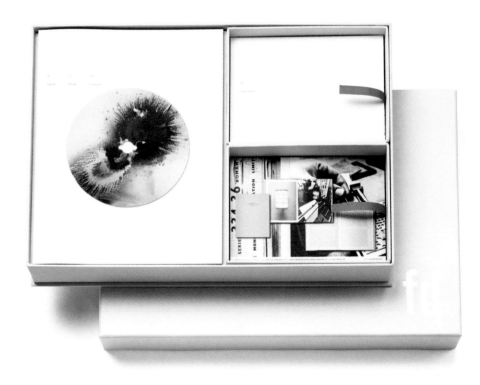

240   **PROMOTIONAL PACKAGE**

**DESIGN** Gabe Campodonico and Craig Williamson *San Francisco, CA*

**ART DIRECTION** Jeff Zwerner

**CREATIVE DIRECTION** Jeff Zwerner

**DESIGN OFFICE** Factor Design, Inc.

**PRINCIPAL TYPE** Various

**DIMENSIONS** Box: 16.75 x 11.75 x 2.25 in. (42.6 x 29.9 x 5.7 cm)

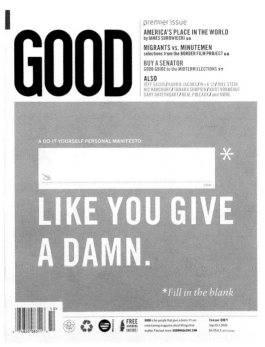

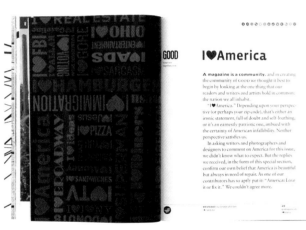

**DESIGN** Susan Barber, Rob Dileso, Gary Fogelson,
Serifcan Özcan, Nicholas Rock, and Scott Stowell
*New York, NY*

**DESIGN DIRECTION** Scott Stowell

**STUDIO** Open

**CLIENT** Good Magazine, LLC

**PRINCIPAL TYPE** Benton, Doric, Sabon, Trade Gothic,
and Vista

**DIMENSIONS** 8.4 x 10.9 in. (21.3 x 27.7 cm)

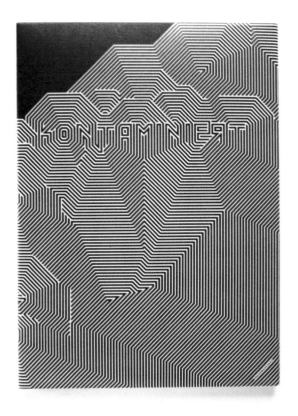

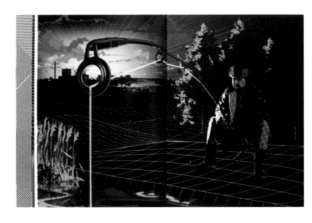

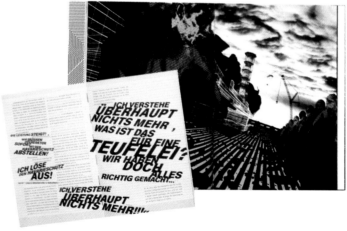

242 **STUDENT
PROJECT**

**DESIGN** Daniel Fitzgerald, Hannes Nordiek, Yuko Stier, and Alan von Lützau *Kiel, Germany*

**SCHOOL** Muthesius Kunsthochschule Kiel

**PRINCIPAL TYPE** Akzidenz Grotesk, Courier, Kombinat, and DTL Romulus

**DIMENSIONS** 9.8 x 13.8 in. (25 x 35 cm)

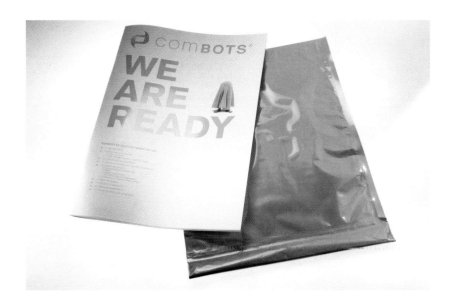

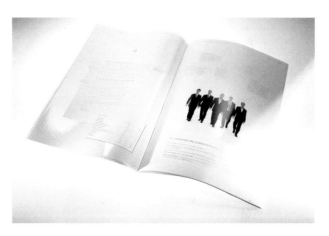

**DESIGN** Holger Jungkunz *Stuttgart, Germany*

**ART DIRECTION** Jochen Theurer

**CREATIVE DIRECTION** Felix Widmaier

**LETTERING** Steffen Hoenicke

**PHOTOGRAPHY** Andreas Teichmann *Essen, Germany*

**AGENCY** Strichpunkt

**CLIENT** ComBOTS AG

**PRINCIPAL TYPE** Akzidenz Grotesk and Franklin Gothic

**DIMENSIONS** 11.7 x 16.5 in. (29.7 x 42 cm)

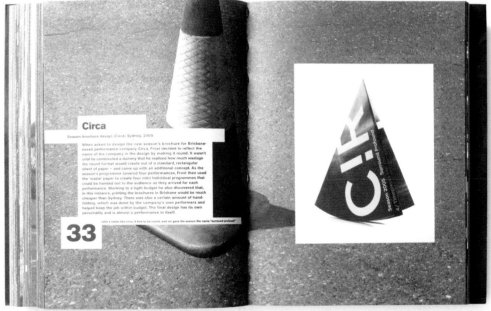

**Circa**
Season brochure design (Circa) Sydney, 2005

When asked to design the new season's brochure for Brisbane-based performance company Circa, Frost decided to reflect the name of the company in the design by making it round. It wasn't until he constructed a dummy that he realised how much wastage the round format would create out of a standard, rectangular sheet of paper – and came up with an additional concept. As the season's programme covered four performances, Frost then used the 'waste' paper to create four mini individual programmes that could be handed out to the audience as they arrived for each performance. Working to a tight budget he also discovered that, in this instance, printing the brochures in Brisbane would be much cheaper than Sydney. There was also a certain amount of hand-folding, which was done by the company's own performers and helped keep the job within budget. The final design has its own personality and is almost a performance in itself.

**33**

"with a name like Circa, it had to be round, and we gave the season the name "surround profound"

---

244    **BOOK**      **DESIGN** Vince Frost and Anthony Donovan
*Sydney, Australia*

         **ART DIRECTION** Vince Frost

         **CREATIVE DIRECTION** Vince Frost

**STUDIO** Frost Design

**PRINCIPAL TYPE** Akzidenz Super

**DIMENSIONS** 8.3 x 11 in. (21 x 28 cm)

ADULT
THEMES
REWRITING
THE RULES
OF ADULTHOOD
KATE CRAWFORD

**DESIGN** Mark Gowing *Sydney, Australia*

**ART DIRECTION** Mark Gowing

**CREATIVE DIRECTION** Mark Gowing

**DESIGN OFFICE** Mark Gowing Design

**CLIENT** Pan Macmillan

**PRINCIPAL TYPE** Franklin Gothic

**DIMENSIONS** 6 x 9.2 in. (15.3 x 23.3 cm)

und so weiter.                                          Wo's anfangt,

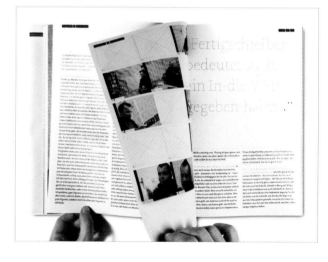

**STUDENT PROJECT**

**DESIGN** David Lindemann and Matthias Wörle
*Bremen, Germany*

**PROFESSORS** Dr. Elke Bippus and Eckhard Jung

**SCHOOL** Hochschule für Künste Bremen

**PRINCIPAL TYPE** Dolly

**DIMENSIONS** 9.1 x 13 in. (23 x 33 cm)

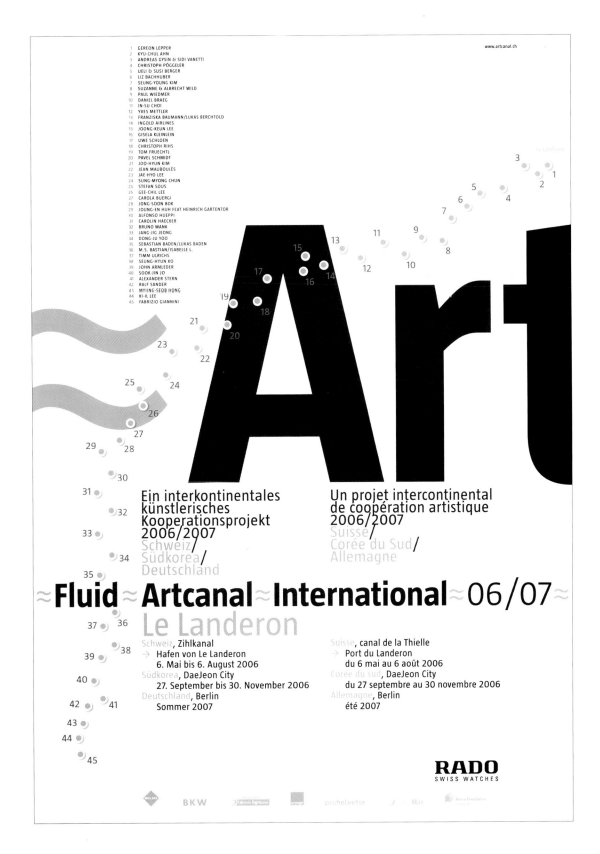

**DESIGN** Andréas Netthoevel and Martin Gaberthüel
*Biel, Switzerland*

**ART DIRECTION** Andréas Netthoevel and
Martin Gaberthüel

**CREATIVE DIRECTION** Andréas Netthoevel and
Martin Gaberthüel

**DESIGN OFFICE** Secondfloorsouth Netthoevel
& Gaberthüel

**CLIENT** artcanal association

**PRINCIPAL TYPE** Taz III

**DIMENSIONS** 35.2 x 50.4 in. (89.5 x 128 cm)

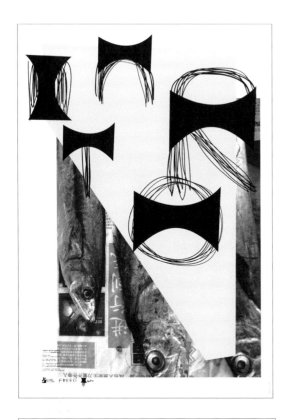

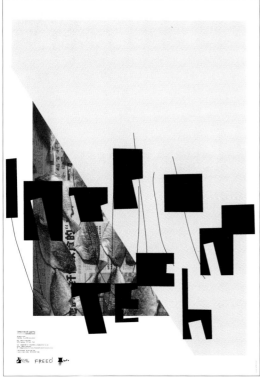

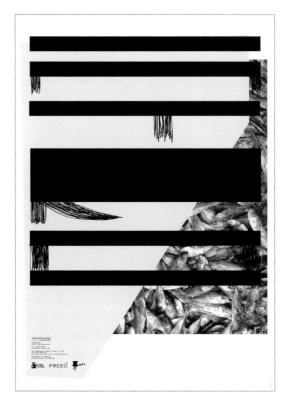

**DESIGN** Zhiwei Bai *Shenzhen, China*

**ART DIRECTION** Zhiwei Bai

**AGENCY** Bai Design Association

**CLIENT** Sound Filter

**PRINCIPAL TYPE** Helvetica

**DIMENSIONS** 27.6 x 39.4 in. (70 x 100 cm)

**DESIGN** Justin Fines *Brooklyn, NY*

**STUDIO** DEMO

**CLIENT** HUSH

LOGOTYPE    249

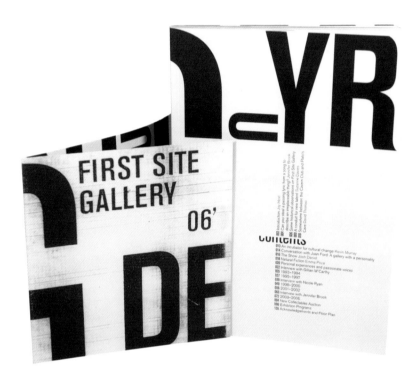

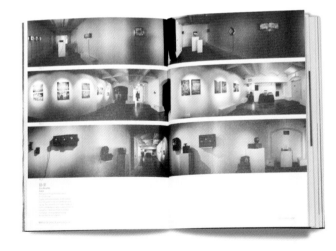

**DESIGN** David Czech, Su-Ann Len, Claire Ryan, and Kim Tran *Melbourne, Australia*

**INSTRUCTOR** Russell Kerr

**DESIGN OFFICE** RMIT Design Consultancy, The Works

**SCHOOL** RMIT University

**CLIENT** First Site RMIT Union Gallery

**PRINCIPAL TYPE** Akzidenz Grotesk

**DIMENSIONS** 5.9 x 8.3 in. (15 x 21 cm)

**DESIGN** Alessandro Floridia, Masa Magnoni, and Mauro Pastore *Milan, Italy*

**CREATIVE DIRECTION** Alessandro Floridia, Masa Magnoni, and Mauro Pastore

**PRINTER** Fontegrafica

**STUDIO** Cacao Design

**PRINCIPAL TYPE** Tarzana Wide

**DIMENSIONS** 10.6 x 7.9 in. (27 x 20 cm)

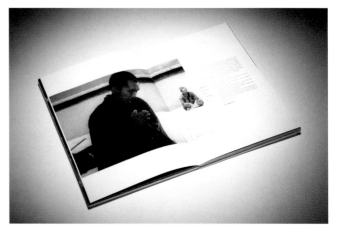

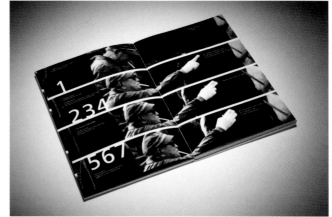

**STUDENT PROJECT**

**DESIGN** Jae Un Jeon *Pasadena CA*

**INSTRUCTOR** Tracey Shiffman

**SCHOOL** Art Center College of Design

**PRINCIPAL TYPE** Frutiger and Meriden

**DIMENSIONS** 10 x 13 in. (25.4 x 33 cm)

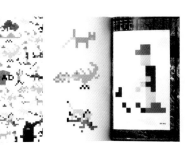

**DESIGN** Julia Hoffmann, Lenny Naar, and Paula Scher *New York, NY*

**ART DIRECTION** Richard Wilde and Paula Scher

**CREATIVE DIRECTION** Richard Wilde and Paula Scher

**PRODUCTION** Adam S. Wahler

**DESIGN OFFICE** Pentagram Design Inc.

**CLIENT** School of Visual Arts

**PRINCIPAL TYPE** Interstate Hairline

**DIMENSIONS** 5 x 7 in. (12.7 x 17.8 cm)

# 2007

# DENNIS PASTERNAK

## TDC² CHAIRMAN'S STATEMENT

As new type design evolves, so do the variety and sophistication of highly specialized type tools available to today's type designers. Through the knowledge and use of those tools, many of the entrants to TDC² revealed new and original type designs created with mature insight, passion, and flair.

This year many submissions covered a full range of entry categories from pi and ornament sets to type families and complex type systems. Notably, non-Latin design was well-represented and was exhibited in a number of language scripts.

New and exciting type design appears to be alive and well worldwide given the large number of international entries. The depth and breadth of new and original type design will serve more worldwide locales and typographically enhance the reading experience for a greater number of people.

The full day of judging TDC² by a distinguished jury was punctuated with very lively and, at times, passionate discussions of the submitted designs. From a type designer's point of view, it was quite inspiring to see a multitude of original, highly sophisticated, and well-crafted type designs at one time and one location. We had to appreciate the amount of time taken to research, design, edit, produce, and present those designs. It was nothing short of extraordinary.

An emphatic thank you to my colleagues on the jury, the award winners, and all type designers who submitted entries whose participation truly made this year's competition a success.

Dennis Pasternak is currently a founding partner and principal designer at Galápagos Design Group, Inc. (www.galapagosdesign.com) where he has designed and produced numerous custom fonts and font families for a wide range of clients for the past thirteen years. His clients include Adobe Systems, Inc., Apple Computer, Bitstream, Inc., Hewlett Packard, International Typeface Corporation, Landor Associates, Linotype Library, Microsoft Corporation, Monotype Imaging Corporation, Saatchi & Saatchi, and TBWA Chiat Day.

Previously, Dennis contributed to the design development of font libraries for several companies in the font industry, including Autologic Inc., Bitstream, Inc., and Compugraphic Corporation.

Dennis's type designs include Bartholemé™, Bartholemé Sans™, Bitstream Chianti™, Maiandra ® GD, and ITC Stylus, among others.

Dennis graduated with a BFA in design from Massachusetts College of Art. He has taught at the Art Institute of Boston at Lesley University and Massachusetts College of Art. He has also lectured and conducted workshops in type design.

Bartholeme

Architectural gems can be viewed along the Seine River

*Patagonian vistas of rugged mountain ranges, glaciers, and ice floes*

Varieties of minerals lie below the vast Siberian taiga

*Immense plutons are exposed in the volcanologic environments of*

El Niño unleashes unstable climatological conditions

*Each member of a foursome takes fourscore strokes to complete a*

**Puffy white cumulus clouds dot the clear blue skies**

*Aboriginal pictographs found on multicolored rock formations*

Magnificent gardens color the confines of Versailles

Maiandra GD

Thoughtfully designed letterforms of the era

*Period furniture complements the interior architecture*

**Selective ingredients make great recipes**

***Great classical music always soothes a weary soul***

**Meandering streams and green fields**

***Icy fruit smoothies are refreshing on hot days***

Bitstream Chianti

The deep river valley carves it way through the

*Silhoeutting the sky are massive monoliths built by the ancients*

**Virtual environments meticulously created**

***Darkness slowly envelops the immediate vicinity of the***

**Katistocracy can be found in any part of**

***Prehistoric coelacanths caught off the West African***

TDC² 2007 JUDGES

# SUMNER STONE

Sumner Stone is the founder of Stone Type Foundry Inc. located on Alphabet Farm in Rumsey, California. The Foundry is a one-man band. Sumner designs and manufactures the typefaces, produces and maintains the web site HYPERLINK <http://www.stonetypefoundry.com/> and the specimens, and occasionally mops the floor.

Sumner's first type design, ITC Stone, is a super-family which contains serif, sans, and informal versions. It has recently been extended with the addition of the Humanistic Sans subfamily. Other recent fonts are Cycles Five, Leaves & Straw, Magma, and Munc. Sumner's work includes a wide variety of design styles, including original designs and historical revivals.

He was the art director and one of the designers of the ITC Bodoni. Other super-families, which he designed over a period of fifteen years, include Cycles, SFPL, and Stone Print. The many Cycles versions continue the tradition of size-specific designs from metal type. The family includes fonts for use at 5, 7, 9, 11, 18, 24, and 36 point.

From 1984 to 1989 Sumner was director of typography for Adobe Systems, Inc., Mountain View, California, where he conceived and implemented Adobe's typographic program, including the Adobe Originals.

Sumner is the author of many articles on typography and type design. His book credits include *On Stone: The Art and Use of Typography on the Personal Computer* and *Font: Sumner Stone, Calligraphy and Type Design in a Digital Age*.

Sumner has taught calligraphy, type design, and typography at various institutions. His education in the graphic arts began when he studied calligraphy with Lloyd Reynolds at Reed College in Portland, Oregon. His formal education includes degrees in sociology and mathematics.

abcdefghijklmn
opqrstuvwxyz

ABCDEFGHIJKLMNOPQRSTUVWXYZ

# BASALT

| EARTH | ✳ | MEETING AREA |
| WATER | ⇶ | CROSS TRAFFIC |
| FIRE | ↯ | ROUNDABOUT |
| METAL | ◈ | AIRPORT |
| WOOD | ⋀ | ENTRANCE |

BASALT
WWW.STONETYPEFOUNDRY.COM

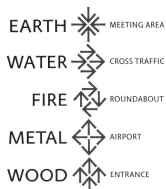

HAGMA · PENCIL ON DRAFTING FILM · · SUMNER STONE · ROME 1998

# Cicerone

Venio nunc ad voluptates agricolarum, quibus ego incredibiliter delector, quae nec ulla impediuntur senectute et mihi ad sapientis vitam proxime videntur accedere. Habent enim rationem cum terra, quae numquam recusat imperium nec umquam sine usura reddit quod accepit, sed alias minore, plerumque maio Now I come to the pleasures of farming. These give me an unbelievable amount of enjoyment. Old age does not impede them in the least, and is my view they are among the
CICERO CATO MAIOR DE SENECTUTE

Venio nunc ad voluptates agricolarum, quibus ego incredibilite delector, quae nec ulla impediuntur senect ute et mihi ad sapien tis vitam proxime videntur accedere. Habent enim rationem cum terra, quae numquam recusat imperium nec u Now I come to the pleasures of farming. These give me an unbelievable amount of enjoyment. Old age does not impede does not imped
CICERO CATO MAIOR DE SENECTUTE

Venio nunc ad voluptates agricolarum, quibus ego in credibiliter delector, quae nec ulla impediuntur sene ctute et mihi ad sapientis vitam proxime videntur ac Now I come to the pleasures of farming. These give me an unbelievable amount of enjoyment. Old age does not imp
CICERO CATO MAIOR DE SENECTUTE

Venio nunc ad voluptates agricolarum, quibus ego incredibiliter delector, quae nec ulla impe diuntur senectute et mihi ad sapientis vident Now I come to the pleasures of farming.These give me an unbelievable amount of enjoyment
CICERO CATO MAIOR DE SENECTUTE

Venio nunc ad voluptates agricolarum quibus ego incredibiliter delector quae nec ulla impediuntur senectute et mihi Now I come to the pleasures of farming. These give me an unbelievable amount
CICERO CATO MAIOR DE SENECTUTE

Venio nunc ad voluptates agricola, quibus ego incredibiter delector quae nec ulla impediuntur senect Now I come to the pleasures of far
CICERO CATO MAIOR DE SENECTUTE

Quibus ego
Quibus ego
Quibus ego
**Quibus ego**
**Quibus ego**
**Quibus ego**
**Delecto**
**Delecto**
Delecto
Delecto
Delecto

SILICA
WWW.STONETYPEFOUNDRY.COM

# LUC[AS] de GROOT

Luc(as) de Groot (born 1963, Noordwijkerhout, The Netherlands) studied at the Royal Academy of Fine Arts in The Hague. He then spent four years with the Dutch design group BRS Premsela Vonk mainly on corporate identity work. In the meantime, he taught at the Art Academy in Den Bosch and freelanced before moving to Berlin in 1993 to join MetaDesign for another four years. As MetaDesign's typographic director, Luc(as) worked on a diversity of corporate design projects from logos, magazine concepts, and custom typefaces to finetuning and implementing type.

Luc(as)'s most well-known type family up to now is Thesis. It grew out of dissatisfaction with the unavailability of good typefaces for corporate identities. Thesis was first conceived about 1989 and first published in 1994. Since then it has grown to be one of the largest, most comprehensive digital type families available on the market.

In 1997 Luc(as) founded FontFabrik where he offers services like type and logo development and digital implementation to design and advertising agencies. The goal of Fabrik is the enrichment of the typographic climate (check out FontFabrik.com). Early in 1997 Luc(as) accepted a half-time teaching position in Potsdam.

In 2000 the font foundry LucasFonts was established where Luc(as) now sells and distributes his own typefaces directly (LucasFonts.com). He keeps designing new and custom typefaces as well as extending his own type families, including Corpid, Sun, and Taz. Luc(as) is devoted to type by day and night.

Und es war um die sechste Stunde, und es ward eine Finsternis über das ganze Land bis an die neunte Stunde. Und die Sonne verlor ihren Schein, und der Vor- hang des Tempels zerriß mitten entzwei. Und Jesus rief laut und sprach: Vater, ich befehle meinen Geist in deine Hände! & als er das gesagt, verschied er.

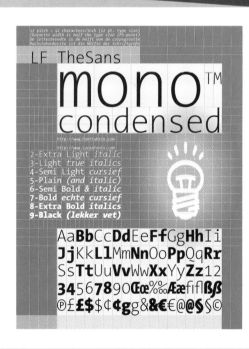

12 pitch = 12 characters/inch (12 pt. type size)
Character width is half the type size (PS-point)
De letterbreedte is de helft van de corpsgrootte
Buchstabenbreite ist die Hälfte der Schriftgröße

LF TheSans

# mono™
## condensed

http://www.FontFabriek.com
http://www.LucasFonts.com

2-Extra Light *italic*
3-Light *true italics*
4-Semi Light *cursief*
5-Plain *(and italic)*
6-Semi Bold & *italic*
7-Bold *echte cursief*
8-Extra Bold *italics*
9-Black *(lekker vet)*

AaBbCcDd EeFfGgHhIi
JjKkLlMmNnOoPpQqRr
SsTtUuVvWwXxYyZz12
34567890 Œœ‰Æfiflßß
®£$$¢¢gg&&€@@§©

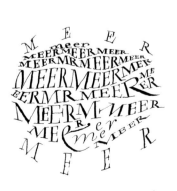

# MAXIM ZHUKOV

Maxim Zhukov specializes in multilingual typography and cross-cultural design. For many years he served as a typographic coordinator at the United Nations.

Maxim is involved in type design and consulting for many type foundries and individual designers. Among his clients are Adobe, Ascender, Bitstream, Carter & Cone, Font Bureau, International Typeface Corporation, Linotype, Microsoft, Monotype, and ParaType. He teaches typography in New York at Parsons School of Design and in Moscow at the British Higher School of Art and Design.

Maxim has received many awards and honorary citations for his work in Russia, the United States, and elsewhere. He does research and writes on typography and type design. A member of a number of Russian and American professional societies and associations, he is a member of the board of the Association Typographique Internationale (ATypI) and the delegate from Russia.

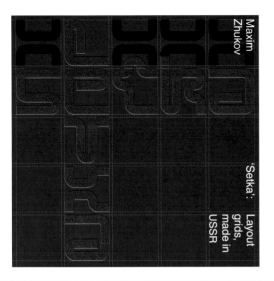

Maxim Zhukov

'Setka': Layout grids, made in USSR

---

THIS IS A PRINTING OFFICE,
*Это – типография,*
CROSSROADS OF CIVILIZATION,
*перекресток цивилизаций,*
REFUGE OF ALL THE ARTS
*убежище всех искусств*
AGAINST THE RAVAGES OF TIME,
*от разрушительных набегов времени,*
ARMOURY OF FEARLESS TRUTH
*арсенал неустрашимой истины,*
AGAINST WHISPERING RUMOUR,
*гибельной для наветов толпы,*
INCESSANT TRUMPET OF TRADE.
*неумолчный рупор цеха.*
FROM THIS PLACE WORDS MAY FLY ABROAD,
*Отсюда слова разлетаются,*
NOT TO PERISH ON WAVES OF SOUND,
*не рискуя сгинуть в пучине звуков,*
NOT TO VARY WITH THE WRITER'S HAND,
*или исказиться под пером переписчика,*
BUT FIXED IN TIME, HAVING BEEN VERIFIED IN PROOF.
*чтобы чеканным текстом остаться в веках.*
FRIEND, YOU STAND ON SACRED GROUND.
*Друг, ты стоишь на священной земле*
THIS IS A PRINTING OFFICE.
*Это – типография.*

---

## 'The Story of Ka'

Page: **1**

*Published by M.Riess, CP*

# ККК
# ККК
# ККККККК
# КККК
# КК КККККК
# К

There is a number of construction patterns of the Cyrillic К. The treatment of its limbs makes a lot of difference.

Arched legs, with feet standing firmly on the baseline, were typical for the early, pre-reform Cyrillics (*ustav, poluustav*), whereas in Peter the Great's *Civil Type* they take a wavy, tilde-like shape. Many post-Pertine types of the 18th century also feature bowed legs. The hooked foot terminals and the heavy bulbous finials developed in 19th century styles (mostly Moderns and Ionics); the limbs became squarish.

The arched shape of the leg works better in Transitionals and some Moderns, not in Old Styles where the sabre-like, ⟋ slightly sagging variety often looks much more natural.

The above comments are also true for the к, К, к, Ж, и, Я and я. Of course, there are always exceptions…

**К**

---

*Frederic W. Goudy*

# I AM TYPE

*Of my earliest ancestry neither history nor relics remain.*

Я — шрифт.

От моей древней родословной не сохранилось ни следов, ни хроник.

*The wedge-shaped symbols impressed in plastic clay by Babylonian builders in the dim past, foreshadowed me; from them, on through the hieroglyphs of the ancient Egyptians, down to the beautiful manuscript letters of the medieval scribes, I was in the making.*

Среди моих предшественников во мгле веков — клинописные знаки, оттиснутые в мягкой глине строителями Вавилона; от них — через египтян древних письмена — до благородных почерков писцов средневековья — я рос и развивался.

*With the golden vision of the ingenious Gutenberg, who first applied the principle of casting me in metal, the profound art of printing with movable types was born.*

Трудами и талантом хитроумного Гутенберга, кто первым взялся отливать меня в металле, жизнь обрело высокое искусство печати подвижными литерами.

*Cold, rigid, and implacable I may be, yet the first impress of my face brought the devine word to countless thousands.*

Каким бы ни был я холодным, жестким и негибким, мне удалось первым же оттиском божественное слово до многих тысяч донести.

*I bring into the light of day the precious stores of knowledge and wisdom long hidden in the grave of ignorance.*

Увидеть свет я помогаю тем кладам мудрости и знаний, что до поры покоились в неведеных гробнице.

*In books I present to you a portion of the eternal mind caught in its progress through the world, stamped in an instant, and preserved for eternity.*

Я в книгах открываю вам запечатленное мгновенье полета разума в его движеньи вокруг света, навечно сохраненное для будущих времен.

*I coin for you the enchanting tale, the philosopher's moralizing, and the poet's phantasies; I enable you to exchange the irksome hours that come, at times, to everyone, for sweet and happy hours with books-golden urns filled with all the manna of the past.*

В моих чеканных знаках воплотились волшебные преданья, степенные суждения философа и грезы стихотворца; я помогаю коротать часы тревоги и сомнений — удел печальный каждого и всех — и усладить досуг общениями счастливым с книгами — сосудами златыми, хранящими всю манну прошлых лет.

*Through me, Socrates and Plato, Chaucer and the Bards, become your faithful friends whoever surround and minister to you.*

Через меня Сократ, Платон и Чосер, и Барды издолго станут вам верными и мудрыми друзьями.

*I am the leaden army that conquers the world.*

Весь мир лежит у ног моих солдат свинцовых — литер.

Фредерик У. Гауди

# ROD McDONALD

Rod McDonald has forty years' experience working with lettering and type. Much of his career was spent providing handlettering and typographic styling to the Toronto advertising and design community. He has designed logos for many of the leading Canadian magazines, including *Applied Arts*, *Maclean's*, and *Toronto Life* and has also created typefaces for these and other magazines. Rod was one of the first typographers to switch to the Mac in the mid-1980s and was soon providing custom fonts to ad agencies and design studios.

In addition to the Type Directors Club, Rod is a member of the Registered Graphic Designers of Ontario, a founding member of the Type Club of Toronto, and an ex-board member of The Society of Typographic Aficionados (SoTA). He has taught typography at the Ontario College of Art & Design and NSCAD University in Halifax.

Rod's work has won numerous awards despite the fact he never enters competitions. He now lives on a beautiful lake in Nova Scotia and spends his days working on new typefaces. It's a tough job—but somebody has to do it.

"LE PLUS GRAND CHEF-D'ŒUVRE DE LA LITTÉRATURE N'EST JAMAIS QU'UN DICTIONNAIRE EN DÉSORDRE."

JEAN COCTEAU

SLATE LIGHT

Slate Light *Slate Light Italic* Slate OSF Light *Slate OSF Light Italic* SLATE SMALL CAPS LIGHT • Slate Book *Slate Book Italic* Slate OSF Book *Slate OSF Book Italic* SLATE SMALL CAPS BOOK • Slate Regular *Slate Regular Italic* Slate OSF Regular *Slate OSF Regular Italic* SLATE SMALL CAPS REGULAR • **Slate Medium** *Slate Medium Italic* Slate OSF Medium *Slate OSF Medium Italic* SLATE SMALL CAPS MEDIUM • **Slate Bold** *Slate Bold Italic* **Slate OSF Bold** *Slate OSF Bold Italic* **SLATE SMALL CAPS BOLD** • **Slate OSF Black** *Slate OSF Black Italic* **SLATE SMALL CAPS BLACK** • Slate Light Condensed Slate Book Condensed Slate Regular Condensed **Slate Medium Condensed** **Slate Bold Condensed** **Slate Black Condensed** • Egyptian Slate Light Egyptian Slate Book Egyptian Slate Regular **Egyptian Slate Medium** **Egyptian Slate Bold** **Egyptian Slate Black** MONOTYPE IMAGING

**"The tendency of the best typography has been and still should be in the path of simplicity, legibility, and orderly arrangement."**

**THEODORE LOW DEVINNE**

EGYPTIAN SLATE BLACK

# 2007

JUDGES' CHOICES &
DESIGNERS' STATEMENTS

**SUMNER STONE**
Judge

Beorcana belongs to an elite class of letterforms with thick/thin contrast resulting from the use of the edged writing tool and no serifs. There are thick and thin sans serif letters from the Italian Renaissance (some of which inspired Hermann Zapf's Optima), but they follow a different paradigm. Beorcana is in the same tradition as Walter Chappell's wonderful Lydian.

I find Beorcana a welcome addition to the typographic vocabulary and a worthy member of the class. The level of craftsmanship is very high. The micro weights work very nicely at 5 point. There are thin to ultra display weights and light to black text weights. I like the light text, and the heavier weights are clear and clean. The whole family is well-spaced.

Beorcana grew out of an experiment to develop a calligraphic, serifless Roman, with a true chancery Italic, and proportions, color, and contrast appropriate for book typography. Test settings and printings over a long period allowed me to refine the design to function at text sizes. Beorcana evolved from this experiment into a fully-featured type family complete with text, display, and fine print variants. Once proportions and contrast were resolved, it seemed natural to add small caps, swash caps, and other refinements that are useful in book design.

Beorcana refers to classic Renaissance book types in its structure, though the calligraphic stress is more explicit. The small sizes are intended to be clear and strong in challenging settings like dictionaries and maps. Digital imaging and offset printing conditions suggested that Beorcana's basic weights be rich in color and moderate in contrast.

**CARL CROSSGROVE**
Designer

ABCDEFGHIJKLMNOPQRSTUVWXYZ &

abcdefghijklmnopqrstuvwxyz

ABCDEFGHIJKLMNOPQRSTUVWXYZ &

0123456789 $¥€¢£ƒ 0123456789 0123456789 $¥€¢£ƒ 0123456789

½¼¾⅛⅜⅝⅞⅓⅔ %‰ 0123456789 0123456789 0123456789 0123456789 abdeilmnorst

+÷<=>≠≈±≤≥~¬∞^°#@℮∂∑√◊ΔΩπµ*†‡ªº§¶©®™

!?¿!¡¡¿¿¡{}{}{}()()()[][][]|\/.,:;•·…""''""„„‹›«»«»--–——_ ` ´ ˆ ˜ ¯ ˘ ˙ ˚ ¨ " ˇ ¸ ˛

ÀÁÂÄÃÅĀĂĄÆǼĆÇČĊĎÐÉÈÊÊÈÉËĒĘÞĜĠĞĤĦÍÌÎÏĨĪİĮĲĴĶĹĽĿŁŃÑŇŊ
ÓÒÔÖÕŐØǾŒŔŘŖŚŜŠŞŠŢŤŦÐÚÙÛÜŨŪŮŰŲẂŴẀŴÝŶŸỲŹŽŻ
áàâäãåāăąæǽćçčċďđéèêêèéëēęþĝġğĥħıíìîïĩīįĳĵķĺľŀłńñňŋ
óòôöõőøǿœŕřŗśŝšşšßţťŧðúùûüũūůűųẃŵẁŵýŷÿỳźžż
ÁÀÂÄÃÅĀĂĄÆǼĆÇČĊĎÐÉÈÊÊÈÉËĒĘÞĜĠĞĤĦÍÌÎÏĨĪİĮĲĴĶĹĽĿŁŃÑŇŊÓÒÔÖÕŐÖ
ØǾŒŔŘŖŚŜŠŞŠŢŤŦÐÚÙÛÜŨŪŮŰŲẂŴẀŴÝŶŸỲŹŽŻ

ABCDEFGHIJKLMNOPQRSTUVWXYZ &

abcdefghijklmnopqrstuvwxyz

ABCDEFGHIJKLMNOPQRSTUVWXYZ &

ABCDEFGHIJKLMNOPQRSTUVWXYZ Th y &

A B C D E F G H I J K L M N O P Q

R S T U V W X Y Z Th y & 0123456789

0123456789 $¥€¢£ƒ 0123456789 0123456789 $¥€¢£ƒ 0123456789

½¼¾⅛⅜⅝⅞⅓⅔ %‰ 0123456789 0123456789 0123456789 0123456789 abdeilmnorst

+÷<=>≠≈±≤≥~¬∞^°#@℮∂∑√◊ΔΩπµ*†‡ªº§¶©®™

!?¿!¡¡¿¿¡{}{}{}()()()[][][]|\/.,:;•·…""''""„„‹›«»«»--–——_ ` ´ ˆ ˜ ¯ ˘ ˙ ˚ ¨ " ˇ ¸ ˛

ÀÁÂÄÃÅĀĂĄÆǼĆÇČĊĎÐÉÈÊÊÈÉËĒĘÞĜĠĞĤĦÍÌÎÏĨĪİĮĲĴĶĹĽĿŁŃÑŇŊ
ÓÒÔÖÕŐØǾŒŔŘŖŚŜŠŞŠŢŤŦÐÚÙÛÜŨŪŮŰŲẂŴẀŴÝŶŸỲŹŽŻ
áàâäãåāăąæǽćçčċďđéèêêèéëēęþĝġğĥħıíìîïĩīįĳĵķĺľŀł
ńñňŋóòôöõőøǿœŕřŗśŝšşšßţťŧðúùûüũūůűųẃŵẁŵýŷÿỳźžż
ÁÀÂÄÃÅĀĂĄÆǼĆÇČĊĎÐÉÈÊÊÈÉËĒĘÞĜĠĞĤĦÍÌÎÏĨĪİĮĲĴĶĹĽĿŁŃÑŇŊÓÒÔÖÕŐÖ
ØǾŒŔŘŖŚŜŠŞŠŢŤŦÐÚÙÛÜŨŪŮŰŲẂŴẀŴÝŶŸỲŹŽŻ
ÀÁÂÄÃÅĀĂĄÆǼĆÇČĊĎÐÉÈÊÊÈÉËĒĘĜĠĞĤĦÍÌĴĴĴĴĴĴĴĵĵĵĶĹĽĿĿŃÑŇŊ
ÓÒÔÖÕŐÖÕØŔŘŖŚŜŠŞŠŢŤŦÐÚÙÛÜŨŪŮŰŲẂŴẀŴÝŶŸỲŹŽŻ
ǍǍǍǍǍǍǍǍǼǼÇÇÇÇĎ Đ ĚĚĚĚĚĚĚĢ Ĝ Ğ Ĝ ĤĦ
ĴĴĴĴĴĴĴĴĴĴĶĹĽĿĿĿŃŃŇŊŎŎŎŎŎŎŎŎØŔŘŖŚŜŠŞŞ
ŢŢŦŨŬŬŬŬŬŬŬŬŬŲẂŴẀŴÝŶŸỲŹŽŻ

TYPEFACE DESIGNER Carl Crossgrove
San Francisco, CA

FOUNDRY www.fonts.com

MEMBERS OF TYPEFACE FAMILY/SYSTEM Text: Light, Light Italic, Regular, Italic, Medium, Medium Italic, Bold, Bold Italic, Black, and Black Italic. Display: Thin, Thin Italic, Light, Light Italic, Regular, Italic, Medium, Medium Italic, Bold, Bold Italic, Black, Black Italic, Ultra, and Ultra Italic. Micro: Regular, Italic, Bold, and Bold Italic

**LUC(AS) de GROOT**
Judge

Some typefaces need lengthy descriptions to explain what is special about them. Fakir just needs one look. You can't remain neutral: It's love or hate at first sight. Typefaces by the Finnish/Dutch/German Underware collective are always well-drawn, mostly pretty smart, and often unusual. This one goes a step further: There is something provocative about it. Fakir is a Blackletter typeface for the streetwise. It taps into the history of fractura—broken type— but there's also an element of graffiti and a hint of political incorrectness. More importantly, it is fun.

Paraphrasing Frank Zappa, does humor belong in type design? I think it does.

Fakir, a Blackletter with a holy kiss, is a contemporary interpretation of past letterforms that originate as Blackletters. More precisely, Fakir is based on the construction of a broad nib textura with lots of broken, edgy, interrupted strokes. Try to sit on a nail bed, and you'll know why fakirs like to read just these kinds of fonts!

After being abandoned for some time (not accepted, nearly forbidden), Fakir is a Blackletter for the current generation. Fakir is not a revival but a new 21st-century Blackletter uncorked in 2006.

The Fakir type system consists of eleven fonts. A set of five edgy text fonts, five display fonts, and an ornament font. They range from tight and heavy to light and wide. The text family has real Italics, which is unusual for a Blackletter. This rich typographic palette makes it possible to handle complex typographic situations.

**UNDERWARE**
Designer

**Fakir**

A BLACKLETTER WITH A HOLY KISS

DESIGNED BY Underware

THERE ARE FREAKS AROUND

Indian swamis

gurus & fakirs

hold sway over tourists

creating miracles that leave people

mind·twisted

◀ AVAILABLE AT WWW.UNDERWARE.NL ▶

**TYPEFACE DESIGNER** Underware *Den Haag, The Netherlands*

**FOUNDRY** Underware

**MEMBERS OF TYPEFACE FAMILY/SYSTEM** Text: Regular, Italic, Small Caps, Black, and Black Italic. Display: Regular, Regular Condensed, Black, Black Condensed, and Black Small Caps. Ornaments

**MAXIM ZHUKOV**
Judge

Grotesque sans serifs—such as Subtil—are not known for the subtlety of their design (hence the jocosity of the name). Nor are they known to be soft and cuddly. The image they normally project is one of efficiency, functionality, and matter of factness. Subtil is all of the above and yet is set apart by a certain friendliness and warmth. It is not cute like the many popular sans serif designs that feature rounded corners and stroke endings—guaranteed crowd-pleasers often used in the identity styles of fast-food chains; food, drink, and toy packaging; and baby and toddler products.

Subtil is not a generic, all-purpose sans serif. Its design has been carefully customized and fine-tuned to its special purpose. Created as part of the visual identity for municipal public services, its design was derived from a preexisting logotype—DSW21. This could be seen as a handicap, yet it accounts for a few idiosyncratic design details that secure the uniqueness of the typeface: a subtle (yes!) emphasis of the stems, bulging stroke terminals, and an I-like Arabic numeral 1. Such uncommon, distinctive features are indicative of the stimulating role of restrictions, which can challenge design skills and get the creative juices flowing, leading to nonstandard—fresh and original—visual solutions.

Subtil was developed for the design studio +malsy as part of the corporate design of DSW21, public services of the city of Dortmund, Germany. The conglomerate DSW21 consists of twelve enterprises such as Dortmund Airport, the harbor, and the city's public transport. The font was designed to augment the logotype for these enterprises. For this purpose Subtil had to be space-saving, bold, and tightly spaced. It also had to work equally well as all caps or lowercase.

The main characteristics of Subtil are its rounded stroke endings and the slightly curved inner verticals in most of the capital letters. They resemble DSW21's logo, a stylized uppercase D. These curves are also useful to incorporate ink traps that occur under bad printing conditions for such things as bus tickets.

**HANNO BENNERT**
(concept & type design)

**ALEXANDER GIALOURIS**
(idea & concept)
Designers

# GREEN METROPOLIS

------------------------------------------------

Nearly half the municipal territory consists of waterways, woodland, agriculture and green spaces with spacious parks. Historically seen, after nearly a hundred years of extensive coal mining, coking, and steel milling within the city limits, this is quite a contrast.

------------------------------------------------

# COAL, BEER &
# STEEL

------------------------------------------------

ABCDEFGHIJKLMNOPQRSTUVWXYZÄÖÜ
abcdefghijklmnopqrstuvwxyzäöüß
#0123456789 2I 2I .,:;!?...„"‚' »«›‹
_ -- — + = [(/|\)] * $ & @ %

**TYPEFACE DESIGNER** Hanno Bennert and Alexander Gialouris *Düsseldorf, Germany*

**CLIENT** Dortmunder Stadtwerke AG

**ROD McDONALD**
Judge

Olga is a well-thought-out, mature typeface. It sets well and has a nice, even color. The wide, robust characters produce good, strong lines. The Regular is very readable. I was actually a little amazed at how legible it is in text.

Olga Lino is a bold display version of the Regular. Inspired by linocut illustrations, the designer has cut deep notches into each character. At small sizes the notches help the characters remain clear and open. But at large sizes they soon become overbearing, and I can't see anything but those notches. Don't misunderstand, the Lino version does work, and it works surprisingly well. I just think too many people are going to find that the notches get in the way of reading, and this typeface is meant for reading.

The Regular needs an Italic companion, and if the Roman is any indication, this designer should have no trouble creating an excellent one. It could also benefit from having an alternate Bold without the notches. I would like to see Olga offered in two distinct families, a standard range without notches, and a matching Lino range with the notches. That would give designers a truly useful typographic palette.

My comments are not intended as criticism. In the end I chose Olga because I think it is an exceptionally fine typeface, and I want to see more of it.

As a typographer I know how difficult it can be to find the right combination of a good working text typeface and a prominent, extraordinary typeface for titling and emphasis. This difficulty is far too often underestimated, and the results do not work very well. The outcome is Olga.

Olga Regular is a modern renaissance of Antiqua with a solid, warm, organic character that makes it legible. Olga Lino is based on Olga Regular, but it is also inspired by linocut illustration technique. With the bold character and the sharp cuts, the typeface reflects the roughness and strength of linocut. To keep the handmade and irregular image, Olga Lino has different glyphs for the same character.

**CHRISTINA BEE**
Designer

# OLGA
## regular & lino

### A MODERN RENAISSANCE ANTIQUA

solid, warm and friendly text face & a strong headline version which is inspired by linocut

**TYPEFACE DESIGNER** Christina Bee *Darmstadt, Germany*

**MEMBERS OF TYPEFACE FAMILY/SYSTEM** Regular and Lino

TDC²

# 2007

## ENTRIES SELECTED FOR EXCELLENCE IN TYPE DESIGN

**XTRA SANS**

**TYPEFACE DESIGNER** Jarno Lukkarila
*Helsinki, Finland*

**FOUNDRY** Jarno Lukkarila Type Foundry

**MEMBERS OF TYPEFACE FAMILY/SYSTEM** Regular,
Regular Italic, Bold, Bold Italic, Heavy, Heavy Italic,
Small Caps, and Lining Figures

**I know what you're thinking:** [bold, 22]
did he fire six shots [regular, 35]
*OR ONLY FIVE?* [italic sc, 52]
Well, to tell you the truth, in all this excitement, [regular, 14]
*I've kinda lost track myself.* [italic, 27]
But being as [regular, 58]
**this is a .44 magnum, the** [bold, 26]
*most powerful handgun* [italic, 31]
IN THE WORLD AND WOULD [bold sc, 22]
**blow your head clean off,** [bold, 24]
you've got to ask yourself one question: [regular, 17]
Do I feel lucky? Well, [regular, 34]
**do ya punk?** [bold, 54]

**TYPEFACE DESIGNER** Mitja Miklavčič *Postojna, Slovenia*

**MEMBERS OF TYPEFACE FAMILY/SYSTEM** Regular, Italic,
and Bold; all weights include Small Caps, four sets of
figures, and case-sensitive forms

# Poemas y cuentos vanguardistas

## *Es un periódico de información comercial local*

# International Bank

## *Newspapers use photographs to illustrate stories, editorial cartoonists*

## Verbatim 2003 reports were quickly

### *Printed newspaper "was published in 1605" and the form has thrived*

---

**Sphinx of black quartz, judge my vow.** Thief, give back my prized wax jonquils. The quick brown fox jumps over the lazy dog. Sixty zippers were quickly picked from the woven jute bag. Jaded zombies acted quaintly but kept driving their oxen forward. *In a formula deus, qualem paulus creavit, dei negatio.* Such a religion as christianity, which does not touch reality at a single point and which goes to pieces the moment reality asserts its rights at any point must be inevitably the deadly enemy of the wisdom of this world which is to say of science and it will give the name of good to whatever means serve to poison, calumniate and cry down all intellectual discipline. Paul well knew that lying that "faith" was necessary.

---

**TYPEFACE DESIGNER** Eduardo Manso *Barcelona, Spain*

**FOUNDRY** Emtype Foundry

**MEMBERS OF TYPEFACE FAMILY/SYSTEM** Regular, Italic, Semibold, Semibold Italic, Bold, and Bold Italic

كبير [kabīr], *pl.* كبار [kibār] *u.* كبراء [kubara] groß, bedeutend; alt, bejahrt; السن ~ [sinn] alt; المهندسين ~: Chefingenieur *m;* ة ~, *pl.* كبائر [kabāir] schwere Sünde *f.*

كبيس [kabīs], eingemacht, konserviert; *s.* سنة.

كتاب [kitāb], *pl.* كتب [kutub] Buch *n,* Schreiben *n,* Schriftstück *n,* Brief *m;* الـ~ أهل Christen *u.* Juden (*als Besitzer der hl. Schrift*).

+ [kuttab] *pl.* كتاتيب [katātīb] Koran- *od.* Elementarschule *f; s.a.* كاتب.

كتابة [kitāba] Schreiben *n,* Schreibkunst *f;* Schrift *f;* Aufschrift *f,* Inschrift *f;* [kitābatan] *Adv.* schriftlich.

كتابي [kitābī] schriftlich, Schreib-; literarisch.

كتاف [kitāf], *pl.* كتف [kutuf] Handschelle *f,* Fessel *f.*

كتام [kitām], Verstopfung *f,* Konstipation *f.*

كتان [katān], Lein *m,* Flachs *m;*

كتب [katāb (jaktub)], schreiben, aufschreiben; verfassen; *Gott:* bestimmen, verhängen (j-m لـ , على); III [katāb] korrespondieren (mit ة); IV ['aktāb] schreiben lassen; diktieren (j-m ة); VI [takatāb] miteinander in Briefwechsel stehen; VIII [iktatāb] abschreiben; sich einschreiben; zeichnen, subskribieren; X [istaktāb] schreiben *od.* abschreiben lassen; diktieren كتبة *s.* كاتب (j-m ة).

كتبي [kutubī], Buchhändler, *m.*

كتف [kataf (jaktīf)], fesseln; V [takattaf] die Arme verschränken; VI [takātaf] einander stützen, solidarisch sein.

+ [katf *u.* katif], *pl.* أكتاف ['aktaf] Schulter *f;* Berghang *m;*

---

# Nassim

Regular • **SemiBold** • **Bold** • **Heavy** • *Italic* • *SemiBold Italic* • **Bold Italic** • **Heavy Italic**

---

## Avicenna

ABŪ ʿALĪ AL-HUSAYN IBN ʿABD ALLĀH IBN SĪNĀ, dit Avicenne (en persan: أبو علي الحسين بن عبد الله بن سينا ) était un philosophe, médecin et mystique persan. Il naquit en 980 à Afshéna, près de Boukhara dans la région de l'actuel Ouzbékistan, et mourut à Hamadan en 1037.

### Contexte historique
La conquête de l'Égypte mit les musulmans au contact de l'école d'Alexandrie. Aux premiers siècles de l'hégire (VIIe et VIIIe siècle), l'Orient est pris d'une soif de traduire, d'apprendre, de compiler les écrits des anciens, grecs surtout, de les commenter, de les assimiler. Une surenchère au savoir commence entre la culture arabe

## ابن سينا

ابن سينا (شيخ الرئيس ابو علي سينا) یا پور سینا (۹۸۰ – ۱۰۳۷) دانشمند، فیلسوف و پزشک ایرانی، ۴۵۰ کتاب در زمینه‌های گوناگون نوشته‌است که تعداد زیادی از آن‌ها در مورد پزشکی و فلسفه‌است. جرج سارتون او را مشهورترین دانشمند سرزمین‌های اسلامی می‌داند که یکی از معروف‌ترین‌ها در همه زمان‌ها و مکان‌ها و نژادها است. کتاب معروف او کتاب قانون است.فهرست مندرجات.

## زندگی
ابن سینا یا پورسینا حسین پسر عبدالله زاده در سال ۳۷۰ هجری قمری و در گذشته در سال ۴۲۸ هجری قمری، دانشمند و پزشک و فیلسوف. نام او را به تفاریق ابن سینا، ابوعلی سینا، و پور سینا گفته‌اند. در برخی منابع نام کامل او با ذکر القاب چنین آمده:

**TYPEFACE DESIGNER** Titus Nemeth *Vienna, Austria*

**FOUNDRY** sehstoerung@sonance.net

**LANGUAGE** Arabic and Latin

# Arno Pro

ABCDEFGHIJKLMNOPQQRSTUVWWXYZ
abcdefghijklmnopqrstuvwxyz & 1234567890
ABCDEFGHIJKLMNOPQQRSTUVWWXYZ
*ABCDEFGHIJKLMNOPQRSTUVWWXYZ*
*abcdefghijklmnopqrstuvwxyz bd ∂fghijklpqy & 1234567890*
*ABCDEFGHIJKLMNOPQRSTUVWXYZ*

АБВГГДЕЖЗИЙКЛМНОПРСТУФХЦЧШЩЪЫЬЭ
ЮЯабвгддежзийклмнопрстуфхцчшщъыьэюя
АБВГГДЕЖЗИЙКЛМНОПРСТУФХЦЧШЩЪЫЬЭЮЯ
*АБВГГДЕЖЗИЙКЛМНОПРСТУФХЦЧШЩЪЫЬЭЮЯ*
*абвггдежзийклмнопрстṻуфхцчшщъыьэюябббдdruyфḥjḥ*
*АБВГДЕЖЗИЙКЛМНОПРСТУФХЦЧШЩ*

ΑΒΓΔΕΖΗΘΙΚΛΜΝΞΟΠΡΣΤΥΦΧΨΩ
αβγδεζηθικκλμνξοπϖρςστυφφχψωγγλλκ⊗
ΑΒΓΔΕΖΗΘΙΚΛΜΝΞΟΠΡΣΤΥΦΧΨΩ
*ΑΒΓΔΕΖΗΘΙΚΛΜΝΞΟΠΡΣΤΥΦΧΨΩ*
*αβγδεζηθικκλμνξοπϖρςστυφφχψωγγλλκ⊗βγδζηϑλμξρφχψ*
*ΑΒΓΔΕΖΗΘΙΚΛΜΝΞΟΠΡΣΤΥΦΧΨΩ*

**TYPEFACE DESIGNER** Robert Slimbach *San Jose, CA*

**FOUNDRY** Adobe Systems, Inc.

**LANGUAGE** Cyrillic, Latin, and Polytonic Greek

**MEMBERS OF TYPEFACE FAMILY/SYSTEM** Regular, Italic, Semibold, Semibold Italic, Bold, Bold Italic.

Caption: Italic, Semibold, Semibold Italic, Bold, Bold Italic. Small Text: Italic, Semibold, Semibold Italic, Bold, Bold Italic. Subhead: Italic, Semibold, Semibold Italic, Bold, Bold Italic. Display: Italic, Light Italic, Semibold, Semibold Italic, Bold, Bold Italic

www.Linotype.com

نموذج من خط ميدان ميدان

تاريخ لاينوتايب العريق في فن
# الطباعة العربية

لاينوتايب لها تاريخ عريق في فن الطباعة العربية. ففي العام 1911 كانت أول من اخترع آلة الصف الميكانيكي للخط العربي. وفي العام 1954 أصدرت خط النسخ المبسط الذي سهل وسرع عملية الطباعة. واليوم تقوم لاينوتايب بتحديث مجموعتها لتناسب آخر التطورات في مجال الكمبيوتر. كما أنها تتعامل مع أهم المصممين من أجل توسيع مجموعتها لتتناسب مع حاجة المنطقة العربية. كما تتعامل لاينوتايب مع أكبر الشركات فترخصهم خطوطها لكي يضيفوها إلى برامجهم. وتملك لاينوتايب القدرة على إنتاج الخطوط بأحدث وأعلى التقنيات الموجودة اليوم.

وتتألف مجموعتها من 7700 خط وبهذا فهي من أكبر الموزعين في العالم. وهي تعطي أهمية كبيرة لحماية مجموعتها ولهذا فهي تسجل معظم خطوطها بالإضافة الى كونها ماركة مسجلة في بعض الأحيان. وتتكفل لاينوتايب بنفقات هذه الخطوة التي تحمي حقوق لاينوتايب والمصممين الذين تتعامل معهم. يتم

ء آ آ أ أ ؤ ؤ إ إ ئ ئ ئ ا ا ب ببب ة ة ت تت ت ثث ث جج
ج حح خ خخخ د د د ذ ذ ر رز ز سس سس ش شش ش ص صصص
ض ضضض ط ططط ظ ظظظ ع عع ع غ غغ غ ف ففف ق
ققق ك ككك ل لل ل م ممم ن نن ن ه هه ه و و ى ى ي ي يي ي أ أ
ت ت ت پ پپپ چ چچچ ڈ ڈ ڑ ڑ ژ ژ ٿ ٿقٿ ک ککک گ گگگ ن
ة ة ه ه ـ ـ ء ء لا لا لأ لأ لإ لإ لآ لآ 0123456789
٠١٢٣٤٥٦٧٨٩ ٪ . ، ؛ : ؟ ! ... . » » « « لله ★ ◌
_ _ _ {} ( ) * ◌ © ® ™ × + - # ×

لاينوتايب لها تاريخ عريق في فن الطباعة العربية. ففي العام 1911 كانت أول من اخترع آلة الصف الميكانيكي للخط العربي. وفي العام 1954 أصدرت خط النسخ المبسط الذي سهل وسرع

**TYPEFACE DESIGNER** Kameel Hawa *Beirut, Lebanon*

**FOUNDRY** Linotype GmbH

**LANGUAGE** Arabic, Persian, and Urdu

**MEMBERS OF TYPEFACE FAMILY/SYSTEM** Regular

**MIDAN** 285

Custom font project for the digital setting of the musical notation system used for Gregorian chant (Neumatic notation).

Example in use

↓ "Proprium Missarum de Tempore" – Dominica I. Adventus, Responsorium.
Copied from "Graduel Dominicains", 1928.
In yellow are the key entries combinations for each line. Red hightlight represent the use of bold and italic complementary fonts for *liquescences*.
NB: Setting and designing the text of the song was not part of the project; the font used in this example is Xavier Dupré's *Zingha*.

Today, Gregorian chant is still written using the Middle Ages notation, which is also the base of our modern notation for music. But for years now, the need for digital documents for publishing pushed the Gregorian community to look for new solutions, such as programming, softwares and fonts.
OpenType technology can facilitate the work of type setting and improve the result quality: with a number of glyphs almost unlimited but easy to access, it gives quite a lot of freedom for experimentation. Gregoria uses ligatures and contextual alternates for simple to complex combinations of notes, for spacing adjustments, for rythmical signs positioning. To obtain the "liquescent" alternate forms an italic and a bold version have been designed. Modular widths ensure a plain rhythm and a constant line length.

**TYPEFACE DESIGNER** Elena Alberton *Berlin, Germany*

**FOUNDRY** Anatoletype and Abbaye Sainte-Madeleine du Barroux

**CLIENT** Abbaye Sainte-Madeleine du Barroux

**LANGUAGE** Musical Notation

**MEMBERS OF TYPEFACE FAMILY/SYSTEM** Regular, Italic, Bold, and musical notations

The underlying principle in the design of Flexion is mirror-image symmetry, which occurs naturally in the structure of eleven capital letters in the Roman alphabet. Another few have been coaxed into adopting that symmetry, while still others find their reflected counterparts elsewhere in the alphabet.

# FLEXION

QWERTY
UIOPAS
DFGHJ
KLZXC
VBNM

(123.,#QWERTYUIOP
456;:@!%ASDFGHJKL"
7890€*?$)ZXCVBNM'

**TYPEFACE DESIGNER** John Langdon and Hal Taylor
*Philadelphia, PA*

**MEMBERS OF TYPEFACE FAMILY/SYSTEM** Regular, Medium, Bold, and Black

**FOUNDRY** Veer

Alphabet Booboo Crawling Doll
Earache Finger-painting Giggle
Hephelumps Iodine Jack-in-the-box
Kickball Lullaby Mommy Nana
Oops Poopy Quizzical Rashes
Sniffles Tummy Uh-uh Virus
Willy-nilly X-ray Yawn Zigzag
1 2 3 4 5 6 7 8 9 & 0
Some Peanut Alternates:
Q R Q A K E Z Y L V
Th fi rr tt o ss ff g e l q t y u ll
ft s z i d h n m k fl & u

**TYPEFACE DESIGNER** Michael Clark
*Richmond, VA*

**FOUNDRY** P22/International House of Fonts

**MEMBERS OF TYPEFACE FAMILY/SYSTEM** Regular,
Pro, and Salted

## QUIOSCO ONE

# Nn

# *Etc*

GRUMPY WIZARD MAKING *TOXIC BREWS FOR THE EVIL* queens and jack. Lazy movers quit hardly packing of jewelry box. Back in a quaint gardens, jaunty zinnias vie with flaunt phlox. Hark! 4,872 toxic wait vipers quietly drop atop zebra for meals! *New farmer's hand (picking just over six quinces) proved strongest but lazy.* For about $650, jolly housewives made 'expensive' meals using quick-frozen vegetable. **Jade zombie acted quaintly but kept driving their ox afore.** At my grand prix, J. Blatz was equally vilified for his funkier ways. My Grandfathers spent their day quickly carving wax buzzards, mostly from a junk. When we travel back to Juarez Mexico, do we fly over picture of Arizona? Murky haze envy

**GRUMPY WIZARD MADE** *TOXIC BREWS FOR THEIR* **evil queens and jacks. Lazy movers quit hard packings of jewelry boxes.** *Back into my quaint gardens, jauntier zinnias vie with a flaunting phlox.* **Hark! 401,872 toxic jungle water vipers quietly drop onto zebras for meals**

## QUIOSCO TWO

# Nn

# *Etc*

GRUMPY WIZARD MAKING *TOXIC BREWS FOR THE EVIL* queens and jack. Lazy movers quit hardly packing of jewelry box. Back in a quaint gardens, jaunty zinnias vie with flaunt phlox. Hark! 4,872 toxic wait vipers quietly drop atop zebra for meals! *New farmer's hand (picking just over six quinces) proved strongest but lazy.* For about $650, jolly housewives made 'expensive' meals using quick-frozen vegetable. **Jade zombie acted quaintly but kept driving their ox afore.** At my grand prix, J. Blatz was equally vilified for his funkier ways. My Grandfathers spent their day quickly carving wax buzzards, mostly from a junk. When we travel back to Juarez Mexico, do we fly over picture of Arizon? Murky haze envy

**GRUMPY WIZARD MADE** *TOXIC BREWS FOR THEIR* **evil queens and jacks. Lazy movers quit hard packings of jewelry boxes.** *Back into my quaint gardens, jauntier zinnias vie with a flaunting phlox.* **Hark! 401,872 toxic jungle water vipers quietly drop onto zebras for meals**

## QUIOSCO THREE

# Nn

# *Etc*

GRUMPY WIZARD MAKING *TOXIC BREWS FOR THE EVIL* queens and jack. Lazy movers quit hardly packing of jewelry box. Back in a quaint gardens, jaunty zinnias vie with flaunt phlox. Hark! 4,872 toxic wait vipers quietly drop atop zebra for meals! *New farmer's hand (picking just over six quinces) proved strongest but lazy.* For about $650, jolly housewives made 'expensive' meals using quick-frozen vegetable. **Jade zombie acted quaintly but kept driving their ox afore.** At my grand prix, J. Blatz was equally vilified for his funkier ways. My Grandfathers spent their day quickly carving wax buzzards, mostly from a junk. When we travel back to Juarez Mexico, do we fly over picture of Arizona? Murky haze envy

**GRUMPY WIZARD MADE** *TOXIC BREWS FOR THEIR* **evil queens and jacks. Lazy movers quit hard packings of jewelry boxes.** *Back into my quaint gardens, jauntier zinnias vie with a flaunting phlox.* **Hark! 401,872 toxic jungle water vipers quietly drop onto zebras for meals**

## QUIOSCO FOUR

# Nn

# *Etc*

GRUMPY WIZARD MAKING *TOXIC BREWS FOR THE EVIL* queens and jack. Lazy movers quit hardly packing of jewelry box. Back in a quaint gardens, jaunty zinnias vie with flaunt phlox. Hark! 4,872 toxic wait vipers quietly drop atop zebra for meals! *New farmer's hand (picking just over six quinces) proved strongest but lazy.* For about $650, jolly housewives made 'expensive' meals using quick-frozen vegetable. **Jade zombie acted quaintly but kept driving their ox afore.** At my grand prix, J. Blatz was equally vilified for his funkier ways. My Grandfathers spent their day quickly carving wax buzzards, mostly from a junk. When we travel back to Juarez Mexico, do we fly over picture of Arizona? Murky haze envy

**GRUMPY WIZARD MADE** *TOXIC BREWS FOR THEIR* **evil queens and jacks. Lazy movers quit hard packings of jewelry boxes.** *Back into my quaint gardens, jauntier zinnias vie with a flaunting phlox.* **Hark! 401,872 toxic jungle water vipers quietly drop onto zebras for meals**

**TYPEFACE DESIGNER** Cyrus Highsmith *Boston, MA*

**FOUNDRY** Font Bureau, Inc.

**MEMBERS OF TYPEFACE FAMILY/SYSTEM** Roman, Roman LF, Italic, Italic LF, Bold, Bold LF, Bold Italic, Bold Italic LF

# Greta Text

ABCDEFGHIJKLMNOPQRSTUVW

**ABCDEFGHIJKLMNOPQRSTUVW**

ĂÄÃÂÀÅÁÃĄÇĈĊČĆĐĎLĔÊĒËĘĖÈÉĤĦĞĠĜĢĮĪÍĨÎÏÌÎĴĶĹĽŁĻĿŇŅŃÑÑÒÓÕ
ÓÔÖÕØŔŘŖŚŠŜŞȚŢŤŬÛÜŮÚÙŲŨÛŴŶŸÝŹŻŽĐÞ

abcdefghijklmnopqrstuvwxyzß

**abcdefghijklmnopqrstuvwxyz**

*abcdefghijklmnopqrstuvwxyzß*

ääãâàåáãąçĉċčćďđěêēëęèéĥħğġĝģįīíĩîïìĵķĺľłļł''ņńňññòóõ
óôöõøŕřŗśšŝşţţťŭûüůúùụũûŵŷÿýźżž̇ðþ
fiflfhfbfjfkffffiffl+fifi

0123456789 (.,;:) [‰‰] {?!}

*0123456789 (.,;:) ***

€$¥£¢ƒ«»§&@†‡πμ∫Ω

−+×<>±≤≥=≠#∞◊¬®©™

¶

**TYPEFACE DESIGNER** Peter Bilak *The Hague, The Netherlands*

**FOUNDRY** Typotheque Type Foundry

**MEMBERS OF TYPEFACE FAMILY/SYSTEM** Text and Display

# IT WAS A WET, BAD YEAR ON THE OLD WESTERN TRAIL; HERD AFTER HERD WAS WATERBOUND BY HIGH WATER IN THE RIVER AND THE DRIFTWOOD WOULD HAVE MADE IT DANGEROUS SWIMMING FOR CATTLE. THE MEN GOT IMPATIENT WAITING, MAKING INQUIRIES ALONG ALTERNATE ROUTES.

**TYPEFACE DESIGNER** David Jonathan Ross
*Amherst, MA*

**FOUNDRY** DJR Type

**MEMBERS OF TYPEFACE FAMILY/SYSTEM** Regular

**MANICOTTI** 291

The SANS for all seasons

*Multifamily harmony*

Complementary alphabets & the extra glyph ranges

Refreshing READING

*With our building's parking lot*

**SÉRÜLÉST Rođendan čaj:**

That is the Quirinal Hilltop!

mixing & matching ALL THIS TYPE

ABC-0123 0123456789/0123456789

MAGNETIC

ꝗ ꝑ 1st ℭ 2nd ℭ 3RD ⅋

An informal... Palatino?

*58 years later in 2006*

typographic solutions, 21st century communications

Text & Display Type

*Pair with my informal greeting*

**MÉRTÉKŰ přátelé měl**

Quattro são provençal jutro

Hermann Zapf–Akira Kobayashi

CAPS, SMALL CAPS, U&lc...

ARTISANRY

↲ ↬ « ⇝ ↗ ↰ » ↫ ↝

292   **PALATINO SANS AND PALATINO SANS INFORMAL**

**TYPEFACE DESIGNER** Hermann Zapf and Akira Kobayashi *Bad Homburg, Germany*

**FOUNDRY** Linotype GmbH

**MEMBERS OF TYPEFACE FAMILY/SYSTEM**
Sans: Regular, Italic, Light, Light Italic, Ultra Light, Ultra Light Italic, Ultra Light Arrows, Medium, Medium Italic, Bold, Bold Italic.

Sans Informal: Regular, Italic, Light, Light Italic, Ultra Light, Ultra Light Italic, Medium, Medium Italic, Bold, Bold Italic

Est d'un très-mauvais effet

*La conclusion de cette paix*

FILS DU ROI DE HOLLANDE

*MARCHE SUR SAINT-DIZIER*

Cent députés de bologne

*14 octobre bataille d'iéna*

JE NE PEUX PLUS MONTER

***CHASSEURS OU HUSSARDS***

Une grande supériorité

***À de nouvelles batailles***

**MONSIEUR LE CARDINAL**

***FORTE DE 4000 HOMMES***

**TYPEFACE DESIGNER** Joshua Darden *Brooklyn, NY*

**FOUNDRY** Joshua Darden Studio

**MEMBERS OF TYPEFACE FAMILY/SYSTEM** Bold, Italic, Bold Italic, Book, Book Italic, Semibold, and Semibold Italic

**CORUNDUM TEXT**

# Incarnation

## *Verrazzano*

## **Somerville**

## *Brightman*

## **Silverman**

## *Jørgenson*

## **Applegate**

## *Sandwich*

**UNTITLED**

**TYPEFACE DESIGNER** Joshua Darden *Brooklyn, NY*

**FOUNDRY** Joshua Darden Studio

**CLIENT** Michael Picon, Emap UK plc

**MEMBERS OF TYPEFACE FAMILY/SYSTEM** Regular, Regular Italic, Light, Light Italic, Bold, Bold Italic, Black, and Black Italic

# TDC4

included Aaron Burns, Louis Dorfsman, Eugene Ettenberg, Gene Federico, Robert M. Jones, Herb Lubalin, Frank Powers, Bradbury Thompson, and Milton Zudeck. That is as star-studded a panoply of typographic opinions as may ever have been assembled in one room.

The catalog includes winners by Lester Beall, Will Burtin, Ivan Chermayeff, Freeman Craw, Bob Gill, George Lois, Ladislav Sutnar, and Henry Wolf, as well as by many of the judges. (The rule was later changed many years ago to exclude judge's and judge's partner's work to ensure objectivity and integrity in TDC competitions.)

This is the third reprinting of the earliest TDC Competition catalogs. We began this practice two years ago in *Typography 26* to give new life to these historical records. The original catalogs are crumbling with age and need to be preserved. We hope this work may continue to inspire.

*The TDC Board of Directors*

# 1957

Reproduction Notes:
Designed by Robert M. Jones
8 3/8" x 10 3/4" (21.3 x 27.5 cm), saddlestitched.
Pages have been reduced slightly to show trim.

Additional information about this catalog
can be found in the colophon on its last interior page.

Additional information on the development of the TDC Competition
can be found on page 266 in *Typography 23*.

*The Fourth Annual Awards for*

# Typographic Design Excellence

*The Type Directors Club of New York*

*The*
*fourth*
*annual*
*awards*
*for*

# *TYPOGRAPHIC*
# *DESIGN*
# *EXCELLENCE*

The
Type
Directors
Club
of
New York

Trade Ad: **Allan Fleming**
for Cooper & Beatty, Ltd.

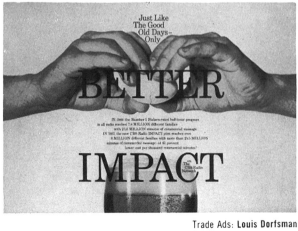

Trade Ads: **Louis Dorfsman**
for CBS Radio Network

Trade Ad: **Freeman Craw**
for Tri-Arts Press, Inc.

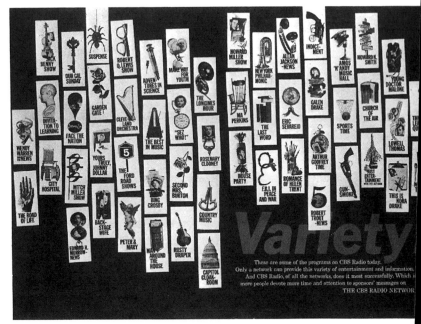

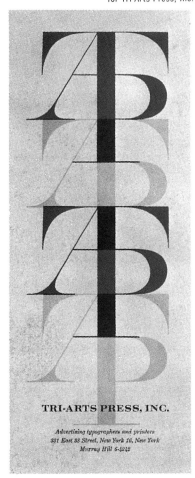

Ad Design: **Gene Federico**
for Douglas D. Simon Advertising

Trade Ad: **Norman Gollin**
for The Dreyfus Co.

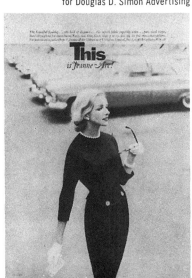

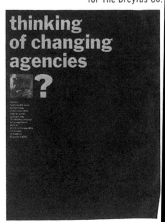

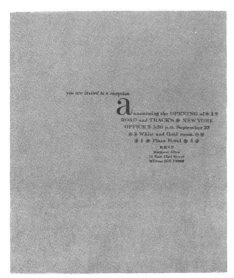

Special Occasion: **Sal Jon Bue**
for Road & Track Magazine

Editorial Design: **Henry Wolf** for Esquire Magazine

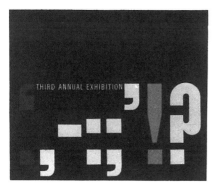

Direct Mail: **Robert Nelson**
for Minneapolis Art Director's Club

Direct Mail: **John Graham** for National Broadcasting Company

Ad Design: **Arnold Varga** for Cox's

Direct Mail: **J. K. Fogleman** for Ciba

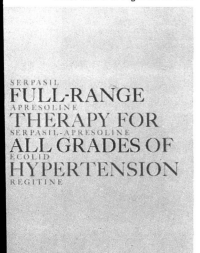

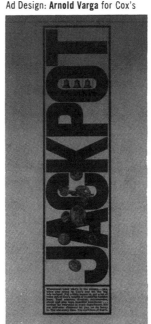

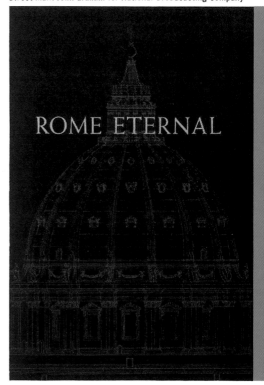

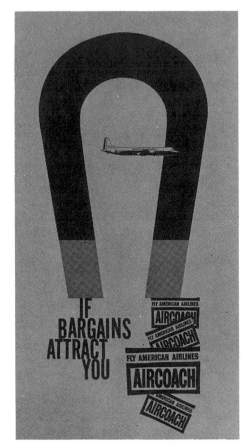

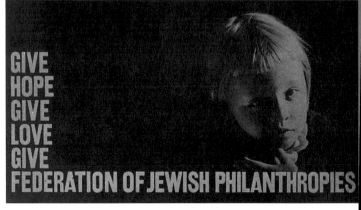

Adv. Design: **Herb Lubalin-Herb Strecker** for Federation of Jewish Philanthropies

Adv. Design: **Michael Wollman** for American Airlines

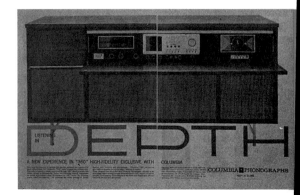

Adv. Design: **Milton K. Zudeck** for McCann-Erickson

Adv. Design: **Gene Federico** for Douglas D. Simon Adv. Agency

Trade Ad: **Herb Lubalin** (Sudler & Hennessey)
for The Wm. S. Merrell Co.

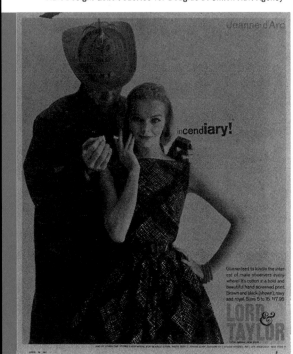

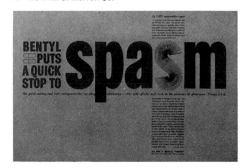

Trade Ad: **Herb Lubalin** (Sudler & Hennessey) for Schering

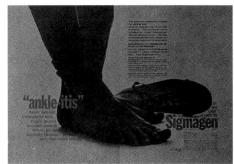

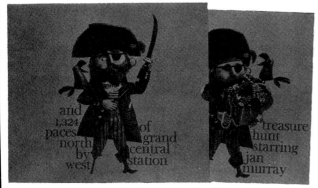

Direct Mail: **John Graham** for National Broadcasting Co.

Direct Mail: **Richard Loew** for Vogue Magazine

Direct Mail: **Bob Gill** for Art and Fay Harris

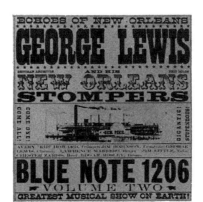

Point of Sale: **Reid Miles** for
Blue Note Records

Direct Mail: **Les Mason, Bill Di Meo**
for Sam Wu

Direct Mail: **Gene Federico**
for Murray Duitz

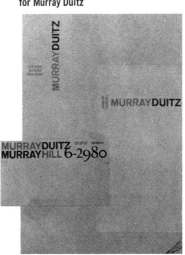

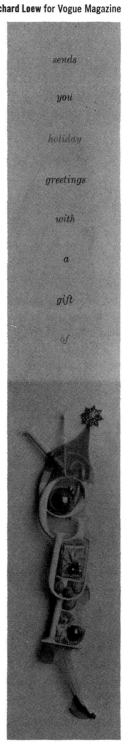

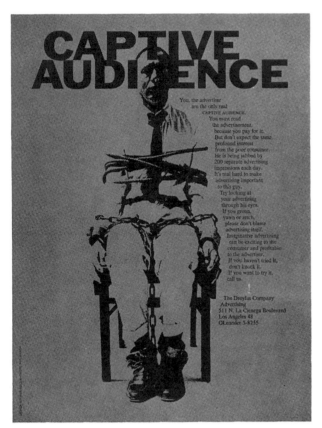

Trade Ad: **Norman Gollin** for The Dreyfus Co.

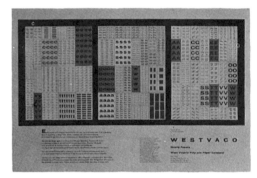

Ad Design: **Bradbury Thompson**
for West Virginia Pulp and Paper Company

Trade Ad: **George Lois** (Sudler & Hennessey)
for Esta Medical Laboratories

Ad Design: **Bob Farber** for Irving Serwer Advertising

Trade Ad: **Herb Lubalin** for Sudler & Hennessey

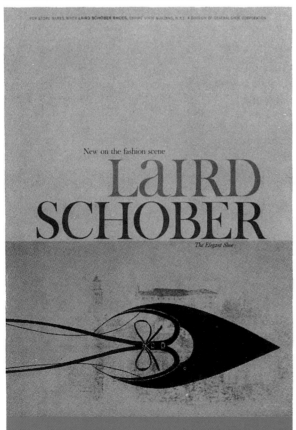

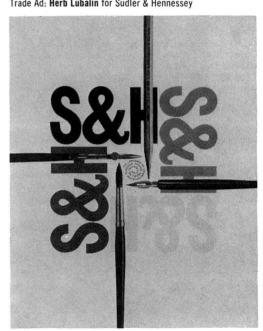

Direct Mail: **Herb Lubalin** for
The Art Directors Club of N. Y.

Direct Mail: **Sam Scali**
for Mary Ann Larkin

Direct Mail: **James P. Camperos** for
The National Secretaries Ass'n.

Point of Sale: **Frederick A. Usher, Jr.** for General Lee's Restaurant

Direct Mail: **Rosemary Littman** for The Composing Room, Inc.

Special Occasion: **John & Marilyn Neuhart** for the Hand Press

Special Occasion: **William Hirsch, Samuel Martin**
for Kramer, Hirsch and Carchidi

Adv. Design: **Peter M. Hirsch** for Douglas D. Simon Agency

Direct Mail: **Arnold Varga**
for Art Directors Society of Pittsburgh

Direct Mail: **Arnold Varga**
for Art Directors Society
of Pittsburgh

Adv. Design: **Louis Dorfsman**
for CBS Radio Network

Adv. Design: **Gene Federico**
for Container Corp. of Amer.

Adv. Design: **Lawrence Gaynor** for AAIN, Inc.

Direct Mail: **Raymond Dowden** for Cooper-Union

Direct Mail: **Bob Corey** for Anderson-McConnell Adv., Inc.

Direct Mail: **Roy Kuhlman**
for Stanley Home Products Inc.

Direct Mail: **George Lois**
(Sudler & Hennessey) for The Upjohn Co.

Direct Mail: **James Shade** for The Ass'n
of Graphic Designers

Direct Mail:
**Roy Kuhlman** for Public Relations Graphics

Trade Ad: **Louis Dorfsman** for CBS Radio Network

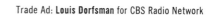

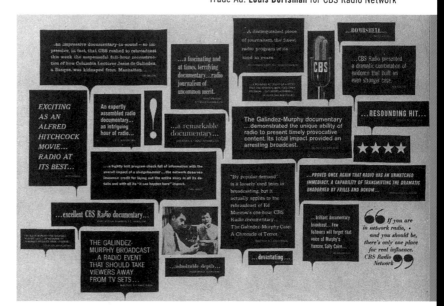

Japanese prints of the nineteenth century at GCA

Poster: **Allan Fleming** for Cooper & Beatty, Ltd.

Direct Mail: **Tony Palladino**
for Irving Werbin Associates

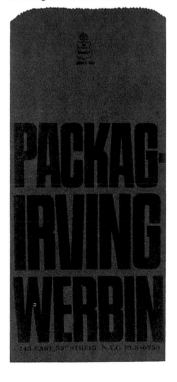

Special Occasion: **Robert M. Jones**
for Robert M. Jones

Ad Design: **Gene Federico** for Douglas D. Simon Adv. Agency

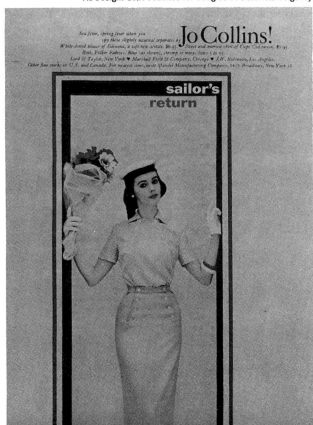

Direct Mail: **Herb Lubalin & Frank Wagner**
for Wallace Laboratories

Direct Mail: **Advertising Designers**
for Institute for Defense Analyses

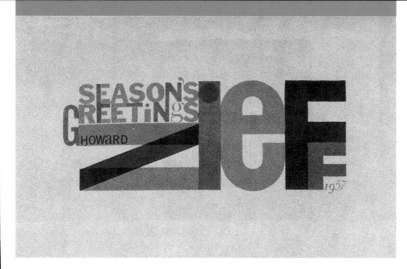

Direct Mail: **Bob Farber** for G. Howard Zieff

Special Occasion: **Henry Wolf** for Henry Wolf

Direct Mail: **Hal Stebbins** for Hal Stebbins, Inc.

Direct Mail: **Gene Federico** for
Art Directors Club of N. Y.

Direct Mail: **Herb Lubalin** (Sudler & Hennessey) for Douglas D. Simon

Direct Mail: **Herb Lubalin** (Sudler & Hennessey)
for N. Y. Life Insurance Co.

Direct Mail: **Robert Nelson**
for Minneapolis Art Directors Club

Direct Mail: **Allan Fleming** for Cooper & Beatty, Ltd.

Direct Mail: **Hy Farber** for Industry & Architecture

Special Occasion: **Onofrio Paccione** for Paccione

Direct Mail: **Ernest R. Smith** (Arranz & Sudler)
for Merck Sharp & Dohme (Australia)

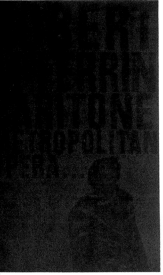

Direct Mail: **Bob Gill**
for Concert Associates, Inc.

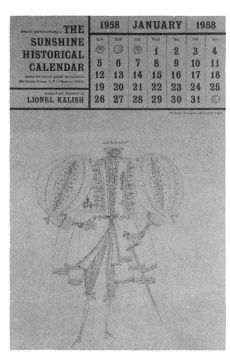

Direct Mail: **Lionel Kalish** (Empire Typographers, Inc.)
for The Sunshine Historical Calendar

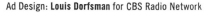

Ad Design: **Louis Dorfsman** for CBS Radio Network

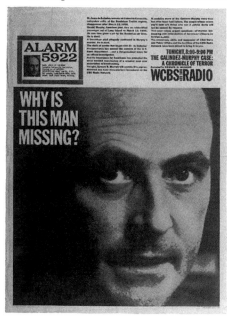

Direct Mail: **Robert M. Jones** for The Glad Hand Press

Poster: **Sutnar-office**
for "addo-x" adding machines

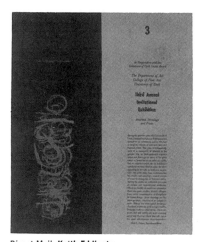

Direct Mail: **Keith Eddington**
for University of Utah

Direct Mail: **Helen Federico**
for The Museum of Primitive Art

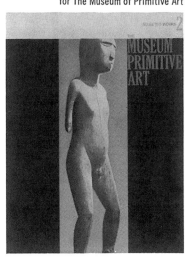

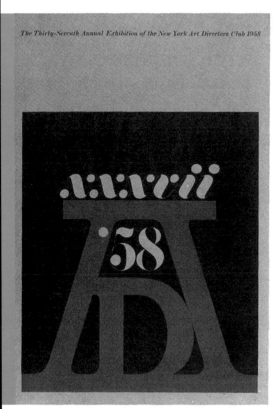

Direct Mail: **Herb Lubalin, Louis Dorfsman** for Art Directors Club of N. Y.

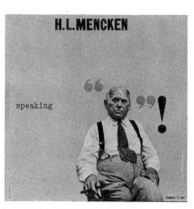

Point of Sale: **Matthew Leibowitz** for Matthew Leibowitz

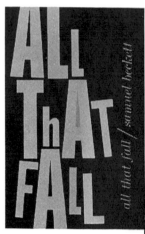

Point of Sale: **Roy Kuhlman** for Evergreen Books

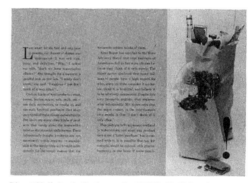

Direct Mail: **Louis Dorfsman** for CBS Radio Network

Direct Mail: **Altman-Stoller Advertising** for Dan Millstein, Inc.

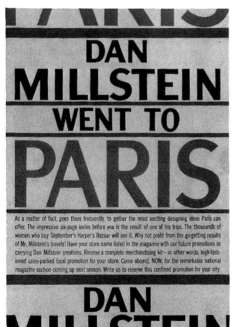

Direct Mail: **Norman Gollin** for Craft-o-grafs

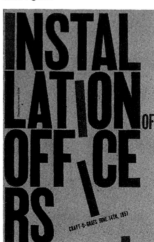

Point of Sale: **Roy Kuhlman** for Evergreen Books

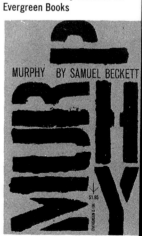

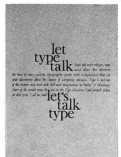
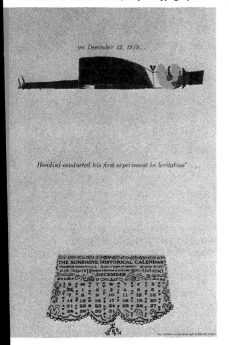
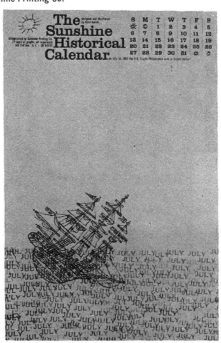
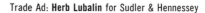
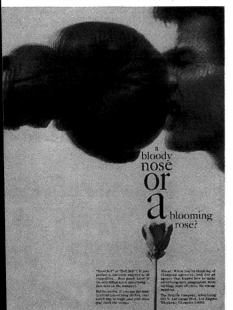
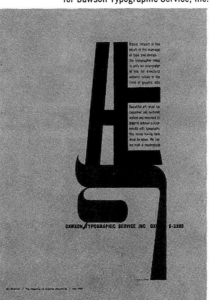
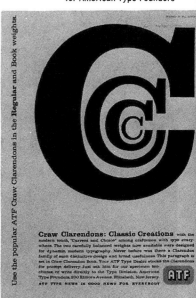

Direct Mail: **Roy Kuhlman** for Public Relations Graphics

Poster: **Herb Lubalin, Gene Federico, Louis Dorfsman**
for Art Directors Club of N. Y.

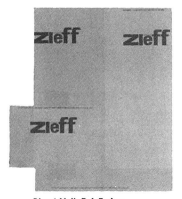

Direct Mail: **Bob Farber**
for Howard Zieff, Inc.

Direct Mail: **George Lois**
for CBS Television Press Information

Special Occasion: **George Lois** for J. P. Stevens & Co., Inc.

Point of Sale: **Emmett McBain**
for Playboy Record Div.
of Playboy Magazine

Point of Sale: **Ivan Chermayeff**
for RCA Camden Records

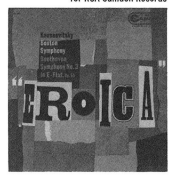

Point of Sale: **Acy Lehman-Carl Fische**
for RCA Victor Record Di

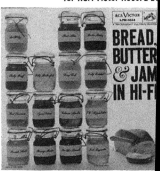

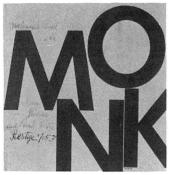

Point of Sale: **Reid Miles**
for Prestige Records

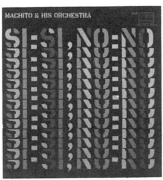

Point of Sale: **Robert Brownjohn**
for TICO Records

Special Occasion: **Gene Garlanda**
for Gilbert Advertising Agency

Direct Mail: **Bob Gill** for Robert Gordon

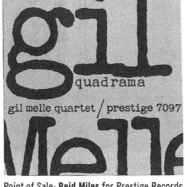

Point of Sale: **Reid Miles** for Prestige Records

Point of Sale: **Irv Werbin-R. M. Jones**
for RCA Victor Records

Adv. Design: **Bob Farber** for R & K Originals

Adv. Design: **Peter M. Hirsch**
for Douglas D. Simon Adv. Agency

Editorial: **Michael Wollman** for "Travel in Fashion Magazine"

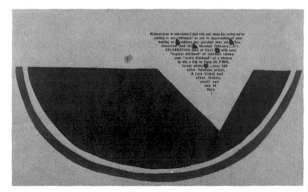

Ad Design: **Arnold Varga** for Cox's

Special Occasion:
**Gene Garlanda** for Gilbert
Advertising Agency, Inc.

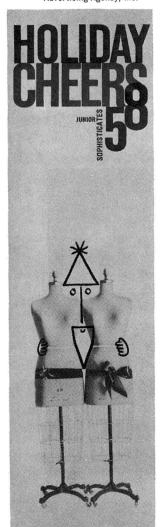

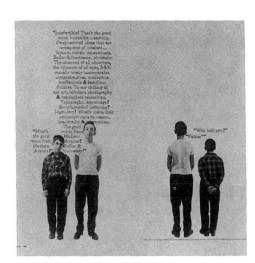

Trade Ad: **Herb Lubalin** for Sudler & Hennessey

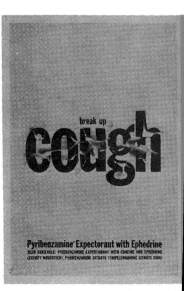

Trade Ad: **Herb Lubalin**
(Sudler & Hennessey) for Ciba

Editorial: **Henry Wolf** for Esquire Magazine

Trade Ad: **Herb Lubalin**
for Sudler & Hennessey

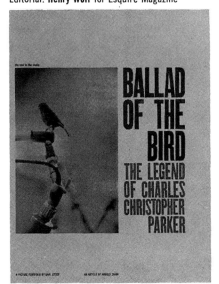

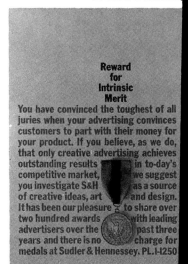

Direct Mail: **Herb Lubalin** (Sudler & Hennessey) for Meier Bernstein

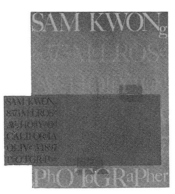

Direct Mail: **Sal JonBue** for Sam Kwong

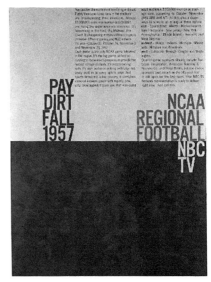

Direct Mail: **John Graham** for National Broadcasting Co.

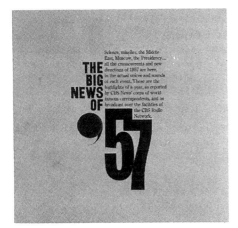

Direct Mail: **Louis Dorfsman** for CBS Radio Network

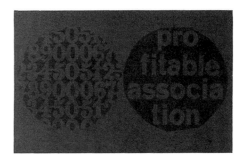

Direct Mail: **Jack Wolfgang Beck** for Jack Wolfgang Beck

Adv. Design: **Matthew Leibowitz** for Container Corp. of America

Direct Mail: **Aaron Burns** for The Composing Room, Inc.

Direct Mail: **Elaine Lustig** for Museu De Art Moderna

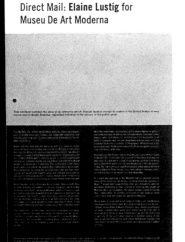

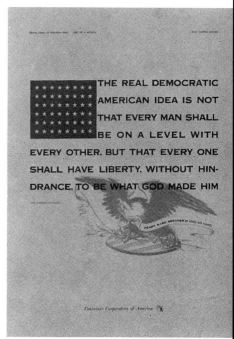

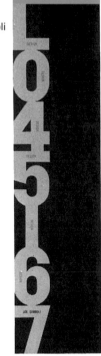

Direct Mail: **Joe Simboli** for Joe Simboli

Poster: **Robert M. Jones** for The Glad Hand Press

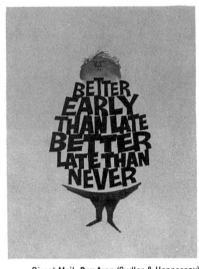

Direct Mail: **Roy Aron** (Sudler & Hennessey)
for A. H. Robins Co., Inc.

Direct Mail: **Roy Kuhlman**
for Public Relations Graphics

Direct Mail: **Roy Kuhlman**
for Public Relations Graphics

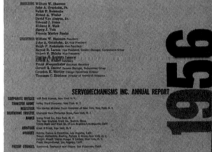

Trade Ad: **Gene Federico**
for Douglas D. Simon Adv. Agency

Special Occasion: **Sal Jon Bue**
for Sam Kwong

Direct Mail: **Aaron Burns**
for Composing Room Inc.

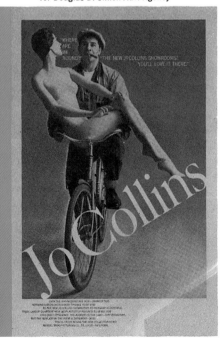

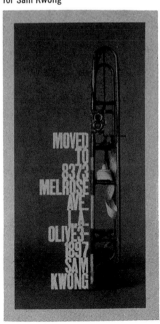

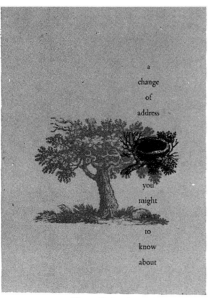

Direct Mail: **Advertising Designers**
for Robert L. Steinle

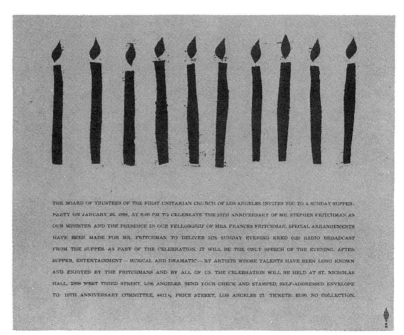

Direct Mail: **Saul Bass** for First Unitarian Church of Los Angeles

Direct Mail: **Asdur Takakjian** for Ski Club of Washington, D. C.

Direct Mail: **Jack Wolfgang Beck** for Jack Wolfgang Beck

Direct Mail: **Hal Stebbins** for Hal Stebbins, Inc.

Special Occasion: **George E. Jaccoma**
for Lawrence Phillip Jaccoma

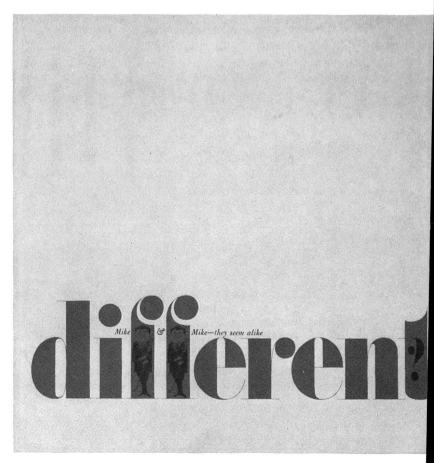

Direct Mail: **Lou Dorfsman** for CBS Radio Netw

Special Occasion: **Bernard Zlotnick**
for Bernard Zlotnick

Direct Mail: **Herb Lubalin** (Sudler & Hennessey) for RCA Tube Div

Special Occasion: **Onofrio Paccione** for John Morrin

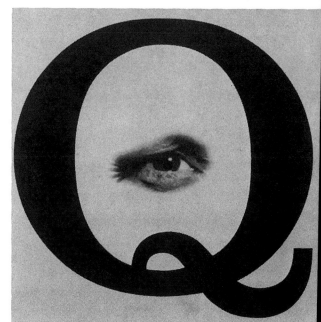

Editorial Design: **Will Burtin** for Scope

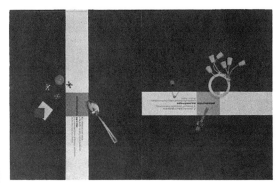

Ad Design: **Will Burtin** for Scope

Direct Mail: **Philip Kirkland**
for Philip Kirkland

Direct Mail: **Allan Fleming**
for Cooper & Beatty Ltd.

Special Occasion: **Tom Heustis** for Nation's Business

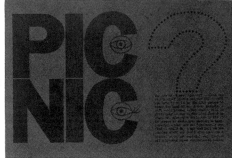

Direct Mail: **Allan Fleming** for Cooper & Beatty Ltd.

Trade Ad: **Louis Dorfsman** for CBS Radio Network

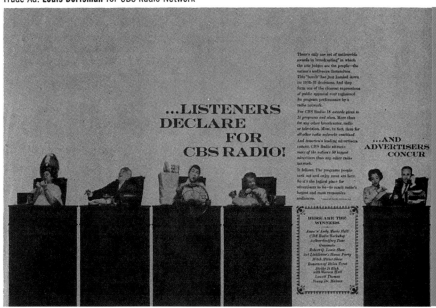

Direct Mail: **Allan Fleming** for Cooper & Beatty Ltd.

Direct Mail: **John Graham** for National Broadcasting Co.

Direct Mail: **Robert M. Jones** for The Glad Hand Press

Direct Mail: **Fred Hausman** for Fred Hausman

Direct Mail: **Herb Lubalin-Martin Weisman** (Sudler & Hennessey) for RCA Tube Div.

Direct Mail: **Ernest R. Smith** (Arranz & Sudler) for Merck Sharp & Dohme

Direct Mail: **Schroeder-Lewis** for Art Directors Club of Philadelphia

Direct Ma **Herb Lubalin** (Sudler & Hennessey) for The Upjohn (

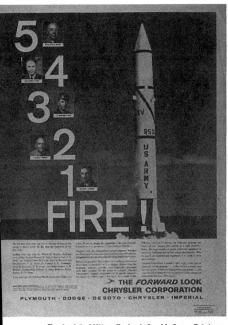

Trade Ad: **Milton Zudeck** for McCann-Erickson

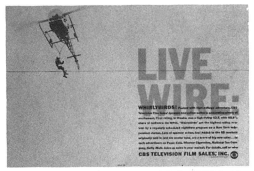

Adv. Design: **George Lois** for CBS Television

Adv. Design: **Lou Dorfsman**
for CBS Radio Network

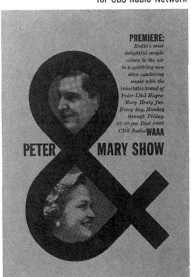

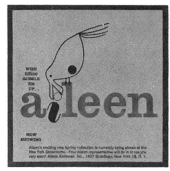

Trade Ad: **Gene Garlanda**
for Gilbert Adv. Agency

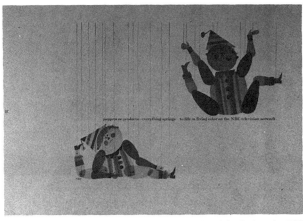

Adv. Design: **John Graham** for NBC

Poster: **George Lois**
for CBS Television Film Sales, Inc.

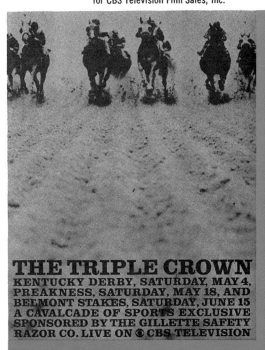

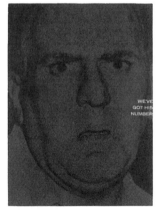

Direct Mail: **John Graham** for
National Broadcasting Co.

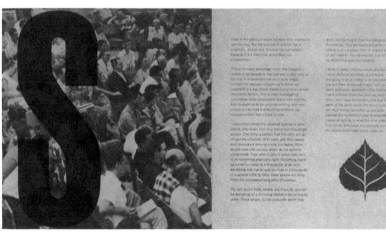

Direct Mail: **Morton Goldsholl** for Morton Goldsholl Assoc.

Direct Mail: **Roy Kuhlman** for Public Relations Graphics

Special Occasion: **William Connell** for Vogue Maga…

Direct Mail: **Gene Federico** for Robert L. Brooks

Special Occasion: **Eugene W. Laurents** for
Eugene W. Laurents

Direct Mail: **John Graham** for National Broadcasting Co.

a flash of her wit, a wave of her personality, and look
a wonderful new variety program comes alive…on
NBC-TV. suddenly the air is filled with fun fun fun
and in the center, arlene francis swinging to the
music of the norman paris trio, creating comedy in
new and surprising situations…laughing it up with
famous guests. what's more she'll move a mountain
of your merchandise…on the arlene francis show.

Direct Mail: **Herb Lubalin** (Sudler & Hennessey) for RCA Tube Div.

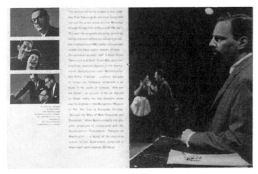

Direct Mail: **John Graham** for National Broadcasting Company

Direct Mail: **Robert M. Jones** for The Glad Hand Press

Direct Mail: **George D'Amato** for George D'Amato

Direct Mail: **Roy Kuhlman** for Public Relations Graphics

Special Occasion: **Allan Fleming** for Cooper & Beatty, Ltd.

Special Occasion: **George E. Jaccoma**
for Concert Associates Inc.

Direct Mail: **Louis Dorfsman**
for CBS Radio Network

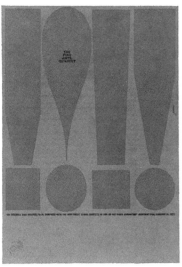

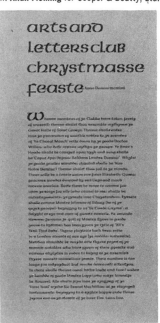

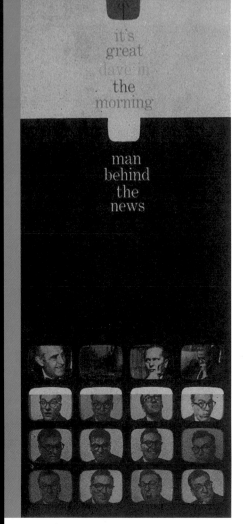

Special Occasion: **Glenn Foss** for Advertising Agencies' Service Co.

Direct Mail: **Herb Lubalin-Martin Weisman** (Sudler & Hennessey) for RCA Tube Div.

Direct Mail: **John Graham** for National Broadcasting Co.

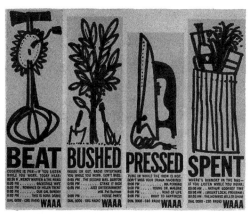

Adv. Design: **Louis Dorfsman** for CBS Radio Network

Direct Mail: **Norman Gollin** for Lefco Products, Inc.

Direct Mail: **Lester Beall** for The Equity Press

Direct Mail: **Frederick A. Usher** for The Museum Ass'n.

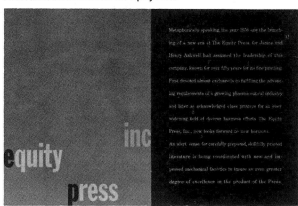

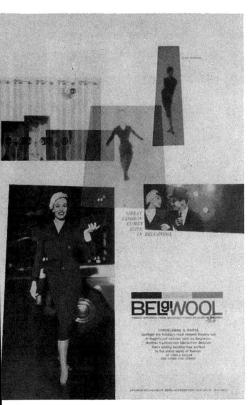

Adv. Design: **Louis Dorfsman** for CBS Radio Network

Adv. Design: **Gene Garlanda** for Gilbert Adv. Agency

Trade Ad: **Louis Dorfsman** for CBS Radio Network
Trade Ad: **Louis Dorfsman** for CBS Radio Network

Adv. Design: **Gene Federico** for Douglas D. Simon Adv. Agency

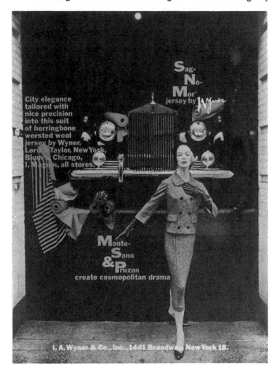

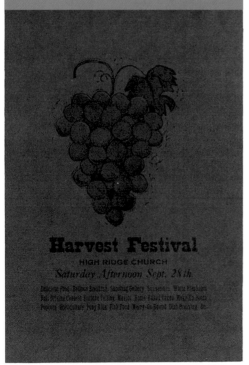

Poster: **Robert M. Jones** for High Ridge Church

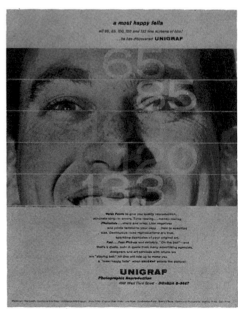

Direct Mail: **Sylvester Brown** for UNIGRAF

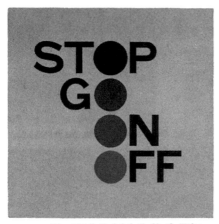

Direct Mail: **Herb Lubalin-Martin Weisman** for RCA Tube Div.

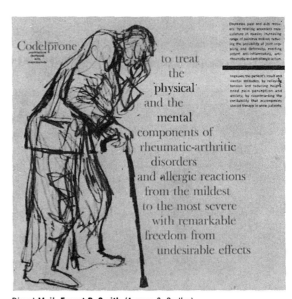

Direct Mail: **Ernest R. Smith** (Arranz & Sudler) for Merck Sharp & Dohme International

Direct Mail: **Ernest R. Smith** (Arranz & Sudler) for Merck Sharpe & Dohme

Direct Mail: **Will Burtin** for Upjohn

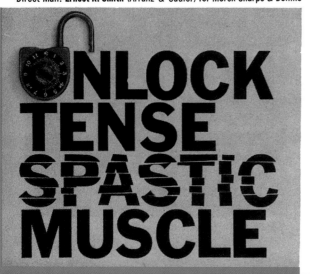

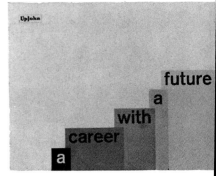

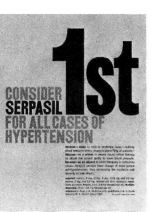

Trade Ad: **Herb Lubalin**
(Sudler & Hennessey) for Ciba

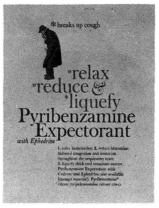
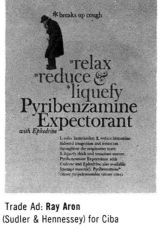

Trade Ad: **Ray Aron**
(Sudler & Hennessey) for Ciba

Ad Design: **Charles MacMurray**
for Stephens-Biondi-DeCicco Inc.

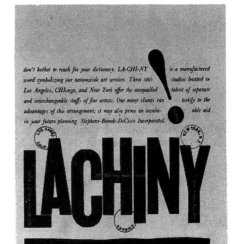

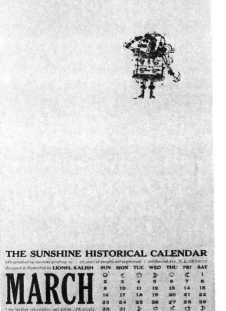

Direct Mail: **Lionel Kalish & Empire Typographers**
for Sunshine Printing Co.

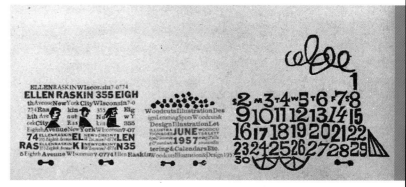
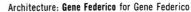

Special Occasion: **Ellen Raskin** for Ellen Raskin

Architecture: **Gene Federico** for Gene Federico

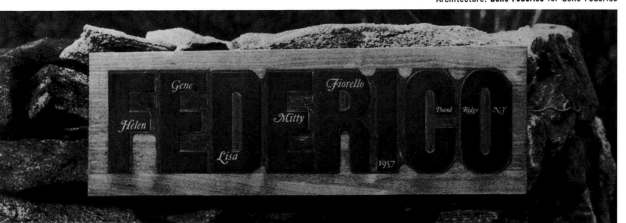

These 196 award pieces are being exhibited at the International Typographic Design Seminar, Silvermine, Conn. on April 26, and also at the Carnegie International Center, New York City on April 28 and 29, 1958.

Design: **Robert M. Jones**
Composition: **Rapid Typographers, Inc.**
Mechanicals: **K.C.&S. Studios**
Paper: **Mohawk, 70 lb. offset**
Photostats: **Active Photo Co.**
Production: **James J. Halpin**
Velox Prints: **Scott Screen Prints Co.**
Printing: **Western Printing & Lithographing Co.**
       **Poughkeepsie, N. Y.**

The Type Directors Club acknowledges with grateful appreciation the contributions made by our own members and all others who helped toward insuring the success of the International Typographic Design Seminar.

Included among those who helped in so many ways are:

International Typographic Composition Association
Advertising Typographers of America, Inc.
The Dictaphone Corporation

**Membership List:**

Arnold Bank, Paul Bennett, Amos G. Bethke, Irwin L. Bogin, Bernard Brussell-Smith, Aaron Burns, Will Burtin, Burton Cherry, Travis Cliett, Mahlon A. Cline, Freeman Craw, Martin Connell, Eugene De Lopatecki, O. Alfred Dickman, Louis Dorfsman, Gene Dunn, Eugene M. Ettenberg, Robert Farber, Gene Federico, Sidney Feinberg, Charles J. Felten, Bruce Fitzgerald, Glenn Foss, Ted F. Gensamer, Vincent Giannone, Louis L. Glassheim, William P. Gleason, Edward M. Gottschall, Hollis W. Holland, Harold Horman, Edward N. Jenks, Robert M. Jones, Randolph R. Karch, Emil J. Klumpp, Edwin B. Kolsby, Ray Komai, Ray Konrad, Arthur B. Lee, Clifton Line, Gillis L. Long, Melvin Loos, John H. Lord, Herb Lubalin, Edgar J. Malecki, Frank Merriman, Francis Monaco, Ross Morris, Tobias Moss, Louis A. Musto, Ariosto Nardozzi, Alexander Nesbitt, Gerard J. O'Neill, Jerry O'Rourke, Dr. G. W. Ovink, Eugene P. Pattberg, William Penkalo, Jan Van Der Ploeg, George A. Podorson, Frank E. Powers, Ernest Reichl, Herbert Roan, Edward Rondthaler, Frank Rossi, Gustave L. Saelens, William H. Schulze, James Secrest, William L. Sekuler, Edwin W. Shaar, Herbert Stoltz, William A. Streever, Robert Sutter, David B. Tasler, William Taubin, Bradbury Thompson, George F. Trenholm, Abraham A. Versh, Meyer Wagman, Steven L. Watts, Joseph F. Weiler, Hermann Zapf, Hal Zamboni, Milton K. Zudeck.

**Sustaining Members:**

Advertising Agencies Service Company Inc., American Type Founders, Inc., Amsterdam Continental Types And Graphic Equipment Inc., A. T. Edwards Typography, Inc., Atlantic Electrotype & Stereotype Company, The Composing Room Inc., Electrographic Corporation, Empire Typographers, Huxley House, Lanston Monotype Machine Co., Oscar Leventhal, Inc., Linocraft Typographers, Ludlow Typograph Company, Mohawk Paper Company, Rapid Typographers, Inc., Sterling Engraving Company, Superior Typography Inc., Tudor Typographers, Westcott And Thomson Inc.

Printed in U.S.A.

# 2007

## TDC OFFICERS, MEMBERS, & INDEXES

## OFFICERS

| | |
|---|---|
| **PRESIDENT** | Alex W. White, Alexander W. White Consultancy |
| **VICE PRESIDENT** | Charles Nix, Scott & Nix, Inc. |
| **SECRETARY/TREASURER** | Diego Vainesman, MJM Creative Services |
| | |
| **DIRECTORS-AT-LARGE** | Christopher Andreola, adcSTUDIO |
| | Matteo Bologna, Mucca Design |
| | Graham Clifford, Graham Clifford Design |
| | Ted Mauseth, Mauseth Design LLC |
| | Chad Roberts, Chad Roberts Design |
| | Anne Twomey, Grand Central Publishing |
| | Maxim Zhukov |
| **CHAIRMAN OF THE BOARD** | Gary Munch, Munchfonts |

## BOARD OF DIRECTORS 2007/2008

### OFFICERS

| | |
|---|---|
| **PRESIDENT** | Alex W. White, Alexander W. White Consultancy |
| **VICE PRESIDENT** | Charles Nix, Scott & Nix, Inc. |
| **SECRETARY/TREASURER** | Diego Vainesman, MJM Creative Services |
| | |
| **DIRECTORS-AT-LARGE** | Matteo Bologna, Mucca Design |
| | Graham Clifford, Graham Clifford Design |
| | Rosanne Guararra, Triumph Learning |
| | Ted Mauseth Design LLC |
| | Chad Roberts, Chad Roberts Design |
| | Anne Twomey, Grand Central Publishing |
| | Maxim Zhukov |
| **CHAIRMAN OF THE BOARD** | Gary Munch, Munchfonts |

## COMMITTEE FOR TDC53

| | |
|---|---|
| **CHAIRMAN** | Graham Clifford |
| **DESIGNER** | Number Seventeen |
| **COORDINATOR** | Carol Wahler |
| | |
| **ASSISTANTS TO JUDGES** | Chris Andreola, Peter Bain, Hida Behzadi, |
| | Deborah Gonet, Nana Kobayashi, Ted Mauseth, |
| | Gary Munch, Alexa Nosal, Daniel Pelavin, |
| | Nick Saleeba, Diego Vainesman, Allan R. Wahler, |
| | Alex W. White, and Andrea Zlanabitnig |

## SPECIAL CITATIONS TO TDC MEMBERS

Edward Gottschall, 1955
Freeman Craw, 1968
James Secrest, 1974
Olaf Leu, 1984, 1990
William Streever, 1984
Klaus F. Schmidt, 1985
John Luke, 1987
Jack Odette, 1989

## 2007 SCHOLARSHIP RECIPIENTS

Meng He,
*Parsons School of Design*
Gleb Lobachov,
*The Cooper Union*
Amanda Morante,
*Fashion Institute of Technology*
Nikola Radovani,
*Art Academy Split, Croatia*
Linton Small,
*School of Visual Arts*
Michelle Testani,
*Tyler School of Art*
Jon Variano,
*Pratt Institute*

## 2007 STUDENT AWARD WINNERS

*First Place ($500)*
Alan von Lützan, Hannes Nordiek, Yuko Stier, and Daniel
Fitzgerald, Muthesius Kunsthochschule Kiel, Germany
*Second Place ($300)*
Tamara Gildengers Connolly, School of Visual Arts, New York
*Third Place ($200)*
Susanna Aldravandi, Academy of Art University,
San Francisco, CA

## TDC MEDAL RECIPIENTS

Hermann Zapf, 1967
R. Hunter Middleton, 1968
Frank Powers, 1971
Dr. Robert Leslie, 1972
Edward Rondthaler, 1975
Arnold Bank, 1979
Georg Trump, 1982
Paul Standard, 1983
Herb Lubalin, 1984 (posthumously)
Paul Rand, 1984
Aaron Burns, 1985
Bradbury Thompson, 1986
Adrian Frutiger, 1987
Freeman Craw, 1988
Ed Benguiat, 1989
Gene Federico, 1991
Lou Dorfsman, 1995
Matthew Carter, 1997
Rolling Stone magazine, 1997
Colin Brignall, 2000
Günter Gerhard Lange, 2000
Martin Solomon, 2003
Paula Scher, 2006

## INTERNATIONAL LIAISON CHAIRPERSONS

ENGLAND
David Farey
HouseStyle
27 Chestnut Drive
Bexleyheath
Kent DA7 4EW

FRANCE
Christopher Dubber
Signum Art
94, Avenue Victor Hugo
94100 Saint Maur Des Fosses

GERMANY
Bertram Schmidt-Friderichs
Verlag Hermann Schmidt
Mainz GmbH & Co.
Robert Koch Strasse 8
Postfach 42 07 28
55129 Mainz Hechtsheim

JAPAN
Zempaku Suzuki
Japan Typography Association
Sanukin Bldg. 5 Fl.
1-7-10 Nihonbashi-honcho
Chuo-ku, Toyko 104-0041

MEXICO
Prof. Felix Beltran
Apartado de Correos
M 10733 Mexico 06000

SOUTH AMERICA
Diego Vainesman
181 East 93 Street, Apt. 4E
New York, NY 10128

VIETNAM
Richard Moore
21 Bond Street
New York, NY 10012

Type Directors Club
127 West 25 Street
8th Floor
New York, NY 10001
212-633-8943   FAX: 212-633-8944
E-mail: director@tdc.org
www.tdc.org

Carol Wahler, Executive Director

For membership information please contact the Type Directors Club office.

# TDC MEMBERS

TDC Membership
Saad Abulhab '04
Marcelle Accardi '98s
Christian Acker '02
Ana Aguilar-Hauke '07s
Masood Ahmed '06s
Erich Alb '96
David Allegra '07
Nikki Allen '06s
Sallie Reynolds Allen '06
Savio Alphonso '07s
Natascha Ampunant '02
Jack Anderson '96
Gabriela Varela Andrade '05
Lück Andreas '06
Christopher Andreola '03
Debi Ani '01
Martyn Anstice '92
Tasnim Ara '06
Pratima Aravabhoomi '06s
J.R. Arebalo, Jr. '03
Don Ariev '98
Robyn Attaway '93
Bob Aufuldish '93
Gayaneh Bagdasaryan '07
Levi Bahn '06a
Peter Bain '86
Elizabeth Ball '07
Juergen Bamberg '04
Stephen Banham '95
Joshua Bankes '06
Boris Banozic '07
Giorgio Baravalle '07
Neil Barnett '01
Mark Batty '03
Dawn R. Beard '07
Greg Beechler '05s
Misha Beletsky '07
Paul Belford '05
Felix Beltran '88
Ed Benguiat '64
Nneka Bennett '06
Kai Bergmann '06
Randy Beringer '07s
Anna Berkenbusch '89
William Berkson '06
John D. Berry '96
Peter Bertolami '69
Marianne Besch '06
Davide Bevilacqua '99
Tadeusz Biernot '00
Klaus Bietz '93
Henrik Birkvig '96
R. P. Bissland '04
Roger Black '80
Linda Blackwell Bently '05
Marc Blaustein '01
Anders Bodebeck '04
Christine Boerdner '06
Matteo Bologna '03
Rachel Bosley '06s
John Breakey '06
Brandt Brinkerhoff '05s
Ed Brodsky '80
Craig Brown '04
Kim Brown-Irvis '06
Paul Buckley '07
Michael Bundscherr '07
Bill Bundzak '64
David Cabianca '05
Lauren Cameron '07

Chase Campbell '06s
Mike Campbell '04
Ronn Campisi '88
Christopher Cannon '06s
Aaron Carambula '05
William Carlson '06s
Ingrid Carozzi '06s
Joshua Carpenter '06s
Scott Carslake '01
Matthew Carter '88
Ken Cato '88
Eduard Cehovin '03
Annie Chambliss '07s
David Chang '07
Florence Chapman '06s
Len Cheeseman '93
Eric Ping-Liang Chen '04
David Cheung, Jr. '98
Hyun Joo Choi '06s
Crystal Chou '06s
Grace Chou '07
Terrence Chouinard '06a
Stanley Church '97
Traci Churchill '06
Nicholas Cintron '03s
Scott Citron '07
Alicia Clarens '05
Graham Clifford '98
Laura Cline '07s
Tom Cocozza '76
Angelo Colella '90
Ed Colker '83
Nancy Sharon Collins '06
Tamara Gildengers Connolly '07s
José Antonio Contreras '07
Nick Cooke '01
Rodrigo Corral '02
Madeleine Corson '96
Fabio Costa '03
Susan Cotler-Block '89
James Craig '04
Freeman Craw* '47
Martin Crockatt '02
Laura Crookston-Deleot '00
Andeeas Croonenbroeck '06
Bart Crosby '95
Carl Crossgrove '07
Matthew Crow '06
Ray Cruz '99
Brian Cunningham '96
Rick Cusick '89
Marilyn Dantes '06
Susan Darbyshire '87
Joshua Darden '07
Giorgio Davanzo '06
Jo Davison '07
Einat Lisa Day '97s
Filip De Baudringhien '03
Josanne De Natale '86
Roberto de Vicq de Cumptich '05
Matej Decko '93
Kymberly DeGenaro '06
Olivier Delhaye '06
Liz DeLuna '05
Alfonso Demetz '06
Richard R. Dendy '00
Mark Denton '01
James DeVries '05
N. Cameron deZevallos '06s
Chank Diesel '05
Claude A. Dieterich '84

Kirsten Dietz '00
Joseph DiGioia '96
Elisabetta DiStefano '07s
Chris Do '07
Sebastian Doerken '05s
Lou Dorfsman '54
Dino Dos Santos '04
Bill Douglas '06
Pascale Dovic '97
Stephen Doyle '98
Christian Drury '07
Melanie Duarte '06s
Christopher Dubber '85
Joseph P. Duffy III '03
Denis Dulude '04
Arem Duplessis '06
Simon Dwelly '98
Lutz Dziarnowski '92
Lasko Dzurovski '00
Don Easdon '05
Dayna Elefant '06
Garry Emery '93
Stefan Engelhardt '01
Marc Engenhart '06
HC Ericson '01
Rafael Esquer '07
Joseph Michael Essex '78
Manuel Estrada '05
Knut Ettling '07
Warren Everhard '07s
Florence Everett '89
Peter Fahrni '93
Hannes Famira '06
David Farey '93
Saied Farisi '06
Lauren Fasnacht '07s
Matt Ferranto '04
Robert Festino '05
Gemma Field '07s
Vicente Gil Filho '02
Louise Fili '04
Anne Fink '06
Claudia Fischer-Appelt '06
Scott Fisk '07
Simon Fitton '94
Kristine Fitzgerald '90
Julie Flahiff '04
Michael Fofvich '06s
Gonçalo Fonseca '93
John Fontana '04
Carin Fortin '02
Dirk Fowler '03
Mark Fox '06
Alessandro Franchini '96
Laura Franz '06
Carol Freed '87
Ryan Pescatore Frisk '04s
Janet Froelich '06
Adrian Frutiger ** '67
Jason Fryer '04s
Takayoshi Fujimot '06s
Kenny Funk '05
Lisa Fyfe '06
Louis Gagnon '02
Ohsugi Gaku '01
David Gallo '06
Jeffrey Garofalo '06s
Christof Gassner '90
Martina Gates '96s
David Gatti '81
Wolfgang Geramb '06

Cassianne Giammarino '07s
Pepe Gimeno '01
Lou  Glassheim * '47
Howard Glener '77
Mario Godbout '02
Giuliano Cesar Gonçalves '01
Deborah Gonet '05
Carole Goodman '06
Jason Mathews Gottlieb '07s
Edward Gottschall '52
Mark Gowing '06
Norman Graber '69
Diana Graham '85
Marion Grant '04s
Katheryne Gray '04
Stephen Green '97
Virgina Green '05s
Joan Greenfield '06
Ramon Grendene '06s
Simon Grendene '02s
James Grieshaber '96
Catherine  Griffiths '06
Rosanne Guararra '92
Linda Gully '06s
Linda Gummert-Hauser '06
Matthias Gunkel '05
Ramiz Guseynov '04
Peter Gyllan '97
Brock Haldeman '02
Allan Haley '78
Debra Hall '96
David Hamuel '07
Hai Rai Han '07s
Dawn Hancock '03
Egil Haraldsen '00
Keith Harris '98
Knut Hartmann '85
Lukas Hartmann '03
Williams Hastings '05s
Diane Hawkins '04
Keith Hayes '06
Luke Hayman '06
Bonnie Hazelton '75
Meng He'07s
Amy Hecht '01
Martinus J. Heijdra '07
Eric Heiman '02
Arne Heine '00
Hayes Henderson '03
Michael Hendrix '06
Rebecca Henretta '05s
Earl M. Herrick '96
Ralf Hermannn '02s
Klaus Hesse '95
Joshua Hester '07s
Darren Hewitson '05s
Fons M. Hickmann '96
Jay Higgins '88
Cheryl Hills '02
Bill Hilson '07
Helmut Himmler '96
Kit Hinrichs '04
Norihiko Hirata '96
Michael Hodgson '89
Rebekah Hodgson '06
Robert Hoffman '05a
Fritz Hofrichter '80
Michael Hoinkes '06
Samuel Holleran '06s
David Hollingsworth '03a
Clark Hook '06

Amy Hooper '05
Susanne Horner '07
Kevin Horvath '87
Fabian Hotz '01
Diana Hrisinko '01
Christian Hruschka '05
Amanda Huber '06s
Anton Huber '01
Jack Huber '06
John Hudson '04
Simon Huke '05s
Paul Hunt '07
Randy Hunt '06s
Scott Hutchison '06s
Dennis Y Ichiyama '06
Mariko Iizuka '05
Yanek Iontef '00
David Isaksson '07s
Alexander Isley '05
Donald Jackson ** '78
Jessica Jackson '06s
Alanna Jacobs '05
Ed Jacobus '03
Torsten Jahnke '02
Mark Jamra '99
Etienne Jardel '06
Nancy Jasper '05
Jennifer Jerde '06
Jenny Ji '04s
Matt Jones '07
Giovanni Jubert '04s
William Jurewicz '04
John Kallio '96
Tai-Keung Kan '97
Jieun Kang '07s
I-Ching Kao '02
Vinna Kartika '07s
Miriam Kasell '06s
Diti Katona '06
Carolyn Keer '06
Richard Kegler '02
Russell Kerr '05s
Habib Khoury '06
Ben Kiel '06
Satohiro Kikutake '02
June Hyung Kim '06
Min Kim '06
Yeon Jung Kim '05
Rick King '93
Sean King '07
Katsuhiro Kinoshita'02
Jesse Kirsch '06s
Nathalie Kirsheh '04
Poliana Kirst '06s
Rhinnan Kith '01s
Arne Alexander Klett '05
Akira Kobayashi '99
Nana Kobayashi '94
Claus Koch '96
Boris Kochan '02
Masayoshi Kodaira '02
Jonny Kofoed '05
Kiichi Kono '07
Steve Kopec '74
Gabriela Kopernicky '06s
Damian Kowal '05
Marcus Kraus '97
Matthias Kraus '02
Stephanie Kreber '01
Bernhard J. Kress '63
Ivan Krevolin '05s

Gregor Krisztian '05
Kevin Krueger '06
Toshiyuki Kudo '00
Felix Kunkler '01
Christian Kunnert '97
Dominik Kyeck '02
Gerry L'Orange '91
Raymond F. Laccetti '87
Mindy LaClair '07
Ying Ching Lai '06s
Kevin Lamb '07
Ellen Lampl '05
Melchior Lamy '01
John Langdon '93
Guenter Gerhard Lange '83
Jean Larcher '01
Josh Laurence '07
Amanda Lawrence '06
Jee-Eun Lee '05s
Jin Young Lee '07s
Julianna Lee '04
Jun Lee '07
Lillian Lee '06
Wei Lieh Lee '05s
Jennifer Lee-Temple '03
Pum Lefebure '06
David Lemon '95
Jean-Paul Leonard '06
Gerry Leonidas '07
Olaf Leu '65
Joshua Levi '06
Thomas Lincoln '07
Laura Lindgren '05
Jan Lindquist '01
J. Nils Lindstrom '06
Christine Linnehan-Sununu '04
Domenic Lippa '04
Wally Littman '60
Gleb Lobachov '07s
Uwe Loesch '96
Oliver Lohrengel '04
Jon Lopkin '07s
John Howland Lord ** '47
Bruno Loste '07
Christopher Lozos '05
Alexander Luckow '94
Frank Luedicke '99
Gregg Lukasiewicz '90
Louise Ma '06s
Danusch Mahmoudi '01
Donna Meadow Manier '99
Andrew Maniotes '07
Marilyn Marcus '79
Peter Markatos '03s
Nicolas Markwald '02
Raymond Marrero '06
Rammer Martinez '05s
Magui Martinez-Pena '05
Vanessa Marzaroli '06
Shigeru Masaki '06
Jakob Maser '06
Maurizio Masi '05
Steve Matteson '06
Ted Mauseth '01
Andreas Maxbauer '95
Loie Maxwell '04
Trevett McCandliss '04
Rod McDonald '95
Mark McGarry '02
Matt McGehee '07s
Joshua McGrew '05s

Marc A. Meadows '96
Gabriel Meave Martinez '01
Matevz Medja '02
Roland Mehler '92
Uwe Melichar '00
Bob Mellett '03s
Francesa Messina '01
Frédéric Metz '85
JD Michaels '03
Jeremy Mickel '07
Adam Mignanelli '06s
Mitja Miklavcic '06s
Brian Miller '06
Erik Miller '07
Joe Miller '02
John Milligan '78
Jennifer Miraflor '06s
Elena Miranda '05
Michael Miranda '84
Ralf Mischnick '98
Susan L. Mitchell '96
Bernd Moellenstaedt '01
Sakol Mongkolkasetarin '95
Stephanie Mongon '05s
James Montalbano '93
Richard Earl Moore '82
Amanda Morante '07s
Minoru Morita '75
Jimmy Moss '04
Emmaniel Mousis '05s
Kirk Mueller '06s
Mihac Mukaida '06s
Lars Müller '97
Joachim Müller-Lancé '95
Gary Munch '97
Oliver Mundy '07s
Kara Murphy '06s
Jerry King Musser '88
Louis A. Musto '65
Steven Mykolyn '03
Hirokaru Nakamori '07s
Titus Nemeth '07s
Cristiana Neri-Downey '97
James Nesbitt '06
Helmut Ness '99
Okey Nestor '07
Adam Neumann '05s
Nina Neusitzer '03s
Robert Newman '96
Vincent Ng '04
Charles Nix '00
Shuichi Nogami '97
Gertrud Nolte '01s
Alexa Nosal '87
Beth Novitsky '06
Tim Oakley '06
Robb Ogle '04
Wakako Okamoto '06s
Ezidinma Okeke '05
Akio Okumura '96
Robson Oliveira '02
Toshihiro Onimaru '03
Andy Outis '06s
Petra Cerne Oven '02s
Robert Overholtzer '94
Michael Pacey '01
Frank Paganucci '85
Florence Pak '07s
Brian Papp '07s
Anthony Pappas '05
Enrique Pardo '99

Jim Parkinson '94
Guy Pask '97
Dennis Pasternak '06
Mauro Pastore '06
Gudrun Pawelke '96
David Peacock '06s
Harry Pearce '04
Alan Peckolick '07
Daniel Pelavin '92
Tamaye Perry '05
Giorgio Pesce '05
Steve Peter '04
Oanh Pham-Phu '96
Frank Philippin '06
Max Phillips '00
David Philpott '04
Clive Piercy '96
Ian Pilbeam '99
J.H.M. Pohlen '06
Johannes Pohlen '06
Albert-Jan Pool '00
Aaron Pou '07
Tiffany Powell '05s
Will Powers '89
Vittorio Prina '88
James Propp '97
Lars Pryds '06
Mario Pulice '06
Martin James Pyper '07
Chuck Queener '06
Norman Rabinovich '07
Nikola Radovani '07s
Jochen Raedeker '00
Erwin Raith '67
Jason Ramirez '06s
Sal Randazzo '97
Bob Rauchman '97
Robynne Raye '05
Byron Regej '05s
Francois Reimnitz '07s
Heather L. Reitze '01
Renee Renfrow '04
James Reyman '05
Fabian Richter '01
Claudia Riedel '04s
Helge Dirk Rieder '03
Tobias Rink '02
Phillip Ritzenberg '97
Jose Rivera '01
Chad Roberts '01
Eva Roberts '05
Phoebe Robinson '02
Cindy Rodriguez '06a
Claudia Roeschmann '07
Michael Roma '07s
Salvador Romero '93
Edward Rondthaler* '47
Kurt Roscoe '93
David Ross '07s
Alexander Rötterink '07
Nancy Harris Rouemy '07
Josh Rubinstein '06s
Giovanni Carrier Russo '03
Erkki Ruuhinen '86
Timothy J. Ryan '96
Carol-Anne Ryce-Paul '01s
Michael Rylander '93
Jan Sabach '06
Greg Sadowski '01
Jonathan Sainsbury '05
Rehan Saiyed '06

Mamoun Sakkal '04
Ilja Sallacz '99
David Saltman '66
Ina Saltz '96
Rodrigo Sanchez '96
Michihito Sasaki '03
Nathan Savage '01
Rob Sawyer '06s
David Saylor '96
Nina Scerbo '06
Hartmut Schaarschmidt '01
Martin Schilt '06s
David Schimmel '03
Peter Schlief '00s
Hermann J. Schlieper '87
Holger Schmidhuber '99
Hermann Schmidt '83
Klaus Schmidt '59
Christian Marc Schmidt '02s
Bertram Schmidt-Friderichs '89
Nick Schmitz '05s
Guido Schneider '03
Werner  Schneider '87
Markus Schroeppel '03
Holger Schubert '06
Clemens Schulenburg '06
Eileen Hedy Schultz '85
Eckehart Schumacher-Gebler '85
Matthew Schwartz '05
Daniel Schweinzer '06s
Francesa Sciandra '06s
Peter Scott '02
Leslie Segal '03
Enrico Sempi '97
Mihyun Seong '07s
Jennifer Serota '06
Thomas Serres '04
Patrick Seymour '06
Kambiz Shafei '06s
Li Shaobo '04
Paul Shaw '87
David Shields '07
Manvel Shmavonyan '07
Philip Shore, Jr. '92
Etta Siegel '07
Robert Siegmund '01
Bruno Silva '07s
Mark Simkins '92
Scott Simmons '94
Todd Simmons '06
Leila Singleton '04
Ploy Siripant '06
Martha Skogen '99
Pat Sloan '05
Linton Small '07s
Sam Smidt '06
Sarah Smith '05
Steve Snider '04
Jan Solpera '85
Mark Solsburg '04
Brian Sooy '98
Michael Spatschek '07
Peter Specht '06
Erik Spiekermann '88
Denise Spirito '02
Christoph Staehli '05
Frank Stahlberg '00
Rolf Staudt '84
Dimitris Stefanidis '06
Olaf Stein '96
Judah Stevenson '07s

Charles Stewart '92
Michael Stinson '05
Anke Stohlmann '06
Clifford Stoltze '03
Peter Storch '03
Lorna Stovall '05
William Streever '50
Ilene Strizver '88
Hansjorg Stulle '87
Shinnoske Sugisaki '07
Derek Sussner '05
Zempaku Suzuki '92
Don Swanson '07
Barbara Taff '05
Douglas Tait '98
Yukichi Takada '95
Yoshimaru Takahashi '96
Katsumi Tamura '03
Jack Tauss '75
Pat Taylor '85
Rob Taylor '04
Anthony J. Teano '62
Marcel Teine '03
Johann Terrettaz '07
Mitzie Testani '07s
Régine Thienhaus '96
Anne Thomas '07
Wayne Thomspon '06
Wayne Tidswell '96
Eric Tilley '95
Colin Tillyer '97
Siung Tjia '03
Alexander Tochilovsky '05
Laura Tolkow '96
Klemen Tominsek '05s
Jakob Trollbäck '04
Niklaus Troxler '00
Minao Tsukada '00
Viviane Tubiana '05
Manfred Tuerk '00
Marc Tulke '00
François Turcotte '99
Michael Tutino '96
Adam Twardoch '07
Anne Twomey '05
Andreas Uebele '02
Thomas Gerard Uhlein '05
Diego Vainesman '91
Patrick Vallée '99
Christine Van Bree '98
JanVan Der Ploeg '52
Jeefrey Vanlerberghe '05
Jon Variano '07s
Brady Vest '05
Barbara Vick '04
Mathias Vietmeier '06
Prasart Virakul '05
Nici von Alvensleben '07
Thilo von Debschitz '95
Frank Wagner '94
Oliver Wagner '01
Allan R. Wahler '98
Jurek Wajdowicz '80
Sergio Waksman '96
Garth Walker '92
Allison Warner '06
Katsunori Watanabe '01
Steven W. Watson '06
Harald Weber '99
Kurt Weidemann '66
Claus F. Weidmueller '97

Sylvia Weimer '01
Courtney Weiss '06
Marco J. Wenzel '02
Sharon Werner '04
Judy Wert '96
Alex W. White '93
Christopher Wiehl '03
Heinz Wild '96
Richard Wilde '93
James Williams '88
Mike Williams '06
Steve Williams '05
Grant Windridge '00
Carol Winer '94
Conny J.Winter '85
Delve Withrington '97
Burkhard Wittemeier '03
Peter Wong '96
Willy Wong '06
Fred Woodward '95
Eric Wrenn '06s
René Wynands '04
Sarem Yadegari '03
Oscar Yañez '06
Kyung Mo Yang '07s
Henry Yee '06
Vladmir Yefimov '07
Rubina Yeh '07
Garson Yu '05
Hermann Zapf ** '52
David Zauhar '01
Yun Feng Zhu '07s
Maxim Zhukov '96
Roy Zucca '69
Jeff Zwerner '97

Sustaining Members
Conair Corporation '06
Diwan Software Limited '03
Grand Central Publishing '05
Grove Atlantic, Inc. '06
Massholfer/Gutmayer '06
Pentagram Design, Inc.,
New York '04

*    Charter member
**  Honorary member
s   Student member
a   Associate member

Membership as of April 30, 2007

# TYPE INDEX

When there are several variations of a typeface, faces are grouped together under the primary name. Some typeface names are preceded by the name or abbreviation of the type foundry that created them (such as Monotype or ITC), but they are alphabetized under the generic name.

# GENERAL INDEX

## ABOUT NO.17 (DESIGNERS OF THIS BOOK)

Number Seventeen was founded by Emily Oberman and Bonnie Siegler in the summer of 1993. It is a multidisciplinary design studio working in television, film, print, and the Web. Their office is in the heart of Tribeca in beautiful New York City.

Their work includes the logo and collateral for the National September 11 Memorial and Museum; the opening titles for "Saturday Night Live" (which they have been doing for 12 years); the conceptualization and design of the culture web site veryshortlist.com (check it out; you'll love it); the *Daily Candy* book; creative direction and design of *Colors* magazine; design of the comedy news website 23/6; the identity and advertising for Air America Radio; the titles for "Shut Up and Sing," the documentary about the Dixie Chicks; advertising and design for New York's River to River Festival (for 5 years running); the co-creation and design of *Lucky* magazine; and the identity/packaging for Homemade Baby, a new line of organic baby food (which is delicious).

Other clients include NBC, IAC, Nickelodeon, Hyperion, MTV, HBO, "Will & Grace," The Mercer Hotel, the Chateau Marmont, and Starwood Hotels.

They also write a monthly comic which runs on the back page of *STEP* magazine.

In their spare time, they teach design for television at Cooper Union and in the MFA program at the School of Visual Arts and are visiting critics for the Yale University graduate design program.

www.number17.com

## CREDITS

**Typography 28**
Design Firm:
Number 17

Creative Direction:
Emily Oberman and Bonnie Siegler

Design:
Elsa Chaves

**TDC 53 Call for Entries**
Design Firm:
Number 17

Creative Direction:
Emily Oberman and Bonnie Siegler

Design:
Holly Gressley

We'd also like to thank Graham Clifford and Carol Wahler for giving us this opportunity, and Nancy Heinonen for her dedication to printing the best *Annual* possible.

BYE!